BOBBY THE BIRDMAN

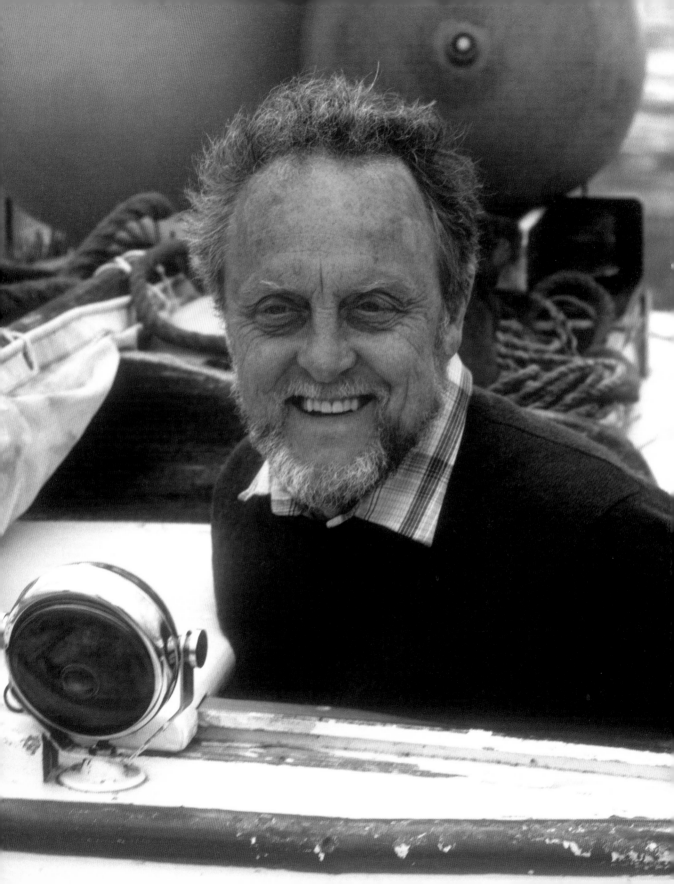

Bobby •THE Birdman

An Anthology Celebrating the Life and Work of Bobby Tulloch M.B.E.

(4 January 1929–21 May 1996)

COMPILED AND EDITED BY

Jonathan Wills

and Mike McDonnell

SHETLAND'S
WILDLIFE AMBASSADOR
REMEMBERED BY

*Bill Oddie • Jonathan Wills •
Mary Ellen Odie • Johnny Clark
• Charlie Inkster • Mary Blance •
Roy Dennis • Liz Bomford • Mike
McDonnell • Annie Say • Wendy
Dickson • Frank Hamilton • Pete
Kinnear • Laughton Johnston •
Charlie Hamilton-James • Mike
Richardson • Martin Heubeck •
Chris Gomersall • Libby
Weir-Breen • Lynda Anderson •
Freeland Barbour • Dennis Coutts*

First published in 2016 by Birlinn Ltd
West Newington House
10 Newington Road
Edinburgh
EH9 1QS
www.birlinn.co.uk

Frontispiece: Bobby Tulloch by Chris Gomersall

Design and layout by James Hutcheson and Tom Johnstone

ISBN: 978-1-78027-422-5

British Library Cataloguing in Publication Data

A catalogue record for this book is available from the British Library

Typeset in Bembo at Birlinn

Printed and bound by Livonia Print, Latvia

CONTENTS

'Bobby wis born on da 4th o' January 1929 an he wis a fast developer. At da Aywick bairns' Christmas pairty in December o' da sam year, he walked up ta Santa ta get his present and say: "Thank you."

Wir grandfaider, Robbie Johnnie Tulloch, lived wi' wis at Aywick. He loved ta wander trow da hills on a Sunday. It wis him at tellt Bobby aa da names o' da birds. Grandad lived ta be 87.'

Mary Ellen Odie
(Bobby Tulloch's sister)
Burravoe, Yell, Shetland
21 November 2009

Shetland

Muckle Flugga

Hermaness

UNST

Gloup

Cullivoe

Uyeasound

YELL Gutcher

Uyea Haaf Gruney

Ramna
Stacks

Basta
Voe

Urie

Lang
Ayre

Hascosay FETLAR

Yell
Sound

Mid Yell

Ronas
Hill

Aywick

Eshaness

Burravoe

Sullom
Voe

Out
Skerries

Lunna

Muckle Roe

Brae

WHALSAY

Papa Stour

Voe

Sandness

Aith

Nesting

Walls

Weisdale

Whiteness

Vaila

Tingwall

BRESSAY

FOULA

LERWICK

NOSS

Scalloway

BURRA
ISLE

Cunningsburgh

60 degrees North

Sandwick Mousa

St Ninian's Isle

Dunrossness

FAIR ISLE

Fitful Head

*Fair Isle 24 miles SW of
main archipelago*

Sumburgh Head

PREFACE
Bill Oddie

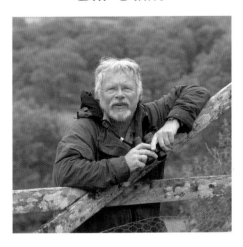

Sometimes memory exaggerates the feelings and faces of the past. There was a time when, if you had asked me what Bobby Tulloch looked like, my description would have involved a generous tummy, rosy cheeks and an enormous white beard. A ringer for Father Christmas in fact. Bobby didn't live in Norway, but he wasn't far away, just across the North Sea in Shetland. I didn't live in Shetland but I did travel up there from London both in spring and in autumn in pursuit of the rare birds that the islands were famous for. Almost inevitably I started on Fair Isle, and I know now that Bobby spent quite a long time there himself, but I don't recall seeing him, or Father Christmas. I did hear him spoken of quite often and I formed the impression that he was a sort of father of Shetland ornithology, or was it the grandfather? Is that why I imagined the big white beard?

By the 1970s, I had switched my allegiance to the islands of Out Skerries, confirming the pretty obvious theory that if Fair Isle got rarities so must the rest of Shetland. By this time, Bobby Tulloch was an almost mythical figure. It was he who proved the first breeding of snowy owls in Britain since who knew when. In 1967 they settled on Fetlar, and so did Bobby, along with an itinerant team of RSPB volunteers. I fancied that there was something almost mystical about the man with the

big white beard, protecting the big white owls, on the remote rocky island. They wouldn't have been out of place in *Game of Thrones*.

For some years I continued to visit Skerries. Towards the end of the 70s, news filtered out that the snowies were no longer on Fetlar, but I didn't know whether Bobby had moved on or not. Until one calm spring evening, when I and my wife Laura were relaxing on the cushiony turf outside our chalet. 'There's a boat coming in,' she pointed out. So there was. It was still some way offshore, but close enough to see that it was being steered by Father Christmas. I was as hundred per cent certain of my identification as of the male rustic bunting I had found the previous day. 'That,' I announced to Laura, 'is Bobby Tulloch.' As he pulled the boat onto the pebbles, I got in first. 'Bobby!'

'Bill!' he reciprocated. I think we spoke almost simultaneously: 'Have we actually ever met?'

'We have now!'

I would love to say that we became great friends, but our brief reunions were restricted to the occasional RSPB events down south. I never got to hear him singing and fiddling, which is again a shame since I am a great fan of Shetland music. I didn't know him well, but I feel that I did. I think it is because his persona was so complete. He lived on an island, travelled in his own little boat, looked after the wildlife, and played in a band. A blend of solitude and sociability. Only one thing not quite right: his beard wasn't enormous, and it wasn't white. Well, not when I last saw it.

Bill Oddie O.B.E.

FOREWORD
Jonathan Wills

No excuse is necessary for a book on Bobby Tulloch but an explanation is certainly required for why it has taken us so long:

I've been busy. So has my fellow compiler, Mike McDonnell, particularly since he retired from medicine and took up art for a living. So have the contributors. And we wanted to make a proper job of it. Better late than never.

Deciding how to organise the book and what form it would take took almost as long as the actual writing, nagging and cajoling that is an editor's lot, even with writers as able and willing as ours. In the end, we abandoned the attempt to integrate all the memoirs into a conventional, seamless 'timeline' narrative and decided just to let the authors speak for themselves, in roughly chronological order. They overlap a bit, of course, so that sometimes we have several accounts of the same event, but this is not a bad thing.

We have not written the definitive biography of Bobby Tulloch. Friends cannot really write analytical biographies. They lack the necessary detachment. So this is just a collection of reminiscences (with some pictures worth thousands of words) which we hope will convey to those readers who didn't have the pleasure and privilege of knowing Bobby Tulloch, what sort of a man he was, why he influenced the lives of all who knew him, and why his legacy matters.

The royalties from this book will go to the Shetland Bird Club, that most admirable voluntary organisation, of which Bobby was a founder member and an office-bearer for so many years.

Sundside, Bressay, Shetland
27 September 2016

Bobby could turn his hand to anything, as this fine scraperboard of the Fetlar snowy owl shows.
(Bobby Tulloch.)

NOTES ON THE EDITORS
AND CONTRIBUTORS

Jonathan Wills is a Shetland councillor who describes himself as 'a recovering jour-nalist'. He got to know Bobby while working as a student reporter on The Shetland Times and later worked closely with him in the early years of BBC Radio Shetland. Later still, Bobby was the inspiration for Jonathan's wildlife tourism business, Sea-birds-and-Seals.

Mary Ellen Odie is one of Bobby Tulloch's three younger sisters. She wrote songs for him and with him and they often performed together at entertainments in the North Isles of Shetland. A stalwart of the Old Haa heritage centre, Mary Ellen has taken particular care in preserving her brother's musical and photographic archives.

Johnny Clark is an accomplished accordionist and was a good friend of Bobby's. They enjoyed many a musical session together, especially after Bobby moved to Lus-setter House and they became near neighbours.

Charlie Inkster, who sat in on Mike McDonnell's interview with Johnny Clark, makes his own contribution towards the end of the session transcribed here. Charlie worked with Bobby at the Mid Yell Bakery in the early 1960s and is a grandson of Charlie Inkster, Bobby's predecessor as RSPB representative for Shetland.

Mary Blance, who interviewed Bobby for 'In Aboot da Night' in 1986, is a broad-caster who has been making programmes for BBC Radio Shetland for over 35 years. Starting in 1978 as 'da secretary wi' nae typewriter', she pioneered local broadcasting in the Shetland dialect, was senior producer of the station for many years, and is now a freelance presenter and producer with a special interest in local literature.

Roy Dennis is a naturalist and a former warden of the Fair Isle Bird Observatory, in which capacity he trained Bobby in bird-ringing techniques. They made many

ringing excursions together in various parts of Shetland and became firm friends. When the snowy owl was discovered nesting in Fetlar, the late George Waterston sent Roy to help Bobby with protecting the nest site – and with handling the massive media interest.

Liz Bomford is a wildlife film maker. From 1969 to 1972 Liz and her former husband, the late Tony Bomford, worked with Bobby on three films about Shetland wildlife, including 'Isles of the Simmer Dim' for the RSPB and the BBC Natural History Unit.

Mike McDonnell was the Mid Yell and Fetlar doctor for 25 years, during which time Bobby was one of the boatmen who ferried him between the two islands. Betty Tulloch was the district nurse and the couple were friends and neighbours of Mike and his family. Mike inspired and helped to found the Old Haa heritage centre in Burravoe, which now houses Bobby's photographic archives.

Annie Say is a retired environmental consultant who first came to Shetland as a Durham University undergraduate and later as one of Professor David Bellamy's postgraduate students. Bobby befriended her and her colleague, helping with their studies and sharing their enthusiasms. Annie's notes of a voyage to Foula in Bobby's old *Consort* are vintage 'Tucker'.

Wendy Dickson is a retired wildlife guide, naturalist and writer who first met Bobby in Fair Isle. Wendy worked in the BBC Natural History Unit in Bristol before migrating towards Shetland via Northumberland. She was once the Hon. Sec. of the Shetland Bird Club. Her description of their Norwegian travels is a classic.

Frank Hamilton succeeded George Waterston as Scottish director of the Royal Society for the Protection of Birds, inheriting the sometimes challenging task of 'line-managing' Bobby Tulloch. His story of the Leith piano illustrates Bobby's talent for improvisation.

Pete Kinnear is a professional conservationist and author of numerous ornithological papers. His career has taken him to Antarctica, Fife and Shetland – where for many years he worked with Bobby in wildlife surveys and monitoring. He was

a fellow founder of the Shetland Bird Club and played a major role in the annual *Shetland Bird Report*.

Martin Heubeck is an Aberdeen University zoologist who has run the annual seabird monitoring programme in Shetland for almost 40 years. Bobby was his boatman and local adviser for many seasons and they were close friends and collaborators in the Shetland Bird Club.

J. Laughton Johnston is a Shetland author, well known for his books *A Naturalist's Shetland*, *Victorians at 60 Degrees North* and *A Kist Full of Emigrants*. A former merchant seaman and schoolteacher, he was the first Nature Conservancy Council officer for Shetland and worked with Bobby Tulloch in the early 1970s.

Charlie Hamilton-James is a well-known wildlife photographer who experienced Bobby's extraordinary kindness and generosity at first hand, when he visited Yell as a teenage amateur.

Mike Richardson came to Shetland in the early 1970s, to run the local office of the Nature Conservancy Council. He later transferred to the Foreign and Commonwealth Office, ending his civil service career as head of the Polar Regions section. He was involved in setting up wildlife baseline studies and monitoring for the Shetland oil terminal, and often worked with Bobby, having a few adventures along the way.

Chris Gomersall has been a regular visitor to Shetland, formerly as an RSPB staff photographer and latterly as a freelance, and worked with Bobby on wildlife photography – notably the famous visit to Yell by a walrus on the day of a royal wedding.

Libby Weir-Breen runs a specialist wildlife tour company, Island Holidays, which she founded with Bobby in 1988. In her fond memoir of their business partnership and long friendship she recalls highlights of Bobby's travels to islands all over the world.

Lynda Anderson is a Shetland fiddler who grew up next door to Bobby and Betty Tulloch in Mid Yell. Bobby was her inspiration to learn the fiddle, passing on his own compositions and always willing to listen to a new tune learned.

Freeland Barbour is a renowned Scottish accordion player and leader of the Wallachmor Ceilidh Band. He worked with Bobby as an entertainer on many National Trust for Scotland cruises and became a lifelong friend.

Dennis Coutts is a retired professional photographer and the doyen of Shetland ornithologists. He was one of Bobby's closest friends and shared his enthusiasms for wildlife photography and the Shetland Bird Club. He famously partnered Bobby in the (unsuccessful) attempt to use a pantomime horse as a hide when photographing the snowy owls in Fetlar. His 'A to Z of Bobby Tulloch', composed for the 21st anniversary of Island Holidays in 2009, is printed here as the last word on the subject.

The editors are grateful to **Liz Gillard** for her kind permission to reproduce the copyright photographs by Bobby Tulloch.

An Introduction to 'Tucker'
Jonathan Wills

After his sensational discovery of a pair of snowy owls nesting on the island of Fetlar in 1967, the Shetland representative of the Royal Society for the Protection of Birds (RSPB) became a national celebrity almost overnight. His name was Bobby Tulloch, known to his pals as 'Tucker'. The son of a crofter in the island of Yell, he'd started his working life as a baker and became, through his own extraordinary talents and a certain amount of good luck, a renowned field ornithologist, tour guide, author and wildlife photographer. He was also an accomplished musician and songwriter, a skilled fisherman and a daring (some would say reckless) navigator of small boats among big rocks. But perhaps his greatest gift was for friendship. When he died in

Bobby Tulloch with his trademark binoculars and Shetland jumper.
(Photograph by the late Gunnie Moberg.)

1996 at the age of 67, felled by a series of debilitating strokes, he was mourned by hundreds of friends throughout his native islands and far beyond.

I like to think Bobby would have enjoyed his funeral. As the minister, Magnie Williamson, began the committal prayer at the graveside in the Mid Yell kirkyard, a blackbird started singing. As Magnie's voice got louder and louder, the blackbird trilled louder still. When Magnie fell silent after the blessing and the casting of three handfuls of earth onto the coffin lid, the blackbird reached a crescendo and finished his recital with a flourish. Bobby would certainly have told this as one of his stories. He would probably have been inspired by the blackbird's song to write a fiddle tune, as he once did with the 'caa-ca-caloo' yodel of the long-tailed duck, or calloo.

Twenty years after that blackbird sang in the kirkyard, those of us who regarded Tucker as a friend (and that includes many who only met him once) still miss him. He left a large gap in our lives. That explains this book.

Bobby would have disapproved, strongly, of someone writing his biography. He might well have made caustic and ironical remarks. So let's call this a celebration, rather than the definitive psychological study. Under pressure from his publisher, he did attempt an autobiographical memoir in his book *Bobby Tulloch's Shetland*, but it was not very revealing and he clearly preferred writing about the birds and islands he made famous.

He was good at being a celebrity. His illustrated lectures for the RSPB, in the Royal Festival Hall and many other big city venues, were usually packed out. Bobby's enthusiasm wasn't just infectious; it was epidemic, as the RSPB's membership figures showed after he'd done a nationwide tour. He was funny, informative, original and, as the BBC Natural History Unit would soon discover, a natural television performer.

A problem was that, coming from a community where it is not really done to put oneself forward, Bobby found his celebrity rather embarrassing. It was all very well to be a concert turn and the life and soul of the party at community halls and fireside 'foys' (impromptu parties) around his home island of Yell, but being on national TV and in the papers was a much bigger deal in the late 1960s than it is today when, allegedly, anyone and everyone can be famous for 15 minutes – or is it 15 seconds? This problem was particularly acute for Bobby, living most of the year in Shetland, where there was only one black-and-white TV channel and local radio hadn't yet been invented. He coped with celebrity by poking gentle fun at the media and, of course, at himself. Anyone who affects airs and graces and seems to be 'getting abune hissel' is

always 'pitten doon' very firmly in Shetland's rather egalitarian society. So Bobby's humorous self-deprecation was much appreciated. In belittling his achievements he was unconsciously reaffirming the self-esteem of the community from which he came. That's what the social psychologists might say but Bobby didn't go in much for self-analysis. He shared the view of the James Thurber character who said: 'For God's sake, let your mind alone!'

I can't remember when I first met Bobby Tulloch but it was probably in the summer of 1968 while I was researching my undergraduate geography dissertation on the isle of Bressay. I used to drop in at Dennis Coutts' photographic studio in Lerwick, to catch up on the birdwatching gossip, and Bobby would sometimes be there too. I remember being with Dennis one day at the Malakoff shipyard pier and looking down onto the deck of a converted 'scaffie' – a small haddock-fishing boat called *Consort*, where an oil-spattered Bobby was wrestling more or less cheerfully with his latest mechanical breakdown, probably caused (like most of them) by his being too busy with other things to do all the routine maintenance.

Consort straining at her moorings off the Mid Yell pier, in a stiff northerly blow.
(Bobby Tulloch.)

By the late summer of 1969 I was encountering Bobby regularly when he visited the editorial office of *The Shetland Times*, in those days on Commercial Street, opposite the Lerwick Post Office. I had a vacation job as a cub reporter, sharing a cramped office with the legendary Hugh Crooks, the news editor, a man with a sharp tongue and a heart of gold. An even smaller office housed the editor, Basil Wishart, a jovial, kindly man with a fearsome temper. When Basil laughed, the building shook. I was rather wary of him, but not of his companion in the office, Fred Hunter, the business manager. Fred was one of the funniest (and most vulgar) people I ever met. When he and Basil were proofreading the advertisement galleys there was a great deal of ribald mirth. Among his many talents, Fred was a fanatical and expert birdwatcher, despite being crippled by polio in childhood. He could not walk far with his sticks but he used his car as a most effective hide and had many a twitcher's 'tick' to his credit. It was Fred whom Bobby, in his role as County Bird Recorder, came to see on ornithological business. Before the Shetland Bird Club started up, Bobby did much of the work for the annual Shetland Bird Reports.

One morning the roars of laughter from Fred's office were even louder than usual. I went through to investigate and found Basil, Fred and Bobby giggling hysterically over a *double-entendre* in a news report about some local council worthy. At that time Bobby and Fred were also compiling the first pocket guide to Shetland's breeding birds,[1] which was a lot more fun than it sounds. My own, very minor, contribution was a series of pen and ink Shetland landscape sketches to fill gaps at the bottom of some pages. In 1969 there was remarkably little in print about Shetland's birds, let alone our other wildlife, so Fred and Bobby's stapled booklet was a major event. It was also painstakingly accurate, summarising the records kept by a small but dedicated band of local birders. Even so, there were large gaps in our knowledge, many of which would later be filled when Fred, Bobby, Dennis Coutts, Pete Kinnear and the indefatigable Iain Robertson co-founded the Shetland Bird Club in 1973. With its regular meetings, award-winning, lavishly illustrated annual report (in contrast to Bobby's stencilled, monochrome version), and its organised surveys by dozens of active members, the club has hugely advanced our knowledge and enjoyment of Shetland's bird life over the past four decades.

Bobby and his birding pals were also involved with the Fair Isle Bird Observatory, which opened its first purpose-built headquarters and hostel in that summer

1. Hunter, F. and Tulloch, R. J., *A Guide to Shetland Breeding Birds*, The Shetland Times Ltd, Lerwick, 1970.

"Two more common migrants: Tullochus barbus robertus and Couttus barbus maximus." A cartoon from The Shetland Times *of 24 October 1969.*
(Jonathan Wills.)

of 1969, after spending 21 years in converted Royal Navy huts at North Haven. To mark the occasion I drew a cartoon for *The Shetland Times* of Bobby and Dennis twitching in front of the new observatory (which was demolished 40 years later to make way for the magnificent new building opened in 2011).

Bobby, Dennis and Fred were all keen twitchers, but they devoted much time and effort to recording common species as well as the migrating rarities for which Fair Isle and Shetland are famous. They were interested in what we now call ecology, not just in new ticks for their 'life lists'.

I first saw Bobby on his home turf in Yell during one of the early cruises of the yacht *Shearwater*. My friend Richard Moira, an Edinburgh architect who did work for Lerwick Town Council, had the boat built by Andrew 'Sundie' Johnson at the All-craft yard in Lerwick in 1968. She was a beautiful but not very practical mixture of a Shetland sixareen and a folkboat, designed by a naval architect friend of Richard's. She sailed very fast in sheltered waters, but the short, steep tide seas on the exposed outer

The yacht Shearwater *leaving Lerwick for Mid Yell in 1983, with Jonathan Wills at the helm and crew Lesley Roberts, Magnus Wills, Andy Wills and Brendan Wishart.*
(Photo: the late John W.E. Wills.)

coast slowed her down alarmingly, despite her heavy keel. There was no radio, radar or echo sounder. In spite of these drawbacks (and the consumption of a fair quantity of strong drink) Richard and I sailed her round most of the Shetland shoreline in the 20 years before his death in 1988. Now the poor *Shearwater* lies derelict in Burra Isle, alas, but the memories are still bright. One of them is of our first visit to the Zetland County Council's pier at Linkshouse, Mid Yell. Many years later, I discovered that Bobby had worked at the building of this 'Coonty Pier' in 1954.

We berthed next to the *Consort* and within minutes a small crowd of old men and boys had gathered.[2] Whence had we come? Whither bound? To whom were we related? In those days the arrival of a small yacht was an unusual event in Mid Yell.

2. Some of the old men took a seat on blocks of a mysterious substance lying on top of the pier. There was a local story that it was gelignite, excavated from wartime mines – harmless, of course, without detonators, but alarming, nevertheless, when I recall that they knocked their pipes out on it.

Bobby emerged from the cabin of the *Consort* and joined the conversation. Had we seen any *neesiks* (porpoises)? Or *unkan* (unusual) birds? He, of course, had far more information than we did on what was flying and swimming out there, as he'd just come back from a run to Fetlar with the doctor and had noticed many things we'd missed. We asked if that could really be a great northern diver we'd seen? Indeed it was – an immature bird had been off the isle of Hascosay for a few days now. And where was the best place to see otters? Hascosay, again. And how do you tell an arctic tern from a common one? The common has a black tip to the bill and the shading on the wings is different; and if you can't tell the difference they're 'comic' terns.

We were bidden aboard the *Consort* for a cup of tea. Bobby got out the bird books and the nautical chart. Later we walked up to his house in Reafirth for supper. This was before he and his wife, Betty, moved to Lussetter House. Within an hour or so you felt you were a member of the family. I was well used to Shetland hospitality but this was something special. Bobby and Betty both had the knack of making you feel welcome, even if you'd arrived unannounced at an inconvenient time, as I'm afraid we often did. Speaking to many of their former visitors, while working on this book,

Lussetter House – Bobby and Betty's home in Mid Yell. The former manse features as "Soothmooth Hoose" in the novel Noost *by Frank Renwick (Baron Ravenstone), its former owner.* (Bobby Tulloch.)

I've found that everyone who knew them felt they were among Bobby and Betty's very best friends. Betty was the district nurse, much liked and respected in Yell. Bobby once joked that his profession was 'nurse's husband', a calling with a long and respectable history in Shetland. Betty had an encyclopaedic knowledge of the 1,100 or so islanders and could sometimes correct Bobby, the native Yell man, on the details of local kinship linkages. She was particularly kind to bairns and indulged my sons Magnus and Andy on our many visits.

When Bobby and Betty moved up to Lussetter House they had more room to entertain weekend guests like us. Their big kitchen was the warm hub of the house and, it sometimes seemed, the social centre of the whole district. The rest of this old stone manse was decidedly chilly, even after Bobby installed central heating. The attic bedrooms were arctic in winter. There we slept beneath elaborate wall paintings and friezes executed by that eccentric genius Frank Renwick, who'd owned the house before Bobby and Betty. Frank, or Baron Ravenstone,

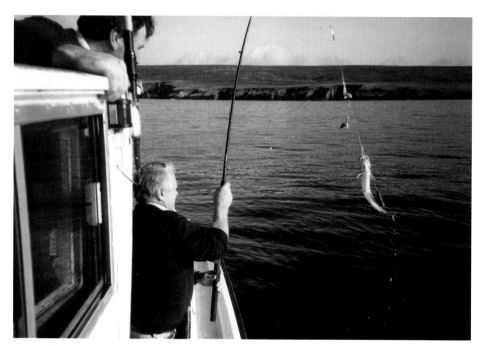

Bobby brings an olik *(young ling) aboard the* Sterna *in the summer of 1992, watched by his friend and neighbour 'Peerie Carl' Anderson.* (K. Jamieson.)

as he prefers to be known, wrote Shetland's funniest and most perceptive novel, *Noost*, in which Lussetter House and Bobby Tulloch have cameo roles as 'Soothmooth Hoose' and 'Toby Bullock'.

In Betty's kitchen you'd typically find several visiting bairns stuffing their faces with treats and playing with toys she'd produced from a cupboard, as Bobby stood at the sink, filleting a bucket of cod and *oliks* (ling) he'd just brought ashore, while exchanging Latin names of migrating birds with a visiting ornithologist, perched with notebook on an armchair. All the adults, including the wildlife cameraman on the sofa, wiping the salt off his lenses, would have a dram at their elbow.

In due course a huge meal would appear from the Rayburn stove, usually as another un-invited guest arrived and was bidden to 'set dee doon and aet!' The menu might include *oliks* fried in their own liver oil, or grilled *spoots* (razor clams) freshly harvested by hand from the chilly sands of Gloup Voe.

The conversation could range from the finer points of warbler identification through the reproductive biology of fish, the depredations of eighteenth-century Yell lairds and the genealogy of the main families in Fetlar, to the prospects of leading skippers at the forthcoming Cullivoe regatta and the best way to cook *spoots*. The forecast gale that had sent us into Mid Yell for shelter would by now be roaring round the lum cans, but we were snug as bugs in rugs. We'd end up in Bobby's study, drinking more whisky than was good for us, while we watched an impromptu slide show. The evening would usually end with a tune or two. And this was just a normal weekend with no special events planned.

No wonder so many people remember their visits to Lussetter House as high points in their lives. It was unfailingly friendly, fascinating and fun. For Betty this

A spootin' expedition to Gloup, north Yell, in February 1980. Bobby and his young helper Magnus Wills gathered a good harvest of razor clams – by the traditional method of getting very cold hands.
(Jonathan Wills.)

continual and erratic schedule must have been a considerable burden on top of her work as the district nurse, but I never heard her complain and indeed she seemed to revel in the company of friends old and new. I fear she was sorely put upon at times. A quiet, secluded life it was not, in one of Britain's remotest inhabited islands.

Tucker and the Scientists

Even before he was appointed as the RSPB Shetland Representative in 1963 Bobby was meeting visiting scientists, mostly ornithologists, who sought him out for advice and directions on where and how to see birds and beasts. With the beginnings of the oil industry in Shetland in 1972 there was an urgent need to do 'baseline' surveys – counts of common species as well as rarities – so we would be able to show what had lived in Shetland before any oiling incident and thus how bad the effects of the spill had been. Hardly any of this fundamental work on describing and quantifying the ecology of the islands had been done. The Institute of Terrestrial Ecology and the Nature Conservancy Council inevitably roped in Bobby and the *Consort* to help with their first coastal surveys. This required taking samples at randomly chosen grid references around the shore, occasionally involving some tricky navigation and scraped paintwork, as not all the sampling sites were easy to reach.

In due course he was an obvious choice as a member of SVEAG – the Sullom Voe Environmental Advisory Group (later, after the trauma of the *Esso Bernicia* oil spill in December 1978, reconstituted as the Shetland Oil Terminal Environmental Advisory Group, or SOTEAG). Here the self-taught crofter's son found himself sitting at the conference table alongside university researchers and eminent professors. He discovered, to his considerable surprise, that he sometimes knew more than they did. Bobby was fascinated by scientific method and research but his attitude to the scientists he met could be ambivalent. On the one hand, he was acutely aware of his own lack of any formal qualifications whatsoever; on the other, he was astonished that some people with doctorates didn't have all the basic skills of a field zoologist. He was flattered to find his views and local knowledge respected and recognised. He admired those who could research and write a scientific paper but he was also sometimes not so secretly delighted when, out on a boat survey, an academic displayed a lack of common sense about practical matters. He enjoyed telling stories about such follies.

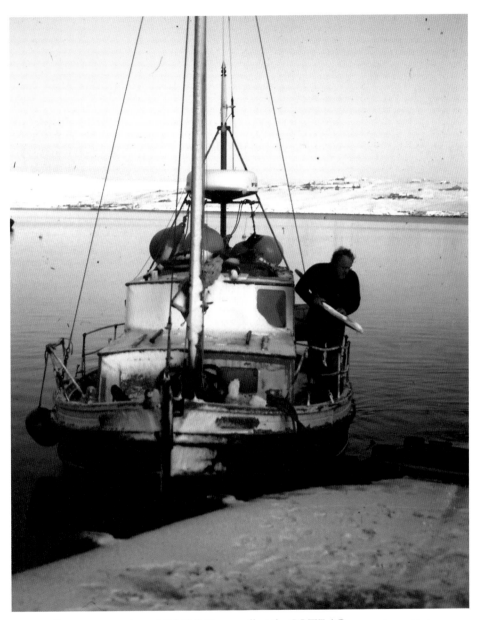

Consort noses in to Mid Yell Pier to collect the SOTEAG survey team on a February morning in 1984. (Mike Richardson.)

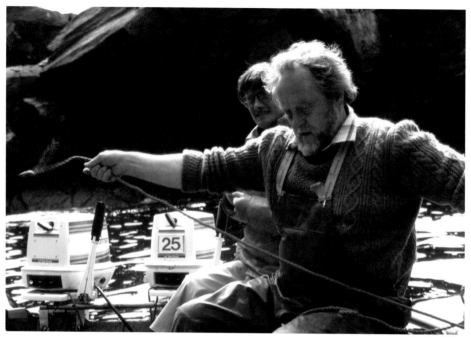

Bobby at work with the late Ann Prior on a Shetland coastal survey in July 1981 for SOTEAG, the Shetland Oil Terminal Environmental Advisory Group.
(Mike Richardson.)

For their part, his new colleagues, such as Mike Richardson[3] of the Nature Conservancy Council and Martin Heubeck[4] of Aberdeen University, on secondment to SOTEAG, found Bobby's knowledge of Shetland's seascape, flora and fauna invaluable as they designed monitoring programmes, selected 'indicator' species and laid down the survey routes for winter counts of the *immer gus* (great northern diver), *tystie* (black guillemot), Slavonian grebe, *dunter* (eider duck) and *calloo* (long-tailed duck).

The routes were chosen to fit the *Consort's* limited range and speed, departing in the midwinter dawn from Mid Yell or Ulsta and returning at nightfall in early

3. Mike later joined the Foreign and Commonwealth Office where he negotiated the surprisingly complex politics of the South Polar Regions and, after retirement, was appointed Chairman of SOTEAG.

4. Martin would become an authority on seabird monitoring and ran the SOTEAG seabird monitoring programme for almost 40 years, devoting most of his career to what is believed to be the longest-running survey of its kind in the world.

afternoon after surveying the 'Bluemull Triangle' between Unst, Yell and Fetlar, or the sheltered waters of Sullom Voe and southern Yell Sound. More than 30 years later, the scientists follow these same routes, originally devised in consultation with Bobby, who knew all the shallow banks and bays where the *immer gus* found its favourite food – *spoots* (razor clams) – and where the *dunters* and *calloos* dived for *yoags* (mussels).

The SOTEAG work was a handy source of funds to supplement Bobby's wage from the RSPB, his charters to take the doctor into Fetlar and increasingly frequent trips with tourists in summer. As the contributors to this book make clear, Bobby's extraordinary abilities as a field biologist, his innate curiosity, his never-failing sense

Martin Heubeck of Aberdeen University logging winter seabird survey results aboard m.v. Dunter III, *successor vessel to Bobby's* Consort *on the Yell Sound surveys for SOTEAG.* (Jonathan Wills.)

of wonder at the natural world and, not least, his developing skills as a showman, were guaranteed to make a memorable occasion of even the most humdrum excursion aboard the *Consort*.

Tucker and the Tourists

As late as the 1970s, wildlife tourism in Shetland was the preserve of a few hundred birdwatching visitors a year. Shetland did not advertise itself very well and, indeed, had few funds to pay for advertising. So most of the outside world had no idea how spectacular, prolific and diverse the islands' wildlife actually was. Keen naturalists had visited Shetland as far back as the eighteenth century, but mainly with the aim of shooting rare birds.[5] In the nineteenth century the islands had produced some home-grown naturalists, such as the precocious Thomas Edmondston[6] and Henry Saxby of Unst. There is a long list of famous ornithological visitors[7] associated with Shetland, and from the earliest days of birdwatching they relied on local people to show them around and to keep records when the eminent visitors returned to the cities for the winter.

For many years the RSPB operated a district 'watcher' scheme that only ended when the society decided to appoint Bobby as their first Shetland representative in 1964. Encouraging wildlife tourism was an important part of the RSPB's work, not only to raise public consciousness of conservation issues but also to attract new members and raise funds. As the local man on the spot, Bobby was expected to act as a guide and companion, often at short notice (or none at all) for all sorts of RSPB members who arrived in Shetland, sometimes with an introduction from Bobby's boss, the

5. Before good optics were widely available at affordable prices, trapping or shooting were the only ways to obtain specimens for the purposes of identification and description. That's how Darwin worked, and many other pioneers in natural history. Hence the saying, 'What's hit's history; what's missed's mystery', attributed to the fanatical bird collector Mr Jemmerling, the baddie in *Great Northern?*, Arthur Ransome's famous book.

6. Edmondston's amazingly productive but tragically short life is admirably described in J. Laughton Johnston's book *Victorians 60 Degrees North*, The Shetland Times, Lerwick, 2007.

7. Including Edmund Selous (who coined the term 'birdwatcher'). The definitive account of Shetland's ornithological visitors and their local contacts is Mike Pennington's 'The Birdwatchers' in *The Birds of Shetland*, edited by Pennington, Osborn, Harvey et al., Christopher Helm, London, 2004. Another excellent history of these early visitors is in the 'Shetland Naturalists' chapter of J. Laughton Johnston's book *A Naturalist's Shetland*, T. and A. D. Poyser, London, 1999.

George Waterston, the RSPB's Scottish Director, who in 1963 hired Bobby to be the society's Shetland representative. Here he's pictured in Fair Isle, during the early days of the bird observatory which he founded there in 1948. (Photographer unknown; picture courtesy of the George Waterston Memorial Centre, Fair Isle.)

enthusiastic, demanding and occasionally choleric Dr George Waterston,[8] a former prisoner of war who had founded the Fair Isle Bird Observatory in 1948 and was now Scottish Director of the RSPB in Edinburgh. George was a charming, hospitable and entertaining man and probably Bobby's greatest fan. He'd picked him as the Society's new Shetland representative, even before Bobby knew the job existed. He once told me Bobby was the finest field ornithologist he'd ever met, and George had met a few. But he had a military approach to discipline that did not always mesh well with Bobby's more relaxed attitude to daily life and work. He also had a terrible temper, as I discovered while working as RSPB warden in Noss in 1970: George arrived on a tour of inspection and, like the army officer he'd once been, tore strips off me for

8. Dr Waterston's remarkable life story is told in Derek Niemann's book *Birds in a Cage* (Short Books/RSPB, 2012).

Consort, looking rather battered, with her legendary leaking dinghy but sporting a big new radar, bumping alongside in Hascosay on a warm afternoon. (Bobby Tulloch.)

not scrubbing the kitchen flagstones before breakfast every day. That he and Bobby got on very well, and together achieved great things for the RSPB, probably owed something to the fact that their workplaces were usually 400 miles apart and mobile phones had not been invented. George's successor, the ever-amiable Frank Hamilton, recalls in this volume the challenges of remotely controlling Bobby's 'workstream', as it would now be called.

Bobby soon became a major asset to the RSPB's recruitment drives. He liked to remind you that the RSPB had more members than all the UK political parties put together and was, in his opinion, a greater force for good.

The visitors sent by the RSPB loved Bobby, even if they didn't always quite take in all the information he imparted. I remember a breathless American lady turning up at the lighthouse shore station in Burrafirth, Unst, after an energetic tramp around Hermaness with Bobby as her guide. 'Oh, Mister Tewloach,' she gushed, 'Ah jes lurve yo' little oystercrackers!' It turned out that the 'garnets', with their black

wingtips, yellow heads and plunge-diving habits, had been 'purdy darn amazin' too', almost as good as the oystercatchers.

As Mike McDonnell recounts in his contribution to this book, based on many years' experience, you never quite knew what might happen on one of Bobby's tourist trips. Even if you missed the snowy owl or the otter, something else was bound to turn up. He had a way of transforming an afternoon chug around Hascosay into an adventure you'd remember all your life – even if the *Consort* didn't hit the rocks of Da Baa o' Hascosay.

In his book *Migrations*[9] Bobby wrote some memorable vignettes of these half-day tours around his home 'patch' at different seasons of the year. In their close observation of detail and perceptive comments on the extraordinariness of everyday fauna and flora, these are some of his best pieces, up there with the works of the 'island' authors whom he so admired – Fraser Darling, R. M. Lockley and Kenneth Williamson.

It was in Hascosay, in the summer of 1983, that I had one of my most memorable encounters with Bobby. I was camping on the island with my two young sons and two slightly older (and rather naughtier) bairns. It was misty and a force five south-easterly drizzle was falling or, rather, moving sideways, hitting things and dripping. Somehow I managed to help the boys light a fire, cook the evening meal, wash up, brush their teeth and, at long last, stop larking about and get out of their oilskins and into their sleeping bags. It must have been coming to ten o'clock at night that I heard the familiar sound of the *Consort*'s engine coming up Hascosay Sound in the fog. It slowed, there was a splash as Bobby threw the kedge anchor over the stern, and a minute or so later a crunch as the *Consort*'s keel ran onto the shingle beach.

As he jumped ashore with the bow rope in one hand and a bottle of rum in the other, he said: 'Da tide's still flowin', boy! Du'll mebbe tak a peerie dram!' It had been a long day and I certainly needed a drink. We had quite a party as we sat by the embers and Bobby entertained the four sleepy heads poking out of their tents with tales of the Hascosay wrecker, Trowie Tammie, and the Edmondston lairds who'd once lived in the ruined house a few yards along the dyke from our campsite. He also told them how to look for *Dratsi*, the otter. At midnight he excused himself, saying they were expecting visitors at Lussetter, waded out to the now refloated *Consort* clutching the remains of the rum bottle, hauled himself aboard and steamed off into the murk. It was vintage Tucker, in his prime.

9. Tulloch, R. J., *Migrations – Travels of a Naturalist*, Kyle Cathie Ltd., London, 1991. See pp. 1–12; 61–64; 104–107; 139–145.

Tucker's Field Guide to Otter Spotting

Next morning we looked for otters. We didn't see any because it was hard for a group of excitable seven to ten-year-olds to follow Bobby's 12 golden rules for otter spotting. They were too noisy, for a start. But I've used his system ever since and it often turns up an otter, not least on Hascosay, which is Shetland's *Dratsi Central*. Like Bobby, I didn't promise to show my wildlife tour customers an otter. What I did promise is to show them how to look for one. Bobby's 12 golden *dratsi* rules go like this:

1. Move at the speed of a sickly sheep and, if you see anything, freeze (or, if in a boat, stop the engine and drift or anchor). Otters are short-sighted but can detect movement at several hundred metres.

2. Make sure you're moving into the wind. If you're upwind of *dratsi* he'll pick up your scent and, believe me, we smell absolutely disgusting to otters.

3. Pick your territory carefully – you don't often see otters around big cliffs. They prefer low-lying, rocky shorelines with plenty of variety – beaches, a fresh-water stream or a brackish lochan, and some deep peat for their holts or *hadds*. Better still, check out the man-made otter habitat in the boulder breakwaters of the inter-island ferry terminals.

4. Check the water depth. Otters prefer to fish in kelp forest less than 10m deep.

5. When fishing, otters rarely venture more than 50m from shore; so concentrate your search there (while keeping an eye on the greensward in case they're gambolling around on dry land).

6. Check the time and tide. Your best chance of a sighting is with a rising tide in the very early morning.

7. Scan 'the reveals' all the time – as you move along a shoreline, keep looking at the new area of landscape and seascape being revealed as you walk (or paddle). That's the bit you couldn't see a second ago. This gives you a chance of spotting an otter, or anything else, before it spots you.

8. Keep your binoculars handy but remember the naked eye is usually better than bins at making the first sighting – because it has a wider field of view.

9. Watch what the great black-backed gulls or *swaabies* are up to. If one of them is standing right at the water's edge but not obviously doing anything, it

may be watching an otter and hoping to share its breakfast. *Dratsi* often takes a fillet out of the side of large fish like the lumpsucker, or sea hen, its favourite food, and leaves the bony bits. So if there's an adult otter fishing, there will almost certainly be a *swaabie* nearby. Unfortunately this rule doesn't work the other way round. *Swaabies* don't usually follow young otters because they catch smaller fish and there are no leavings to scavenge.

10. The easiest way to spot an otter is if it's up on the green or in the water. On the shoreline they're incredibly well camouflaged against kelp and rock.

11. If you see a head about a quarter of the size of a seal's head, it's probably an otter. If it keeps still, it probably isn't. Otters are *very* wriggly and 'sprickly'.

12. If the animal gives a flick of a little pointed tail when it dives, it's an otter. Seals are slower and don't have pointed tails.

What these dozen rules tell us is not only how to maximise your chances of seeing one of Europe's rarest and most beautiful animals but also what an incredibly

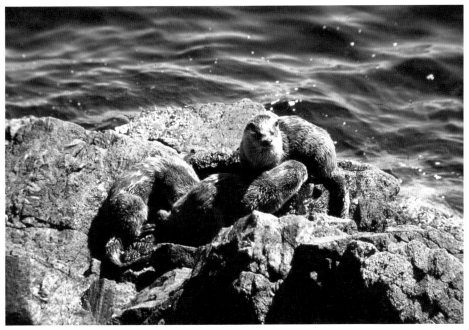

A family of otters in Basta Voe, Yell. (Bobby Tulloch.)

good field naturalist Bobby was. Some of the information in the rules comes from his painstaking, patient observation – and an extraordinarily detailed awareness of the topography of his own island, above and below the surface. But much of it is folklore from his grandfather, other relatives, neighbours and all the generations before them, most of whom, like 'Shootin' Willie' Thomson, whom he described in his first book,[10] would have been more interested in hunting otters for their valuable pelts, than in watching them for fun. So Bobby's handy hints for otter spotting summarised centuries of accumulated, pooled information.

He never wrote it all down like this as a list – he had no need to because it was there in his head whenever he needed it – but he passed it on freely to anyone who showed an interest, whether they were my bairns on a camping holiday or a celebrated wildlife film cameraman like Hugh Miles, who made the superb BBC Natural History Unit film *The Track of the Wild Otter* in 1981–83. His book[11] about the making of the film was dedicated to 'Bobby and Betty whose help, kindness and encouragement made both film and book possible, and whose friendship left myself and family with a host of happy memories.' Before Hugh's film, it was thought to be impossible to film otters in the wild, as Bobby recalled in a BBC Radio Shetland programme:

> I happened to mak a careless remark wan [day] at a 'do' in [the BBC Natural History Unit at] Bristol. It wis at a time when either 'Tarka', or 'Ring o'Bright Watter', had been remade, and somebody wis going on aboot whit a lovely film dis wis and I passed a careless remark dat any competent so-and-so could mak a film using tame animals, an' of course an argument developed as to da ethics of whether, if an animal wis 'impossible' [to film in the wild], you were justified in using tame animals. And I said, weel, you have to first make sure it's impossible. Who says otters are impossible? Oh, everbody knows dey are nocturnal, and only come oot at night. And I said dat's because you don't know.
>
> It wis all a bit light herted, but I got a phone call a couple of weeks later,

10. Tulloch, R. J., *Bobby Tulloch's Shetland – An Islander and His Islands*, p.116, Macmillan, London, 1988.

11. Miles, H., *The Track of the Wild Otter*, Elm Tree Books/Hamish Hamilton, London, 1984. The beautifully evocative watercolour illustrations are by John Busby, another member of the 'extended family' of Lussetter House. He also illustrated Bobby's *Migrations*.

offering to put dir money where my mooth wis. An' dat pit me on da spot, because I dan had ta mak sure I knew what wir local animals wis up tae. Dey said dey wid send a cameraman up fir ten days, and if in dat time he'd got nothin' dan I wid have to admit it wisnae on, even costwise. Well, for da first ten days dat Hugh Miles wis up here lookin' fir otters . . . [only] wan day we did not get some film of otters, and dat set da whole thing goin' . . .

It took over two years, during which Hugh Miles was a frequent guest at Lussetter House, leaving at all sorts of unsocial hours, in all weathers, and returning to that warm, welcoming kitchen, often in despair, sometimes in triumph, and nearly always damp and chilled to the bone.

Hugh recounted an early otter-prospecting visit to Hascosay with Bobby:

It is in the bay below the [uninhabited] farmhouse that we quietly lower the anchor and row stealthily ashore. Just behind the pebble beach lies a small lochan, insignificant by normal standards, but not if you are an otter watch-

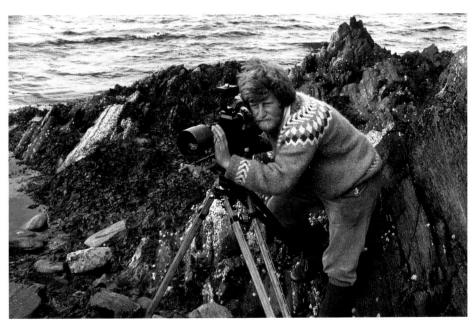

Hugh Miles filming The Track of the Wild Otter. (Bobby Tulloch.)

er. On his surveys of the island's birdlife Bobby had on occasions seen otters here, and determined one day to photograph these elusive beasts, he set a hide in the peat bank by the shore. Armed with warm clothes, a flask of coffee, and a bottle for a dram or two, he sat in the hide from 7 p.m. until 9 a.m. the next morning and saw absolutely nothing! He does admit to dozing off once or twice, and was woken at 2 a.m. by the high-pitched whistle of a nearby otter; but despite the bright moonlight, the whistler remained hidden.

As we search the shores of this lochan, signs of fresh otter activity are everywhere; grass worn by repeated journeys to the water, pad marks and scratches in the peat banks and holes rubbed smooth by the otter's velvety pelt. On several prominent mounds we find piles of 'spraints', fishy remnants of the otter's previous meals, vital clues for an otter tracker and equally significant to otters, for by such means they communicate their presence to each

An 'otter hus' – a trap for unwary 'dratsies'. (Bobby Tulloch.)

other . . . We search the rocky shore and the gently swaying beds of tangle, but if otters are present, we fail to see them.

In nearby Fetlar, Bobby did find Hugh an otter and explained that *dratsi* particularly favoured, as ready-made *hadds*,[12] the rubble and boulder breakwaters the council had recently built for the new vehicle ferries serving the North Isles of Shetland:

> The quay at Oddsta is no exception, having been adopted [by otters] within days of its construction. The ferrymen frequently meet otters here and last autumn saw one coming out of the ladies' loo. Not only was it very well house-trained but it could read too – it was a female otter!

A typically Tucker way of telling a tale, that! After further prospecting (which appears to have occupied much of Bobby's leave time that spring) and only fleeting sightings in Fetlar, Hugh decided to concentrate on a remote but relatively accessible peninsula on the eastern shores of Yell where, in time, he got to know an individual otter and her family very well – so well that he didn't need to use a hide to get those 'impossible' shots in the can. With infinite patience and stiff limbs he made himself part of the landscape. Eventually the otter and her kits paid him no more attention than if he had been a passing sheep. Her descendants thrive there yet.

Otters are mainly nocturnal on mainland Britain but in the long Shetland summer twilight this is not an option. That may be one reason why they are seen here so often in the daytime. As Hugh Miles found when he set out with Bobby to scout for otters back in 1981, they are instinctively shy animals and prefer dense riverbank cover that is not available in Shetland. Perhaps because hunting ceased here in the late 1960s, perhaps because of the inadvertent construction of those magnificent, five-star otter holts at the ferry terminals, and perhaps also because, thanks to Bobby and others, we have all become more expert at looking for them, otter sightings seem to be more frequent than they were when I was a teenager (and surreptitiously destroyed several otter traps while birdwatching in Bressay in 1962 and 1963 – now it can be told). Nowadays, of course, superb quality telescopic lenses and high definition digital cameras bring within the range of the amateur photographer the sort of images

12. Hadd = holt.

The track of an otter (and its tail), sledging down a snowy bank in Hascosay.
(Bobby Tulloch.)

that only the top professionals like Bobby's friend Eric Hosking could hope for back in the 1960s.[13]

As Simon King and other wildlife film makers have discovered in more recent years, some modern Shetland otters can become very bold indeed. On winter nights they often work their way along the Lerwick waterfront, picking over the nets of fishing boats for scraps and apparently oblivious to cars and pedestrians. On several occasions they have strolled aboard the Bressay ferry at the Lerwick terminal. One is even rumoured to have made the seven-minute crossing to the island, although without paying a fare. Sadly, many otters are killed by road traffic, particularly the young ones. Despite 'Otter Crossing' signs at accident black-spots, *dratsi* has never learned any road sense.

The fact that all birds and animals are individuals is obvious but its significance is often overlooked. It was Bobby who taught me to think of each *dratsi*, *immer gus* or *bonxie* (great skua) as a character with personal habits and preferences; not in an

13. For example, see the regular postings of exquisitely detailed otter (and whale) pictures on the Nature in Shetland website *http://www.nature-shetland.co.uk/naturelatest/*.

anthropomorphic, Johnny Morris way (much as I loved the work of that endearing television zoo keeper), but as a means of understanding their behaviour. As Richard Perry had shown in his study of *bonxies* on Noss in 1947–48,[14] by close and prolonged observation you can get to know individuals, even among species that appear on first sight to be identical. So a self-taught naturalist of Bobby's calibre and experience could indeed identify individual great northern divers as they returned every year from Iceland and Labrador to their winter feeding grounds on the Shetland coast, if not always by their plumage then by their daily routines on their preferred territories.

Tucker and the Politics of Oil

The point was tragically demonstrated when an oilspill from the *Esso Bernicia* wiped out nearly all the divers in Sullom Voe in January 1979. As Bobby explained it, these long-lived birds and their ancestors had probably been migrating to the same favoured spots for hundreds, maybe thousands, of years. There were not that many great northern divers in this part of the world and it would probably take a very long time for young birds, prospecting for winter quarters, to discover Sullom Voe and repopulate it. So it proved. Over 30 years later, the *immer gus* count in Sullom Voe in winter remains a small fraction of what it was before the spill, yet numbers on unoiled parts of the coast (particularly between Whalsay and Lerwick) are as high as or higher than before.

The spill of 1,142 tonnes of fuel oil from the tanker *Esso Bernicia* at a Sullom Voe jetty on the night of 30 December 1978 caused a public relations crisis as well as an environmental one. She was only the 12th tanker to use the port. The spill itself was not the oil industry's fault. It happened when a new tug, run by a council-owned company, had a fire in her engine room, due to a design fault. The tug master had to let go his line to the tanker, which was approaching the jetty on a windy night. There was no spare tug to take over the tow (as there should have been, according to the plan) and the huge ship crashed into a council-owned (and unfendered) concrete mooring dolphin, tearing open her starboard bunker tank. The oil terminal operator, BP, deployed two floating booms which corralled the oil in Sullom Voe, as the contingency plan instructed. Then things started to go wrong. Both booms collapsed, the oil escaped into Yell Sound before it could be recovered, and it eventually killed

14. Perry, R., *Shetland Sanctuary,* Faber and Faber, London, 1948.

over 4,000 birds, as well as oiling hundreds of sheep whose winter grazing habitually included kelp along the seashore.

For the council and for BP it was a huge embarrassment. And for people like Bobby, who had helped to plan the wildlife baseline study and the monitoring programme, and had tacitly approved the contingency plans in the event of a spill, this disastrous failure at the very start of Shetland's oil era was deeply disturbing. Bobby certainly felt badly let down by the industry, whose earnest assurances of environmental good intentions he'd been willing to accept at face value at meetings where oil spill containment and recovery had been discussed before the oil terminal opened for business in December 1978. Instinctively averse to confrontation and controversy, he became extremely uncomfortable as the local recriminations multiplied and the spill attracted national media attention (albeit some weeks after it happened – the trigger being a photograph of a single white sheep among a flock of oiled ones).

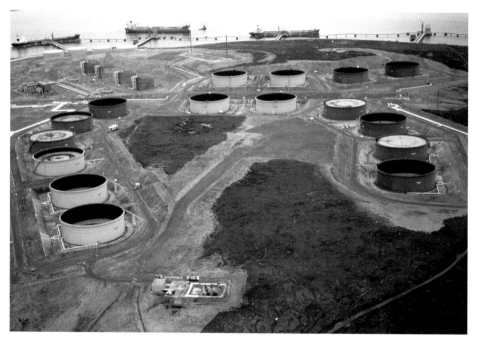

The 16 oil storage tanks, four gas tanks and four dirty ballast water tanks at Sullom Voe in the early 1990s, after peak production had passed. (Jonathan Wills.)

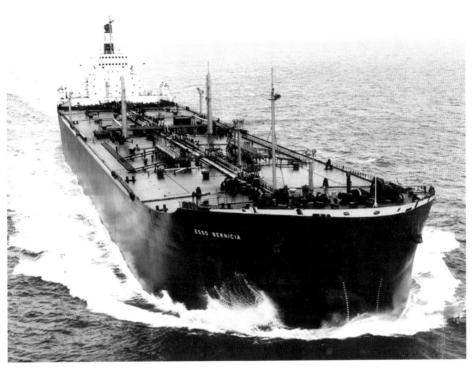

The Esso Bernicia – *notorious but innocent victim of the council's defective tug and unfendered concrete mooring dolphin.*

Being an employee of the RSPB, an organisation which, naturally, took a fairly critical stance towards the industry and its council handmaiden, made things even more awkward. Bobby didn't like it when matters became 'political'. So he didn't join in the public chorus of condemnation from local and national 'greenies', although he did appeal on local radio for practical assistance from the public in finding and recording oiled birds and otters, and helping to put them out of their misery if they could not be saved. He also handed out a list of pertinent questions compiled by the RSPB and the Shetland Bird Club. But he kept his feelings of outrage private, preferring to work behind the scenes to get improvements to the contingency plans, the operating procedures and the oil spill containment and recovery kit at the oil terminal. And he managed to remain on good personal terms with industry officials whom many other bird lovers in Shetland were slagging off publicly, at high volume. His 'softly, softly' approach certainly produced results, but whether it would have

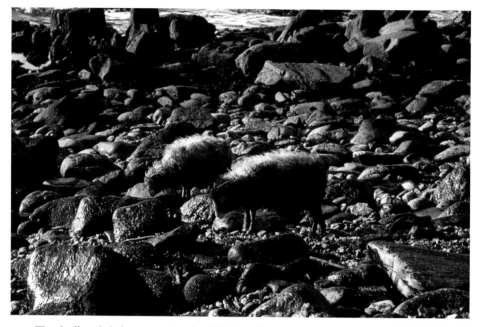

Two badly-oiled sheep scouring the Yell shore for seaweed in early 1979. Pictures like these persuaded the outside world that there really had been serious ecological damage from the relatively small amount of oil spilled in the Esso Bernicia *tanker incident at Sullom Voe on the night of 30 December 1978.* (Bobby Tulloch.)

done so without the entirely justifiable public brouhaha was a point he and I were to debate over drams for many years afterwards.

Feathered and Furry Friends

There is no doubt that the *Esso Bernicia* spill and its political fallout saddened Bobby a great deal and also made him much more cynical than he'd been before. After all, he felt he'd known some of the feathered oilspill victims personally.

Although Bobby was not the first Shetlander to notice that some animals and birds could recognise individual people and boats and even become habituated to them, he was certainly the first to put this knowledge to use in the islands' tourism business. There are records of tame arctic skuas[15] or *skooti alins* as well as herring

15. One of the nineteenth-century 'watchers' on Hermaness, Henry Edwardson, kept two (cited in Pennington, *op. cit.*).

gulls, ravens and crows. While no *bonxie* is very tame, many of them are extremely bold, but this varies from bird to bird, as Richard Perry noted in the late 1940s. They follow boats and some *bonxies* will fly right inboard in their search for scraps, while others hold back.

When I was a schoolboy in the 1950s, coming north from the English Midlands to visit my Shetland grandparents, we never saw any otters. Nor did we see many seals. You could buy a souvenir baby seal ornament made out of real baby sealskin, but you couldn't see a live one without making a special expedition to the remote holms, caves and boulder beaches where they bred, and hid. Until the late 1960s seal shooting was an important source of ready cash and the seals avoided humans, or at least most of them, and particularly they avoided boats. But not all boats for, as Bobby recalled, if you were in a boat that did not shoot seals – a boat like his

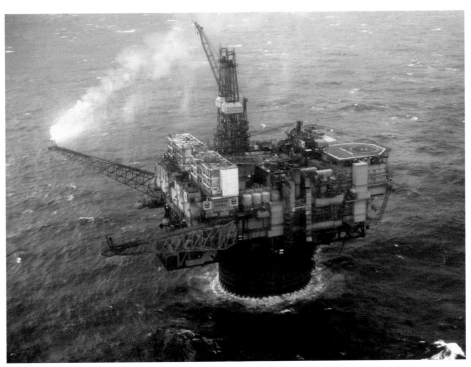

Out of sight, out of mind? A 1970s North Sea oil production platform with its gas flare and the usual 'sheens' of diesel and other minor spillages downwind.
(Bobby Tulloch.)

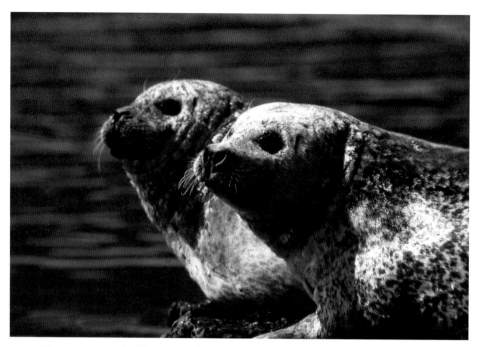

Two common seals (Phoca vitulina) hauled out at Urie, Fetlar. (Bobby Tulloch)

Roselyn,[16] for example – then they would get used to you after a while and not flee at your approach. When he bought the *Consort*, he recalled, the seals were 'suspicious' of her for a couple of years.[17]

This habituation to boats and humans is now seen in extreme form at Lerwick Harbour, where grey seals will come right alongside fishing boats to beg for herring and mackerel, and haul out on rocks below the Tesco supermarket, a few yards from traffic and pedestrians. Even common seals, which are generally less bold, come right into the Bressay Marina, Lerwick's Small Boat Harbour and Hay's Dock, to the delight of visitors. Significantly, there are no longer any fish farms within Lerwick port limits. The port authority found the bad publicity too troublesome, perhaps, after one of the farms was reportedly using trap nets to drown seals (with a 'by-catch' of dolphins and eider ducks in the process).

16. The *Roselyn* was the small creel boat Bobby had before he bought the *Consort*, which in turn was replaced by the *Starna*.

17. Tulloch, R. J., *Migrations*, p. 63.

The Slaughter of the Seals

Salmon farming only began in Shetland in the 1980s. At first, most people welcomed the new industry as a clean, sustainable activity that would bring money to the islands and employment to remote areas. And so it did, particularly in Yell, where Bobby and Betty's house soon overlooked several large fish cages. In those early days the industry was locally owned but as it proliferated into almost every suitable voe there were repeated takeovers, so that it is now almost entirely owned by large corporations based far from Shetland. Even before the consolidation of foreign ownership, the public image of Shetland salmon farming was damaged by a series of scandals involving pollution, illegal use of chemicals and pharmaceuticals and adverse effects on wild fish, in addition to the illegal culling of seals, sea ducks and otters.

In some salmon farming areas, particularly Bobby's old cruising grounds in the 'Bluemull Triangle', common and grey seals have been almost exterminated in the years since his death. The Haaf Gruney nursery (where he discovered that seals use

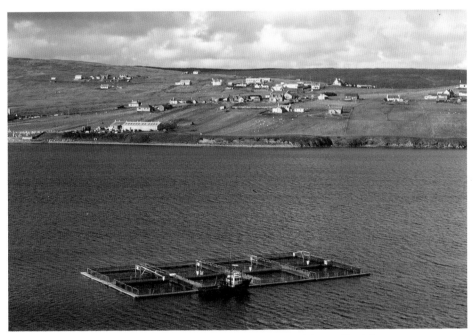

Salmon farm cages in Mid Yell Voe. (Bobby Tulloch.)

gulls as intruder alarms to warn them of approaching photographers)[18] is nearly empty and the boulder beaches under the Blue Banks of north Fetlar, where Bobby and his friend Ian Brooker nearly came to grief photographing seal pups,[19] are greatly depleted.

The salmon farmers deny responsibility for this carnage, of course, but tell-tale cartridge cases on the deserted seal beaches of Bobby's beloved Hascosay, the private testimony of witnesses afraid to speak out, and the circumstance that no-one else has a motive to kill seals, make it fairly clear what has been going on. I deal with the problem in the only way I can: if they kill my seals I won't buy their farmed salmon. I don't think Bobby would have, either, if only because of the drastic decline in the sea trout he delighted to catch, due partly to mass infestations of sea lice among the salmon farms of his once pristine archipelago. It is all very sad.

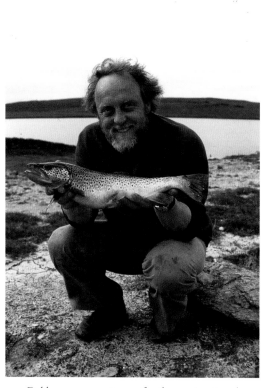

Bobby was a great man for the sea trout and bemoaned the decline of these great fish due to illegal netting and, in part, to the spread of sea lice from salmon farms.
(Liz Bomford.)

If you visit a Shetland fish farm today you are not likely to see many seals. Those that do hang around salmon cages are at severe risk of being shot, particularly if they've become smeared with tell-tale red, anti-fouling paint from the cage nets and can thus be classed as 'rogue' seals. In fact it's some of the salmon farmers who are the rogues because their licences specify 'non-lethal predator control' and they

18. See Tulloch, R.J., *Bobby Tulloch's Shetland*, p. 37.

19. *Ibid*. p. 151. The beach where they were cut off by heavy seas was obliterated by a landslip in 2010, but already the sea is making a new seal-pupping beach out of the fallen rock.

are supposed to have a seal shooting licence, a trained marksman and a high calibre rifle if they intend to kill seals that are causing them financial loss. Not many meet all three requirements, I suspect. The industry now admits its former failings and repeatedly promises to do better and abide by high-minded codes of practice. Bobby did not live to see the worst environmental outrages of rogue salmon farmers but I rather think his reaction to such assurances would have been a sardonic: 'I hear dee,' meaning 'we shall see.'

Ironically, one of the best places to see grey seals at point blank range is at the salmon processing plant in Lerwick, where the factory workers, unlike the salmon farmers, love their seals, have pet names for them and come down to the shore at tea breaks to throw them scraps of salmon from the waste bins. This is probably against some European wildlife conservation regulation or other, but the supply of free lunch attracts up to 50 bull grey seals at times. Bobby (or, indeed, Johnny Morris) would have done a brilliant voice-over for a film of Lerwick's 'industrial' seals. But I digress . . .

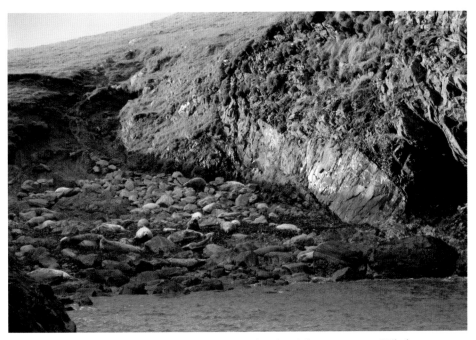

Seals are very particular about their pupping beaches. This one is near Whalsay, on a holm where 21 grey seal pups were clubbed to death in 2008. (Jonathan Wills.)

Knowing Where to Look

As Mike McDonnell recounts in this volume, Bobby was famous for his acute eye-sight. Just as important was knowing how to use his eyes. As George Waterston had noted, even without binoculars Bobby could always pick out birds no-one else in the party had clocked yet, either because experience had taught him to scan the horizon as well as the near-field, or because he could catch the 'jizz' of a distant bird in the corner of his eye and identify it by its distinctive movements and shape, long before the field-guide identification marks were visible through Leitz lenses. He also used his ears, detecting the faraway calls of the first terns or *tirricks* returning to Hascosay Sound in early May, after their astonishing 22,000-plus miles round-trip to South Africa, or the distant honking of whooper swans in October, splashing down in a North Yell loch after a non-stop flight from their breeding grounds in Iceland and beyond.

Tucker and the Media

In September 1976 a man from the BBC came to see me at the office of *The Shetland Times* in Lerwick. His name was Alistair Hetherington. Of course, I'd heard of him as a famous editor of the *Guardian*. Now he was Controller of BBC Scotland and on a mission from his Glasgow headquarters – to see if it was possible to start small community radio stations as 'opt-outs' from Scotland's main national radio service on VHF. He knew it could work technically, but did I think it feasible, editorially? I told him we often had difficulty finding enough news to fill a local newspaper once a week, but agreed it would be fun to try. I introduced Alistair to various local folk who might be interested. In due course the job was advertised under the impressive title of 'Senior Producer-Presenter, BBC Radio Shetland'. I applied and, to my considerable surprise, in view of my fairly modest journalistic qualifications, was accepted. On 7 January 1977 I reported for training at Broadcasting House, London, and learned that we would be going on air in only four months' time. The total staff of the station would be two, although the bosses later agreed to a part-time secretary 'to help with the paperwork'. My colleague was to be Suzanne Gibbs, an experienced wildlife TV producer from BBC Bristol, who'd worked with Bobby Tulloch on the *Isles of the Simmer Dim* film where he made his hugely successful debut as a TV wildlife guide.

Opposite: *Grey seal bulls at the fish factory pier in Lerwick Harbour.* (Jonathan Wills.)

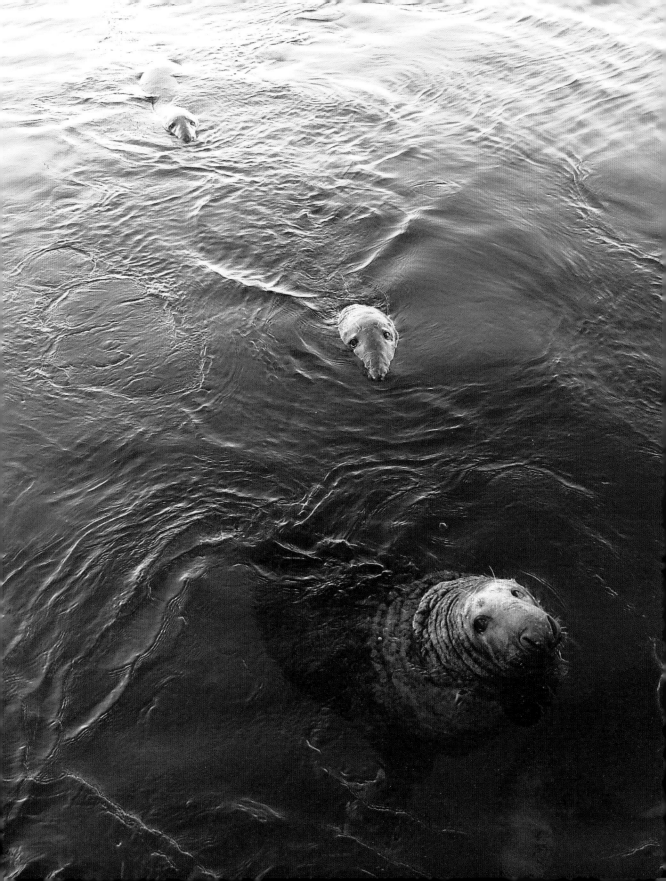

*In March 1977, shortly before the start-up of Radio Shetland, the BBC hired
Loganair to fly producers Jonathan Wills and Suzanne Gibbs to Foula, for a public
meeting to explain plans for 'community radio'. Bobby came along for the trip, along
with Lesley Roberts (left) and Janet Askew (right).*
(Jonathan Wills.)

Without Bobby, I don't think we could have done it. BBC Radio Shetland's
Good Evening Shetland show was to be an 'opt-out' from the national Radio Scot-
land service on VHF, five nights a week. We planned it as a mainly serious news
and current affairs programme, with a weather forecast and listings of community
events, but also as a showcase for local musical talent and folklore. With a staff of two
and a half it was a tall order and probably far too ambitious, particularly as the new
station's equipment, in the tiny studio next to our one-roomed office in Harbour
Street, Lerwick, turned out to be a recycled Telefunken M28 tape deck (in storage
since the Munich Olympics), two Uher portable tape machines, a single turntable,
two microphones and a decidedly dodgy cassette player. There was no 'mixer' and
the control desk was a one-off, designed (by a BBC committee) to be idiot-proof.

It caused problems and, as we went live on air for the first time, an engineer was squatting between my knees, making last minute adjustments to the wiring. No wonder I sound slightly apprehensive on the surviving tape of the first broadcast on 9 May 1977.[20]

By that time we already had a bank of features material on tape, to fill the gaps after the news and weather, between the What's On and the music (mainly local and traditional) that ended the show. A large chunk of this material featured Bobby, who turned out to be a lot more than the wildlife correspondent we'd had in

Bobby with Suzanne Gibbs of BBC Radio Shetland on Foula, March 1977.
(Jonathan Wills.)

mind. In the early months of 1977 I made several weekend trips to Yell to record five- to ten-minute 'packages' with him, mainly about birds and other wildlife but also covering local history and folklore. His fund of stories and information was inexhaustible. This did not surprise me but I quickly discovered that he was an accomplished singer-songwriter as well. Bobby's forté was the comic song, usually a pastiche on some well known melody. Soon we had 'Nobody's Lamb', 'Du Picked a Fine Time ta Laeve me da Streen', 'Da Shetlan' Cowboys' and 'Rabbits' on tape. I recorded the songs with a Uher reel-to-reel tape machine and a single microphone in the living room at Lussetter. When my arm got tired or if I needed to refill a glass or two, the microphone was left on a cushion, in the absence of a microphone stand. The results, from a sound engineer's point of view, were much better than they should have been.

Our impromptu recording studio at 'Broadcasting House, Mid Yell', was warm, comfortable and had one of the best acoustics I've ever known, even with a gale howling outside the shutters. It was also rent-free. At first I had no budget to pay contributors. It had been assumed, in Broadcasting House, Glasgow, that because it was a 'community' station everyone would appear for free. But on training in

20. My dear friend Fred Hunter was buried the same day and I was unable to attend his funeral, which added to the incongruously gloomy tone of Radio Shetland's first broadcast.

London I'd found out about the Performing Rights Society and the Musician's Union. Although there were no professional musicians working regularly in Shetland at that time, it seemed to me that asking people to perform for nothing on the BBC was a presumption too far. After a while I managed to persuade Glasgow to allow us a budget to pay our musical contributors. It was peanuts, but in Bobby's case probably quite useful for the domestic budget. For us, the extra paperwork for paying 'OCs' (Outside Contributors, in BBC dialect) and filling in the details of composer and arranger on the 'PasB' (Programme as Broadcast) forms – complete with details of composer and arranger – meant the case for a full-time Radio Shetland secretary became unanswerable.

We also got hold of a third Uher tape machine and one weekend I accidentally on purpose left it with Bobby. Soon he was turning in even more material, self-started and self-operated (and in contravention of the old BBC rule that every presenter must have a producer, even when working on location). We had enormous fun writing and recording the Radio Shetland Christmas Pantomime, *Bobbyrella*, in which he played the lead role, reading his lines in a falsetto voice and yodelling into the bargain. Listening to it again, over 30 years later, the jokes have not worn well and I suspect that, at the time, the audience enjoyed it rather less than we performers did. But there was no doubt who was the star turn.

Long before he worked with Radio Shetland, Tucker had been taking news photographs for *The Shetland Times* and also pictures to illustrate his talks for the RSPB. His vast collection includes many images recording scenes from Shetland life in the 1960s, 70s and 80s. On the following pages is a small selection.

Tucker's Music and Song

All of Bobby's work proved a big hit with the listeners and we received many letters asking for more. The adulation would have turned many a head, but not Bobby's. He remained modest about his performances, typically describing one popular hit as 'chust a peerie ditty I wrat doon fur da Mid Yell regatta concert'. And in truth his BBC Radio Shetland songs were no more than an extension of what he'd been doing in Yell and elsewhere in Shetland for over a quarter of a century already. I have many favourites among these songs, but the one I particularly remember was *Da Shetland' Cowboys*, which went some way to explaining why Shetland was and is the world capital of country music, outside the United States and Northern Ireland.

Top: *Mid Yell in winter, with the crab factory on the left, the graveyard on the right, and Mid Yell Pier beyond. Lussetter House is the large building on the hill above the pierhead and the Linkshouse shop.*

Bottom: *County council roadmen digging out the main road through Yell after a blizzard.* (Bobby Tulloch.)

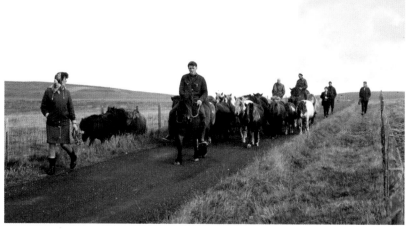

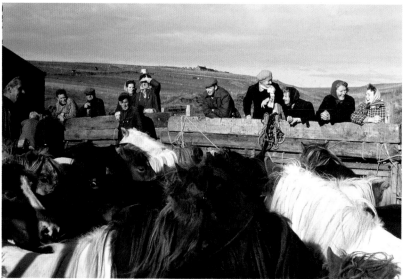

Top and bottom: *The annual round-up of Shetland ponies in the Fetlar hill.*
(Bobby Tulloch.)

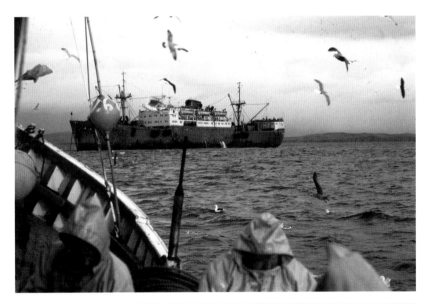

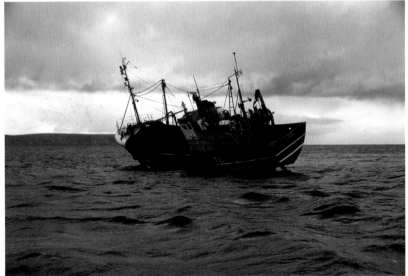

Top: *A Soviet 'klondyker' fish factory ship seen from the deck of a Shetland fishing boat off Yell.*

Bottom: *A trawler aground on the Baa of Hascosay.* (Bobby Tulloch.)

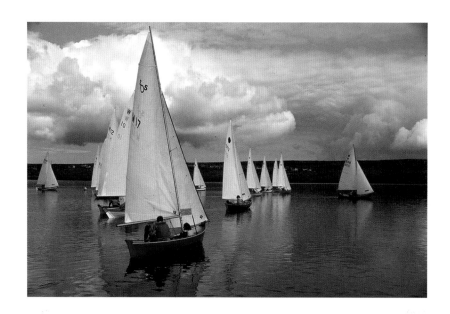

Top: *A sailing race at Mid Yell.*

Bottom: *Off the beaten track: the croft at Sandwick, Swining Voe, now deserted, was one of the most remote parts of the Shetland Mainland when Bobby anchored the Consort there to visit the Morrison family in the late 1960s. Note the thatched roof and the peat smoke.* (Bobby Tulloch)

Da Shetlan' Cowboys

(words by Bobby Tulloch)

Geng ta ony Shetland hall, i' da spring or i' da fall,
 or in winter when da snaa lies on da groond.
You may hear da fiddles play, but if you care to stay,
 you soon will hear dat Country Western soond.

When we wir peerie boys we didna hae sae mony toys
 an' televeeshun sets wir quite unknown,
But on mony a rainy day, we wid bide inside an' play
 some records on dat old gramophone.

Dir wis records on da floor; dey were piled ahint da door;
 dir wis cotton pickin' records on da bed!
Dey wir cracked an' dey wir worn; aa da labels dey wir torn;
 but dey wir played, dey wir played, dey wir played!

Tho' we laughed at Harry Lauder and we danced wi' Jimmy Shand,
 an' we cried when dey shot poor Nelly Gray,
Da sangs we liked da best wir da sangs fae wye oot wast
 aboot da cooboys of yes-ter-day.

Dir wis aald Montana Slim, oh we towt a lok o' him;
 Gene Autry an' Jimmy Rodgers too;
Dan Slim Whitman cam alang, wi' his yodel an' his sang
 an' we lairned da wirds an' tried ta yodel too.

Wir horse becam a mustang and da aald red coo a steer
 an' we hunted mony rustlers trow da stanks.
While in da park of Ramnageo, whaar we held wir rodeo,
 we nearly drave wir ox right ower da banks.

Wi' wir six-guns at da ready, an' wir lariats unfurled,
 we battled wi' da Indians up da toon,

An' we hunted da Apache up an doon da Burn o' Vatchie,
 till we sank wir red canoe an' nearly drooned.

But bairns' games can't last fir ivir, an' reality most com,
 tho' the gramophone o' life most still play on.
Dir'll be thrills, dir'll be spills, waitin' up in 'them thar hills',
 until the last roond-up has bin and' gone.

An' as we struggle an' we strife, trow da canyons o' wir life
 an' we climb wir Rocky Moontains, richt or wrang,
When tings ir lookin' glum, get oot yir aald geetar an' strum,
 an' sing a happy Country Western sang.

Geng ta ony Shetland hall, i' da spring or i' da fall,
 or in winter when da snaa lies on da groond.
You may hear da fiddles play, but if you care to stay,
 you soon will hear dat Country Western soond.

From his early years, Bobby sang with his sister Mary Ellen, who often wrote songs for him and with him. Later, she also made sure that his own sometimes chaotic manuscripts were preserved, so that today we have an almost complete collection of his work, not just the satirical and amusing pastiches but also the more serious ballads. Mary Ellen and other members of the family have likewise preserved and collected most of the fiddle tunes Bobby wrote. Lynda Anderson, who grew up next to Bobby and Betty, and later became a semi-professional fiddle player herself, recalls Bobby's musical career in this volume, with the aid of fellow performers such as Johnny Clark, and assesses his contribution to Shetland's musical heritage. Although Bobby played guitar and accordion from an early age, I was surprised to learn from Johnny Clark that he took up the fiddle quite late in life and was largely self-taught. It seemed to my untutored ear that he must have been a fiddler since childhood.

Tucker the Serial Enthusiast

Among Bobby's many enthusiasms, and one of the few he retained to the end, was photography. He achieved some remarkable results with equipment nothing like as

technically advanced (or as easy to use) as the most ordinary cameras available to amateur photographers today. With help and advice from friends such as Dennis Coutts, he learned the principles of photography and darkroom technique. With money always a problem, he didn't have the best lenses for wildlife photography, until he met the famous bird photographer Eric Hosking, who gave him one of his spare telephoto lenses. Bobby never forgot this kindness and, as Charlie Hamilton-Jones recalls in this book, he would later lend his own precious equipment to encourage a young amateur.

Even before he got proper kit, some of his shots were brilliant – for example, the first pictures ever taken of the guillemot colony on the Ramna Stacks. He took some risks getting those images and many others.

One day in the summer of 1975 I rowed a small boat in between the jagged pinnacles of the Muckle Flugga group and managed to land Bobby on the Rumblings stack. He had a hard scramble to the top, through hundreds of extremely hostile gannets whose stinking, slimy excreta made his foothold extremely precarious on a

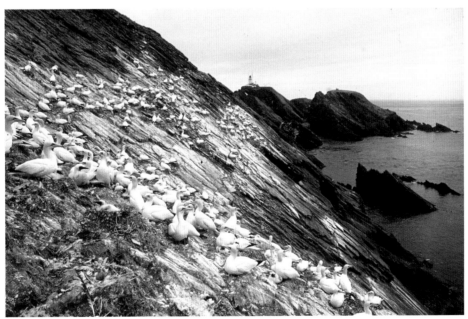

Part of the gannetry on Da Rumblings stack, Muckle Flugga. Bobby climbed up this slippery, guano-encrusted slope in the summer of 1975 to photograph the elegant birds and their ugly, smelly chicks, with the famous lighthouse in the background.
(Bobby Tulloch.)

One of the reasons for landing on and climbing the Ramna Stacks was to count the birds. These guillemots were breeding right next to the tanker lane into the Sullom Voe oil terminal. (Bobby Tulloch.)

40-degree slope. After half an hour, and an equally precarious descent, he leapt from a weedy rock into my boat, triumphant that he now also had the first photographs ever taken on Da Rumblings.

He worked extensively with colour slides and even did his own colour processing for a while, after teaching himself, as usual. His slide collection has been scanned and catalogued and is on public display at the Old Haa heritage centre in Burravoe, Yell, as well as online at *www.bobbytulloch.com*. A vast collection of black and white negatives remains unscanned and uncatalogued, however.

Other enthusiasms that came and went included a marine aquarium, tropical fish and mycology – the study of fungi. The marine aquarium was set up in a tank next to the kitchen at Lussetter House, the idea being to study and photograph sea creatures such as octopus, crabs and whelks. Scuba diving in the sea temperatures around Yell was an enthusiasm too far for Bobby, it seemed. A supply of seawater for the aquarium was no problem but keeping it cold was. The solution was an electric

Top: Consort *moored at the landing place below the Muckle Flugga lighthouse, on a fine day. Note the fibreglass dinghy hauled up on the end of the 'Comb' rock.*
(Bobby Tulloch.)

Bottom: *The Muckle Flugga landing place in a winter gale.* (Jonathan Wills.)

A view from one of the Ramna Stacks, at the north end of Yell Sound, where Bobby made a perilous landing on these rarely-accessible rock pinnacles. This was after Dr Ian Brooker, the Yell GP in the 1960s, had taught Bobby how to climb.
(Bobby Tulloch.)

beer cooler. This worked fine for a year or so until the salt water corroded the cooler. Hence the switch to tropical fish, which lasted rather longer as it was easier to warm fresh water than to cool salt.

Bobby came to mycology late in life but made some interesting discoveries, not the least of which was that fungi associated with Scandinavian and Scottish forests still lingered in Shetland, some three thousand years after the islands were largely deforested by early settlers using nothing more complicated than fire, stone axes and sheep. We were surprised, on one weekend visit, to find strange fungi on the Lussetter menu. Some of them (such as the evil-looking ink-cap) tasted delicious, some less so, but it never occurred to us to question Bobby's assurances that they were all edible. For, of course, he'd done his research, as usual. This brief but remarkably successful enthusiasm for mushrooms and puffballs was what led Bobby to borrow a binocular microscope from the local doctor, Mike McDonnell, in order to identify species by the pattern of their spores. As Mike recounts below, Bobby then completely forgot he'd ever loaned him the instrument.

Other enthusiasms followed. The pattern was clear: Bobby would concentrate all his considerable energies and intelligence on a subject and, once he'd mastered it, was quite likely to abandon it for some new object of fascination. In his *A to Z of Bobby Tulloch*, in this volume, Dennis Coutts mentions some of the trades of which Bobby was a master.

Tucker the Ladies' Man

From infancy, it seems, Bobby Tulloch was what they used to call 'a ladies' man'. Growing up in a household dominated by women, he would always be at ease in female company. In school, boys and girls were not segregated. At Yell dances, to be sure, men and women would sit on opposite sides of the hall when not actually dancing but, if you were a musician and entertainer, as Bobby was from an early age, backstage you would always be on familiar terms with women and girls from outside your immediate family.

Bobby was indeed fond of the ladies and the attraction was reciprocal. Many women found his twinkling eyes, his humour and his saucy gallantry irresistible. Throughout his life he enjoyed the friendship of women, sometimes close friendship. This was unconventional in 1950s and even 1960s Shetland, and it did not pass unremarked.

If I've given the impression of domestic bliss when describing our visits to Lussetter, it was not always so, alas. It was obvious to everyone who knew Bobby and Betty that theirs was not a conventional partnership. Despite the conviviality and hospitality, they lived separate lives to some extent; but it was more than just a marriage of convenience. What exactly went wrong, no-one quite knows, although it's clear that they found themselves incompatible in some ways very early on. However, Bobby and Betty made the best of it and came to a friendly arrangement that, for all the evident strains, worked most of the time. This had advantages for both of them. Although they obviously regretted not having bairns of their own they were a doting aunt and uncle to their nieces, who adored them.

Betty was an excellent cook (as was Bobby) and a good housekeeper (which he wasn't), always accommodating when his work brought unexpected visitors needing food, beds and a washing machine. She was also the main provider after Bobby's bakery venture failed, and even after he secured his RSPB job, which was very poorly paid. It was only when his freelance work took off, as a photographer, writer, broadcaster, lecturer and wildlife guide, that he began to enjoy a modest prosperity, but even then the amount of work he did for free would ensure he never became rich.

Bobby did not always bring a great deal of cash to the table but he contributed plenty in kind to a lifestyle that many visitors would envy. Always a keen angler, he could be relied upon to deliver fresh cod and ling – expertly gutted, skinned and filleted, of course – and he was rarely short of a bucket of shellfish.

As the district nurse, Betty could also find herself the recipient of a bag of tatties

Betty Tulloch in the garden at her parents' home in Newton Stewart.
(Bobby Tulloch.)

or a dozen eggs as she went on her daily rounds of the crofting townships where so many had reason to be grateful for her skill and kindness, to which Mike McDonnell pays tribute below. So it was not exactly a poverty-stricken existence, despite the occasional shortage of ready cash.

Even so, in the early 1970s Bobby and Betty agonised over money for a long time before they took the plunge and bought Lussetter House. It was really beyond their means at the time and needed a great deal of work. So Bobby set about fixing it up, discovering talents as a DIY joiner, plumber and electrician. His electrical installations were somewhat unconventional, not to say cavalier, as later owners of the house would discover to their shock, literally.

Tucker the Globetrotting Tour Leader

As word spread, via Bobby's national RSPB slide-show tours and his work as a local guide, he was soon in demand as a conference speaker and cruise ship lecturer. After

the success of his first film with the RSPB and the BBC Natural History Unit, *Isles of the Simmer Dim* (isles of the summer twilight), he was sometimes obliged to decline paid engagements, so brisk did business become.

When Bobby set off for his first cruise with the National Trust for Scotland, a local wag teased the 'hornythologist' that there would likely be some bonny lasses on the liner. When Bobby returned to Shetland, his crony asked if there had been any notable lovelies aboard. Alas, he replied, almost all of the passengers had been pensioners: 'Whan dey cam in fur brakwist, hit wis mair lik da land o' da zimmer din!' he said with a wink.

By the mid-1980s wildlife tourism was taking up more and more of Bobby's time. As the oil industry came to dominate conservation issues in Shetland and the RSPB became involved, Bobby had found himself less than enthusiastic for the 'political' side of his work. As we'd seen during the *Esso Bernicia* oilspill crisis, he eschewed controversies and campaigning. In particular he disliked being increasingly office-bound and spending time in endless committee meetings. After thinking it over for many months, he decided to leave his job as RSPB Shetland representative and go freelance.

It was the right time to do it. As Libby Weir-Breen recounts below, in 1988 they founded the Island Holidays business together and Bobby began escorting visitors as far afield as the Falklands, the Seychelles, Crete, Alaska, Spitzbergen and Faroe, as well as his tours of Shetland. These travels led to his second book, *Migrations – Travels of a Naturalist*, in which he combined thoughtful and provocative insights on ecology with some entertaining travel writing. His cameo of the Faroese puffin hunter who loved puffins is a treat. He continued as a highly successful tour guide, and unofficial ambassador for Shetland, until his health failed. There was no-one quite like 'Tucker' and it came as no surprise to his friends when, in 1994, he was awarded the MBE for services to wildlife and conservation.

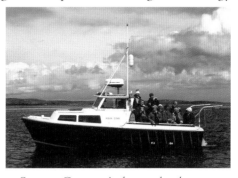

Starna, Consort*'s characterless but very practical replacement, with a full load of visitors at Urie, Fetlar.*
(Bobby Tulloch.)

For some time the *Consort* had been showing her age and she was in any case not really suitable for carrying more than

Bobby's books were beautifully illustrated with watercolours by John Busby. This whimbrel from Migrations *appears by kind permission of John's widow.*

a few passengers. So, regardless of sentiment, Bobby decided he needed a new boat, or at least one new to him, and more use for his growing business as a floating wild-life guide. The secondhand *Starna* was an extremely practical, if unlovely, sea angling launch and Bobby was delighted with her.

In 1990 I'd left the editor's chair at *The Shetland Times* and gone freelance. But there was more to life than journalism, I felt, and for some time I'd been rather envious of how Bobby spent his summers. So I asked him if he thought there was room for another Shetland operator in the local birdy boat trips business. He could so easily have put me off as a potential competitor: even though I'd be operating around Bressay and Noss and far from his 'patch', there was surely a limited market, with the relatively small numbers of visitors coming to Shetland. But, on the contrary, he was enthusiastic about the idea and spent an evening discussing my plans – while ever so gently pointing out that there wasn't much of a living to be made from it, so best not to give up the night job just yet. He lived long enough to hear me confirming his friendly financial advice – my new venture didn't start making a profit for several years. But it was a lot more fun than correcting local newspaper contributors' spelling and grammar into the wee small hours.

The End

Betty's death from cancer on 20 October 1992 hit Bobby very hard. Although they'd never been an ostentatiously affectionate couple, he'd depended on her perhaps more than he realised. He soon decided to leave Lussetter House and its memories. In 1993 he sold up, and had a new house built in Aywick, next to the croft where he'd been born. He'd returned to his roots and, with a view over the bay out towards Skerries, and even a balcony to mount his telescope, it was a perfect spot. Things seemed to be going well for Bobby again, particularly when he found a new partner, Liz Gillard, who shared his interests. But the health worries that had, some time earlier, spurred him to give up smoking and the drams, had not gone away.

The last time I saw Bobby was in the summer of 1995, at his new home in Aywick. He'd had another stroke and could no longer speak properly but he could still make himself understood and cheerfully showed off his new binoculars and some brilliant starling photographs he'd recently taken at his bird table. I talked about the powerful new engine I'd fitted in my boat and told him to watch out for me passing Aywick on the way back from Mid Yell to Lerwick. Sure enough, later that afternoon when I steamed into the bay, there he was, waving from his balcony. I opened the throttle and headed south, leaving behind me what I fancied was a rather impressive wake. Bobby continued to wave. He seemed to be agitated about something. I waved back. His waving grew frantic. And then I hit the Aywick Baa with an almighty bang. Showing off, I'd forgotten about the rock on the south side of the bay. Bobby had been trying to warn me. Fortunately the only thing damaged, apart from my pride, was the skeg of the boat's new stern drive. I could almost hear him cackling 'Bloddy föl!'

Early the following year he was back in hospital. He didn't want visitors and, to tell the truth, his friends didn't much want to see him lying helpless, speechless and miserable. A few months later that wonderful man, my friend, colleague and teacher, was dead.

As Bill Oddie said, in the obituary for *Birdwatch* magazine, 'He was also one of the nicest men you could ever wish to meet – the world needs such people. It will miss him very much.'

MY BROTHER BOBBY
Mary Ellen Odie

My brother Bobby was born on 4 January 1929 at North Aywick in East Yell. His birth was registered on his parents' wedding anniversary. John William Tulloch and Nellie Robertson were married in Lerwick on 11 January 1928. Johnnie (as he was called) was born in the old house of North Aywick and Nellie was born in Newhouse, on the same property. They were fourth cousins, twice removed!

The baby was given his grandfather's full name, Robert John, and with hindsight, it seems very fitting that Robbie Tulloch was his name-father, for there's no doubt that he had a big influence on Bobby's early years. His grandfather liked walking the hills, enjoyed his croft work and going fishing, and above all he was nearly always available to take the restless grandson with him when he was old enough.

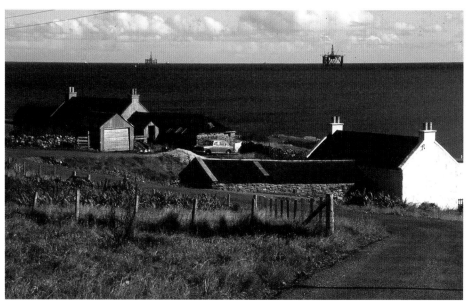

North Aywick, about 1976, with Bobby's birthplace on the left and two oil rigs on the horizon. (Bobby Tulloch.)

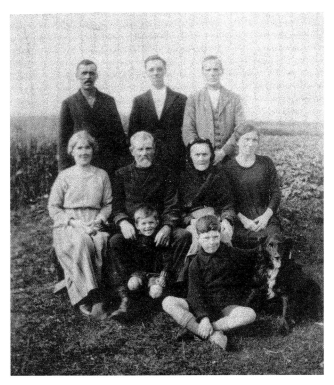

The ancestors: four generations in a family photograph, Yell, 1925. Back row, left to right: Bobby's grandfather and namesake, Robert John Tulloch; his father John William Tulloch; his great uncle Captain William Tulloch. Front row, left to right: Bertha Tulloch (wife of Capt. William); great-grandfather 'Old John' Tulloch; great-grandmother Willa Guthrie Tulloch; Bobby's grandmother Ellen Hoseason Tulloch. Front, seated: his cousins Erik and Bill Tulloch (sons of Capt. William and Bertha), Yell, 1925. (Photographer unknown.)

Our father, on the other hand, was a joiner who had to work out of Yell a lot. He enjoyed making model yachts and sailing them, playing his fiddle, making up songs and singing them at local concerts, and was a great collector of records, mainly Irish fiddle music, some Scottish singers, and country music from America. He was a very good father, and adored by all his family.

Bobby was a good-natured, healthy baby. He took his first steps at seven months and the next year, when his sister Laureen was born, he caused much amusement by singing her a Sankey hymn for a lullaby. No doubt he had heard it from Granny

Ellen, or Mam, as we called her.[21] She took an active part in looking after the bairns, but was an anxious granny, always looking out for our safety and cramping our style.

The summer of 1932 had been unusually warm and Bobby, now three and a half, learned how to escape from the yard and go walkabout, or as he put it, 'I seemed to have an affinity with the sea and shore and was always toddling off shorewards.' He told me that his earliest memory was of being tethered while the family were planting potatoes in the field below the house – too near the sea to risk letting him have his freedom. I was born on St Swithins' Day that year, and it now occurs to me that the runaway was probably feeling outnumbered by females!

The last of the family, our lovely Joyce, was born in November 1933. By then Bobby had given up hoping for a brother.

Bobby and his mother, Helen 'Young Nellie' Robertson, at Aywick, Yell, 1929. Bobby's mother had recently suffered several family bereavements and was not in the best of health when she reluctantly posed for this picture. (John William Tulloch.)

They were always great pals and he was very protective when she went to school. I can remember him taking her hand as they went in to the dentist. She liked sport and was also very artistic. Her cartoons brightened many an afternoon, when it seemed that the hands of the big school clock were clogged up with chalk.

When Bobby's schooldays were approaching, he wouldn't talk about it. The family were anxious in case they had trouble getting him to go to school, which was nearly two miles away from home, but he made no fuss and was soon a seasoned schoolboy. He was a bright pupil but sometimes very bored with some of the subjects he had to learn. He hated the parrot-fashion chant used in those days. I remember him saying that he knew he would never get the exports of Canada and the names of the highest mountains in Britain out of his head, and knowing them hadn't done him a scrap of good in his life.

21. Hymns by Ida Sankey were originally composed for Baptist services but are still widely sung in Shetland churches.

Left: *Grandfather Robbie John Tulloch with a 'caddie' lamb, late 1930s.* (John William Tulloch.) Right: *Bobby's father, John William Tulloch.* (Photographer unknown.)

The teacher, Jessie Mouat, soon noticed that he was very interested in the natural world, and to her great credit, she encouraged him. Once, when he asked her what was the proper name for a swarfish,[22] Jessie said she didn't know, but she bought a book, *Creatures of the Seashore*, out of her own pocket. We all made use of that one.

Bobby's life-changing day at the school was when Miss Mouat decided he was old enough to have access to the beautiful set of bird books she kept in a side room. This was the *British Bird Book*, first published in 1910 and edited by F.B. Kirkman. It had 200 beautiful colour plates by some of the finest wildlife painters of the time, names like A.W. Seaby, G.E. Collins, Winifred Austen, G.E. Lodge.

Up till then Bobby only knew the dialect names of the birds he saw locally. Now he could learn the common British names, and the Latin ones too, for all the birds in Britain. He was very pleased to discover that the bird we called the *immer güs* was the great northern diver, or *Gavia immer* in Latin.

When he was eleven, Bobby got a special birthday present from his father. It was the new, more concise version of the *British Bird Book*. This one was published in

22. The spotted blenny, *Pholis gunnellus*.

1935 and was edited by Kirkman and Jourdain. The text was updated and the 200 plates were there in all their glory. When our grandfather – we called him Papa – saw how thrilled Bobby was with his book, he told him that he would now trust him to borrow his German binoculars when he saw a bird that he couldn't identify. These were old 6 x 30 binoculars, grandfather's only trophy from Germany after four years a prisoner of war.

In the autumn of that year there was a good fall of small migrants, and the birds I remember were the siskins. One day Bobby asked if I would like to come and look at them through Papa's binoculars. It was the first time I'd ever seen a wild bird close up – except for an occasional dead one. The sight of seven beautiful little birds eating on seed-heads really impressed me and I was hooked from that day, a birdwatcher for life!

If Bobby's schooldays were a bit boring at times, the school holidays were the opposite. He had the freedom of the seashore, the loch, several trout burns, not to mention the cliffs – which were supposed to be partly out of bounds! With his pal, Danny, he was outdoors most of the daylight hours. We would often join them and I can remember many adventures and some real frights. Like the day our sheepdog,

Left: 'Stand just there, Bobby, where I'm pointing!' Bobby, aged two, co-operating somewhat reluctantly with the photographer's assistant, Aywick, 1931. He's wearing a red jumper, to make it easier to see him when he strayed (says his sister Mary Ellen). Right: Bobby's father made this sailing boat for him about 1931.
(Both by John William Tulloch.)

Bobby with his sisters (l. to r.) Laureen, Mary Ellen and Joyce in 1936 or 37.
(John William Tulloch.)

Birk, nearly swam into the jaws of a basking shark. It was Bobby's fault! We saw the shark coming when we were catching sillocks [young saithe] at Tonga, a well-used craig-seat. The dog saw it too and rushed to the outer point, wagging his tail and barking. Bobby was amused by Birk's antics and shouted 'Catch 'im!' With that, Birk jumped into the sea and started to swim to the shark! Whenever Bobby told this story he always said that his sisters went hysterical and the dog turned back to see what was wrong.

Another time it was Bobby, on his own, who got the fright. It was an exceptionally low tide and he'd been able to reach what we called 'da ooter desert island'. This was the place to find squat lobsters. We liked to watch their antics in our favourite rock pool before the incoming tide set them free. He'd just managed to climb up onto the rock when he saw something moving in the seaweed and he discovered that it was a very large fish! In his excitement he slid on the wet seaweed and landed on top of a very angry, five-foot-long conger eel. Bobby was always quick-witted and

Snow in Aywick in the winter of 1936, with Mary Ellen (left), Laureen and Bobby.
(John William Tulloch.)

managed to dodge the snapping teeth by rolling over till he could find his footing. He said he found himself crying with fright.

The six years when all four of us were school age were the best. Although the war was on and some irksome things had to be endured, like blackouts, sweet rationing, the mines (both German and British, which regularly landed when the wind was onshore) and last, but not least, having to remain totally silent when Churchill was giving one of his famous speeches.

I can clearly remember the Saturday in November 1944 when a squadron of Lancaster bombers appeared in the southwest sky. They flew to the northeast over Aywick. Bobby, who'd left the school that year, knew his planes and said they were likely going to North Norway to finish off the *Tirpitz*, the German battleship that had been disabled by limpet mines placed on the ship's hull by very brave volunteers from the Navy. The story had been in the papers.

Next day we tried to count how many we saw coming back but couldn't get the total we saw going. Actually, only one bomber failed to return and it landed in Sweden.

But nothing could spoil our fun during the school holidays when we had the freedom of North Aywick. One of the highlights of those years was the unexpected

birth of Jock, the Shetland pony. He turned out to be Bobby's favourite pet. He wrote an essay about him, which Miss Mouat read to the class. I can remember thinking how good it was. However, he didn't put in the story that Jock once threw him off his back and landed him on top of the half built peat stack. What a scramble we had trying to get the stack built again before the next load of peat arrived from the hill!

We always helped in the peat-drying process, which was called 'raisin da paets'. First we took the driest-looking peat and set it on its long edge and then set about five more on their ends around it. This usually happened in June. The hill, about a mile from the house, was a mixture of heather, sphagnum moss and short grass, and had many breeding birds. When we were having a break from 'raisin' we would lie on the warm ground and listen to the birds and compete with each other to see who could distinguish the calls of most species. On calm days we could get into double figures.

Bobby's favourite bird was the kittiwake and I can very well see why. On calm days this beautiful, exuberant little gull supplied the background music to our summer

Tammy Thomson casting a beautifully symmetrical peat bank in Yell.
(Bobby Tulloch.)

Fossil fuels: among the peat are sometimes found the well-preserved roots and branches of ancient trees, several thousand years old. Deposits like these show that Shetland wasn't always treeless. Analysis of pollen grains preserved in peat bogs and loch sediments shows that about 6,000 years ago much of the islands' lower lying land was covered in scrub woodland. (Bobby Tulloch.)

idyll. When we were older we would watch the large colony at the Birrier, about two miles from North Aywick. Kittiwakes always seemed to nest near a source of fresh water and the Birrier loch supplied it. They appeared to fly between the loch and the colony all the time and the volume of sound was amazing. It was the same when the kittiwakes found a ball of sandeels – the old fishermen called it a *fugle caavie*, literally a blizzard of gulls feeding out at sea. It seems to happen during the sandeels' mating season, when they leave the sandy bottom and gather together near the surface. I've seen this many times in the past and the birds would work that spot all day long. To my knowledge it hasn't been seen in any quantity since the 1970s.

In September 1944 we went back to school, but this time it was without Bobby. He'd passed the exam that could take him to the Anderson Institute in Lerwick and his lodgings were booked. Suddenly it was all cancelled. We never knew why, but got

the impression that it was because of the war. Our mother was very disappointed, but Bobby didn't seem in the least put out.

He spent more time with his music than before, and was making good headway with the piano accordion, and with reading music. He'd started his music lessons with the Reverend Frederick Smith, the Unst Methodist minister, who visited the East Yell School regularly teaching us about music, which we all enjoyed. Sadly we only had a year or two of his visits. He moved to a new placement in 1944.

Bobby's 15th year was spent at home. He was no longer a schoolboy and was allowed to go fishing in the family boat, mainly with his grandfather, who was glad of someone to row the boat. Papa was getting on then – nearly 70. He managed to persuade his grandson to do a bit of crofting work, but it was something his blue-eyed boy was not in the least interested in.

VE day 1945 was celebrated with great gusto in Aywick. It was hard work at first, getting the material for the bon-

In his Sunday best for a visit to a Lerwick photographer in 1935, sixteen-year-old Bobby looks ill at ease.
(Photographer: Abernethy?)

fire. We sledged bales of rubber, which had landed on the beach [from a wrecked ship], to the top of the Muckle Knowe. I took part in making Hitler's effigy and can remember trying to get his moustache just right!

Bobby, who was now working in the Mid Yell Bakery, had the day off, and quite a few of the young men who'd been in the war were back home. As soon as it was dark we got dressed for guising. It was a brilliant night – never to be forgotten! It ended up in the East Yell hall with a dance, where we met together with Otterswick and Gossabrough folk – who make up East Yell Parish. All the menfolk seemed to be in drag. Some of them had on really old crinoline-type dresses.

Bobby's teenage years seemed to go by in a flurry of activity. He had a job at the Mid Yell bakery, and later the Excelsior Bakery, where he served his apprenticeship; he had a motorbike, a new piano accordion, and was soon asked to play at dances around Yell; he had lodgings at Reafirth, which was in the centre of the village, and almost next door to Charlie Inkster, one of the RSPB's paid Bird Watchers in Shetland.

He'd known Charlie for a few years and, when still a schoolboy, would cycle the four miles to Mid Yell to report an unusual bird and to hear Charlie's bird news. Now Charlie was getting quite old and was glad of Bobby's regular reports.

It was great to be alive in those years just after the war. The atmosphere in the island was unforgettable. So many men had been at sea in the merchant service when war was declared, and the young men who were called up usually went in the Navy. Now they were home again and it was time to celebrate.

Regattas were very popular in those days, attracting young and old alike. The sailing was the main part. Then there were rowing races, swimming, and land sports. If the wind wasn't too strong, they would have a novice race: anyone who would like to try their hand at sailing a boat could put their name in a hat, and wait for the draw!

The year was 1946 and it was the Mid Yell Regatta day. The wind was reasonable and Bobby drew Willie Steward's boat, *Ruby*. They were directly off the old wooden pier where the crowds gathered, when something went wrong and the Ruby shipped a large lump of water. From the pier we could see frantic bailing! Bobby was getting a lot of advice from the pier-head sailors, and there were cheers when they got the boat sailing again. They raced well after that in a fresh wind. The winning boat was *Miss Gadabout*, sailed by John Nicholson, Bobby's future brother-in-law.

In the late 1940s Bobby made his début on the stage at the Mid Yell hall. It may have been a regatta concert; for the compère was in an extremely good lay, as we would say. He came on quite unsteady on his feet and announced: 'We will now have Bobby Tulloch to play *The Green River Valley* on his melodeon'. Bobby came on looking a bit sheepish, for the audience were still laughing. He managed to sing *The Red River Valley* and accompany himself on his *accordion* without knowing why he got his first laugh on the Mid Yell hall stage!

On 4 January 1950 the family were all together for Bobby's 21st birthday. It was a fine family party. I remember we persuaded Joyce to sing one of her favourite songs, *The Sailor's Prayer*. She had a really fine voice and always loved that song. But it was a bittersweet night, for we all knew that we probably wouldn't be able to gather like this again for a while. This was the year that Bobby's apprenticeship would end and

then he would be off to do his National Service. And Laureen was getting married in April and would soon make her home in Mid Yell. Her husband to be was Charlie Smith, a baker at the Excelsior with Bobby.

As it turned out, the Army kept Bobby waiting all summer and he was relieved when his call-up papers finally came in early autumn. He got his first leave after the initial training period and looked fit and cheerful. He said they'd been told to expect a trip to the Far East. The posting, when it came, was for Korea. The ship taking them there was in the Red Sea when the orders were changed to Hong Kong. In fact he was to spend the rest of his Army time in a bakery in Kowloon, near Hong Kong.

On National Service in Hong Kong in 1950, Bobby and an unknown comrade pose in tropical kit beside the swimming pool. (Photographer unknown.)

He seemed to enjoy his years working with Chinese people and often talked about them and how hard they worked, especially the women, who carried sacks of flour with the men. He learned some Cantonese, but said the bakery workers' English was far better than his Cantonese. He bought himself a fine camera and took some photos, but didn't find much birdlife. Kowloon was a small area with a large human population.

Granny Ellen passed away after a stroke about a week before Bobby left for Britain. She'd been ill since the spring. On 22 July 1952 she said: 'Bobby is comin' hame a Friday.' My mother, who was with her at the time, was a bit shocked that she was able to speak. She died in her sleep a few hours afterwards.

Bobby got the word that Mam was very ill before he left Hong Kong. He was always remarkably tolerant with his grandmother and her quest to keep him alive and well. We didn't know how he could put up with it. When we mentioned it he used to say that he was just glad he hadn't inherited her nervous disposition.

At the end of 1952 Bobby was home again. His pal Danny, from next door, was also back after doing his spell in the army. Both were looking for jobs, but first they would take up their old pastimes of birdwatching, fishing or just walking the cliffs. Tomorrow was another day and it was good to be home.

After the festive season Bobby started job-hunting. There were no vacancies at the Excelsior Bakery where he'd worked before, so he turned his attentions to Lerwick and he seemed to have some hope that he would get work at a bakery there. He was at Ulsta, waiting to cross Yell Sound on the ferry *Tystie*, when he got the dreadful news that his father had collapsed and died of a heart attack. He was just 49.

This was a terrible loss to all the family. Bobby was devastated. He'd looked forward for ages to having more time with his father and doing the things they used to do. They seemed to look at life the same way, their pastimes were alike (except for the birdwatching), they liked music and their poetry was similar and usually comical.

The North Isles 'steamer' Earl of Zetland *approaching Linkshouse Pier, Mid Yell, in the early 1970s. In 1974 she was made redundant by the council's new inter-island, roll-on/roll-off ferries serving Whalsay, Skerries, Yell, Fetlar and Unst. After that, 'Da Earl' served as a North Sea survey vessel and later as a restaurant in Great Yarmouth, London and now North Shields, where she's still afloat.*
(Bobby Tulloch.)

A beardless Bobby with his first boat, the Roselyn, *at the Houbie Pier in Fetlar, about 1960.* (Photographer unknown.)

Now at 23, Bobby didn't know what to do with his life. Rescue came with his Uncle Lowrie, who came down to North Aywick to tell Bobby that there was a labourer's job at the Mid Yell pier, which would last into 1954. He took the job for his mother's and grandfather's sake, so that he'd be home every night to keep an eye on them. Both had been unwell after the shock.

The job went well and he liked the people he was working with, particularly Arthur Nicholson, who was about the same age and full of music and fun. They got together at Hogmanay '54 and wrote a song about Yell's lack of amenities. This was nine years before the Yell Conference [and its 'Yell For Light' manifesto. JW] but very much in keeping with the mood in the island, which still had no mains electricity.

The job at Mid Yell finished sometime in 1954 and Bobby took a job with baker Mitchell Georgeson in Lerwick, driving the bread van for about two years, mainly in the south Mainland, which suited him well. He particularly liked the Spiggie Loch and the Pool of Virkie. Both were very good for birding and he would go there on his motorcycle on days off in summer.

He joined the Islesburgh Band and bought himself a Selmar Invicta accordion. He made some good friends there and often spoke about the 'Islesburgh Days'. When he came home for weekends he would play us some of the new tunes he'd learned and speak about bands he'd heard. We were pleased that he was gradually getting back to his normal self.

Some time in 1956 the Mid Yell bakery came on the market and Bobby and Charlie, his brother-in-law, took it on. They tried very hard to make it work. Bobby said himself that they should have realised that a bakery in Yell was no longer viable. They struggled on for six years before having to give in. It was to be Yell's last bakery

Bobby and Betty on their wedding day in 1957. Betty hated getting her photo taken and there are very few pictures of her. (Photographer unknown.)

During this time Nurse Elizabeth Robertson arrived on the scene. She was the new district nurse for North Yell. Betty, as she was known, was newly graduated in Edinburgh and was from Newton Stewart. She was just a little younger than Bobby. She was all that a good nurse should be, kind, gentle and very good at her work. Bobby was soon house-hunting and lucky enough to get Rose Cottage in Reafirth, with its lovely view over Mid Yell Voe. They were engaged at the end of the year and married in August 1957.

The early sixties were another bad patch for Bobby. When the bakery finally closed he had no idea what he was going to do with the rest of his life. He pottered around doing some repair work on his boat *Roselyn* and then he tried the lobsters. He also did a lot of work on his Reafirth house.

It was about this time that we started writing songs together. He would promise to sing somewhere and then realise that

he'd nothing new to sing, so he'd phone and ask if I had anything. We didn't do this with serious songs. I remember once giving him part of a song about a spinster's search for a husband and then forgetting all about it. I was at a concert in Mid Yell when Bobby came on as the spinster! He had on a green coat and a pink headscarf and make-up – and worse – he looked a lot like me!

The summer of '63 was a very tense time for my brother. It started with a phone call from George Waterston, the Scottish RSPB director. The message was that he was coming to Yell and would like Bobby to take him to Has-cosay, an island near Mid Yell. Bobby had met George before, through his friendship with Charlie Inkster, and he knew that George liked Hascosay a lot. The trip went well, they walked the island and saw lots of the nesting birds. When they were leaving George said: 'Don't take any old job just for the money. I may be able to offer you something more interesting.'

Bobby's sisters Mary Ellen and Joyce climbing the banks above Ronas Voe, in search of the native rowan tree, in April 1972. This was the last outing Joyce made with Bobby before her death the following year at the age of 40.
(Bobby Tulloch.)

Bobby said his mind ran riot, but he didn't know that they were discussing the possibility of getting a suitable person to look after the whole of Shetland on behalf of the Royal Society for the Protection of Birds.

Weeks went by and then months, and Bobby came to the conclusion that George had forgotten him when the letter arrived, offering him the post of Shetland Representative of the RSPB. Bobby said that the opportunity to follow his hobby and be paid for it was a dream come true. We were all delighted that he was in his true element at last!

*Da Lang Ayre on the west side of Ronas Hill, after a long climb from the beach in
Ronas Voe.* (Bobby Tulloch.)

In the first few years it was clear that he had a network of friends around Shetland. A look at his diaries for the sixties shows how many phone calls he had about strange birds in out-of-the-way places. He was quite willing to take a pillion passenger to help him. I can remember climbing Ronas Hill with him, looking for a male snow bunting seen carrying food the day before. Sadly, no nesting was proved.

In October 1965 Bobby took a two-week break and went to Orkney to help tag young grey seals and visit his friend and fellow RSPB representative, Eddie Balfour. After that they attended the RSPB conference at Dunblane. They each spoke for eight minutes and showed half a dozen slides. About a week later he had to check in at Stracathro Hospital and have some cartilage removed from his knee.

Bobby covered every populated island in Shetland and many of the smaller isles and stacks in those first few years. He was a good few times to the Ramna Stacks and went on those stacks that were climbable. Hermaness was another place he would go often to ring birds. In June 1966 Bill Porteous[23] was in Shetland and they went up

23. A keen young Shetland birdwatcher who later became a geologist and now lives in Panama. JW.

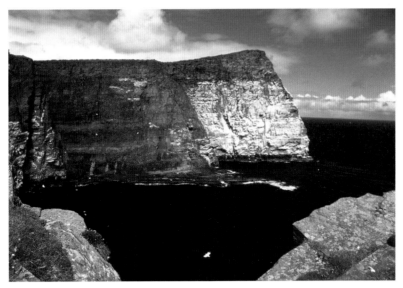

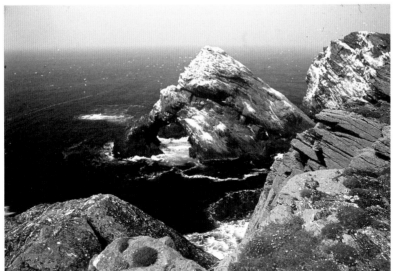

Top: *As Bobby explored Shetland in his work for the RSPB, he kept a camera handy as well as binoculars. This is his version of the classic shot of the gannet cliffs at Noss National Nature Reserve.*

Bottom: *Humla Stack, part of the gannetry at Hermaness National Nature Reserve, Unst.* (Bobby Tulloch.)

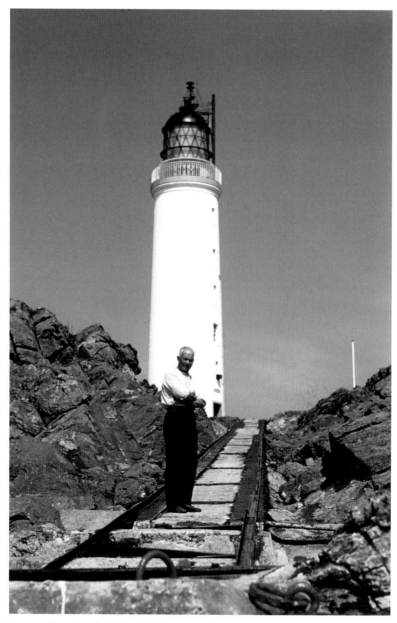

Leaving the Bound Skerry lighthouse after one of Consort's *many visits to Out Skerries.* (Bobby Tulloch.)

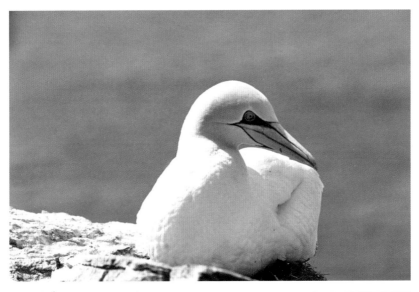

Top: *Adult gannet, Hermaness.*
Bottom: *Gannet nest and egg. Note the plastic trash built into the nest, which sometimes fatally snares gannets because, unlike seaweed, it doesn't snap.*
(Bobby Tulloch.)

Top: *Gannet chick with its first downy feathers.*
Bottom: *Gannet fledgling, waterproof at three months old and ready for sea.*
(Bobby Tulloch.)

A summer gale whips up heavy seas on the stacks west of Hermaness, Unst.
(Bobby Tulloch.)

to north Unst and crossed Hermaness to the 500-feet cliffs at Saito. They managed to climb the cliff and ringed some young birds. When they reached the top again Bobby realised that he'd left his bag halfway up at a very difficult place. He told me that going back for it was his worst-ever climb.

Snowy owls had been seen around the North Isles of Shetland for a few years when Bobby started his job with the RSPB. They often turned up in his bird lists from Whalsay to Hermaness, and Ronas Hill to the Ward of Erisdale and North Yell. There was no mention of females till the year before they nested. This is Bobby's entry in his 1967 diary for Wednesday 7 June:

Went out with the Swiss people and took them to Urie walked along and went up Stakkaberg. Male bird was mildly aggressive and came to within 40 yards and croaked a couple of times. The female flew off and sat about 200 yards away.

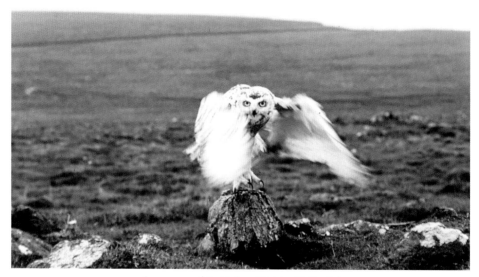

A snowy owl in Fetlar. (Bobby Tulloch.)

In his book he said that he'd left the party on the pretext of looking for owl pellets. When he moved round the back of the rocks there was a nest with three eggs! He said his inclination was to rush back and tell everyone . . . which would send birdwatchers – and possibly egg collectors – hotfoot to Shetland as soon as the news broke. The Swiss people[24] were leaving next day to tour Scotland and he couldn't take the risk. He telephoned the RSPB for advice. Within days a round-the-clock guard was mounted and a watch-hut was erected.

When the snowy owl story was released there was a lot of excitement and the 'Press Gang' – as we called them – were all over Fetlar and Yell. Here's a diary entry for 24 June 1967:

Came back c.6. [from Fetlar] Daily Express photographer & reporter. Daily Mail reporter, and ITV cameraman from Orkney had arrived.

24. Probably Francois Burnier and his father, who visited Bobby at about this time. (Personal communication, Annie Say.)

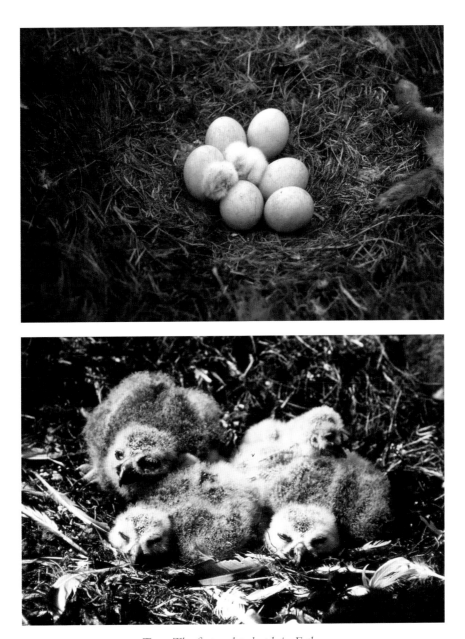

Top: *The first owlets hatch in Fetlar.*
Bottom: *Waiting for more rabbits . . .* (Bobby Tulloch.)

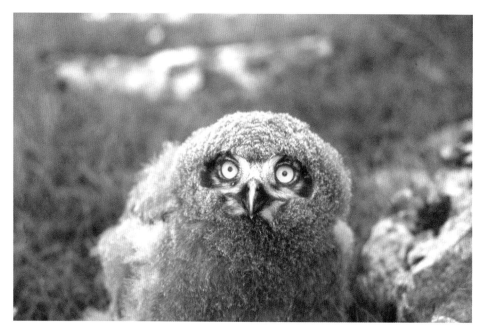

A young snowy owl, born and bred in Fetlar.
(Bobby Tulloch.)

As we expected, Bobby took all this in his stride and later, when he was getting to be well-known, with TV interviews and talks with slides in London, he didn't alter a bit. When a BBC reporter asked him why he lived on this remote island of Yell, he said: 'I've never found anywhere I'd rather be.'

THE YODELLING ACCORDIONIST

Reminiscences of Bobby Tulloch by his fellow islanders Johnny Clark and Charlie Inkster, interviewed by Mike McDonnell, Old School, Camb, Yell, February 2012.

Johnny Clark: My first memories of Bobby really wis when he wis performing in the concerts that wis in Mid Yell – it wid be like the regatta concerts, the New Year concerts, the Social Club concerts, this kind o' thing – and it always stuck in my mind him playin' the accordion, for he would always be doing an item, and I think I maybe even got inspiration from him to play the accordion, and I ended up buying his accordion . . . I think I paid thirty pounds for him . . . And he used to play what I felt was complicated tunes like the 'Trumpet Hornpipe' and the 'Jacqueline Waltz' at that time that had triplets in the tunes which he would call the double dirls, and I was kinda inspired wi' that.

Also at that time he was renowned for his songs – the songs that he composed about the local folk an' that, but also he sang things like 'My China Doll' which he yodelled in and all, and at that time I wis never heard many folk yodelling. He maybe got it from the record of Slim Whitman, or whit. So him yodelling was something else, and then of course all the songs that he made up too for special items in the concerts. So that wis my first impressions o' him.

I was more or less inspired wi' his playing and ended up at that time too, at the dances that wis. It wisna lik noo when they hae bands that they employ to come and play – it wis just anybody that could play, played. So I had different tunes wi' him at dances, and usually at that time it wis me on the accordion and him on the guitar, as you saw in yon photo like – that wid o' been in Fetlar at a Burns' Supper. I maybe got tips from him (about playing the accordion) and certainly played a bit wi' him.

And then when he moved up to the Old Manse [at Lussetter], when he came to be our neighbour, then he took up the fiddle later on, and then he was always comin' in for tunes beside wis. We had a piano and Mary would vamp to him, and Alice, Mary's mother, she would vamp til him. And I would get the accordion.

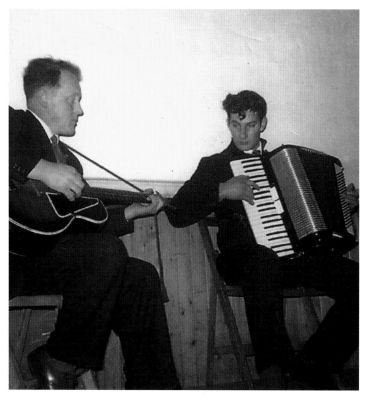

Bobby playing with Johnny Clark at a Burns Supper in the Fetlar Hall, 1964.
(Photo courtesy of Mary Ellen Odie.)

We had many a session, and then he wid ask me to come up, and I met a lot o' yon players like Freeland Barbour . . . and anither yin at that time I met there was Sean McGuire, the great Irish fiddler. He stayed aside Bobby, and I remember him asking me to come up and meet him. That wis an experience for me, and I mind bein' up and Arthur Scott Robertson was there playing, and you ken he had an accompanist wi' him. And it wis just fine that, there wis many a night o' him comin' doon to wis, or wis goin' up to him.

And then at times we wid have Norwegian accordion players o'er, and I would ask Bobby if he wis available to come doon and spend the night wi' them too . . . they were kinda pals. They were over several times aside wis, so Bobby was taken up wi' them for he liked Norwegian music too. Osmund Sandess wis the one chap's name

and the other chap Oscar Husset. Osmund's wife wis on yon photo, Ada. So that's really my most musical memories o' Bobby.

And then weel, really, I should say maybe too what a good neighbour he wis. He wid a' helpit you wi' onything, Bobby. I always mind me wance goin' to put a Shetland ram in my old Landrover oot to the hill. I gaed oot o'er the hill a piece, fir it wis fine and hard, but I gaed too far and I went right to the axles wi' the Landrover and thought how am I goin to get this car oot o' here? So I thought I'll go and see if Bobby will come and gie me a hand. But he wis just delighted, no problem, and he cam and we got the old tractor going. And he came and we dragged and took on, and got her hauled oot. So he wis awful good, and wid of helpit you onytime. Sic a good neighbour.

And anither thing like when he wis composin' yon songs and whit not, he wid

A party under way at Johnny Clark's home in Cashigarth, Mid Yell, with John Laughland on the piano, Bobby, Mary Clark and Ada Sandness (right), a Norwegian visitor. (Johnny Clark.)

just come runnin' in and say I have made up this een, and what do you think o' this een and he wid sing a bit o' it.

. . . I wis . . . mony a time at the fishin' wi' him. He wid come in alang and see if I wanted to go wi' him. One thing in particular that stuck in my mind, he asked me to come to the Ramna Stacks wi' him. I was actually twice wi' him there. I mind the first time he just went right aroond Yell wi' the boat. It wis quite interesting for me that, especially havin' him wi' you, fir he could tell you that much aboot the wildlife on all the different islands. We gaed ashore on the Holm o' Gloup, and then of course we went to the Ramna Stacks and then he gaed up through Yell Soond and went to Muckle Holm and the Little Holm, and then we went to Tinga Skerry – just a peerie skerry covered wi' scarfs' nests. Fir I always mind when we were at the Ramna Stacks he wis very determined to get on them, because the RSPB had ta'en them o'er [as a bird reserve] no' that lang afore then. We gaed there and it wis a fine day, but he just left me wi' the big boat and he took the dinghy and wis goin to try and get ashore.

The sea is rarely calm at the Ramna Stacks. This shot was taken while Bobby was looking for a landing site. (Bobby Tulloch.)

Looking north over Gruney, with the other Ramna Stacks in the background.
Bobby took this picture on a flight with the oil pollution spotter plane.
(Bobby Tulloch.)

And he had just left the big boat when it came up a great surge, whether the tide changed or whit, I don't really ken, but it came up a surge o' sea and he just disappeared o'er a wave. I just waited, and then I eventually I heard him whistlin', and then this was fir me to come wi' the big boat and pick him up, cos he had had to go way aff wi' the surge. But he did win on the big stack, the Gruney – the biggest ane – that day. But it kinda did ease up eftir a bit and he got on that stack but he didna get on ony o' the idder anes that day. We were ashore on all yon islands – Bigga, Muckle Holm, Little Holm, and then we gaed on yon Tinga skerry. I have a lotta photos o' that, but he had the same. He wis takkin photos all the time as weel – the birds on the nests.

The other thing I wis involved wi' him wis trips sooth. The Shetland Tourist Board, through Maurice Mullay, asked him to do this trip sooth to promote Shetland tourism, like. So Bobby wanted to arrange a band to go wi' him, and he asked me through Trevor Hunter. It wis him, Trevor Hunter and me, accordion, and Eileen Hunter on piano and Frances Hunter on bass the first time we went. We toured a

lot o' the toons in England, doon through England, so it wis quite an experience. In England we were in Croydon, Gloucester, Coventry. Manchester, Bolton, Birmingham and Milton Keynes. And then anither year we did a tour of Scotland which was Aberdeen, Glasgow, Edinburgh and we gaed doon Wigan, Gloucester, Blackpool and Solihull. But it wis amazing just to listen at that venues to Bobby speaking – how he could just change, yapping to us in Shetlan' to speaking to a big audience. He wis just gifted wi' that. He had wis backing and we played Shetland music to some o' his slides: he had the slide shows and we played music in the background. I thoroughly enjoyed that trips.

Another thing was the yearly visit to the Motel wi' him. It wis just a standing thing for a few years. It wis a busload of tourists, mainly foreigners, mainly Norwegian, that came to the motel in Sellafirth, and they would ask him to come and gie a talk on the wildlife. He got me to come along to play too; he mainly wanted Norwegian tunes played for that. Yon photo again wis me and Robert Goodlad, we got

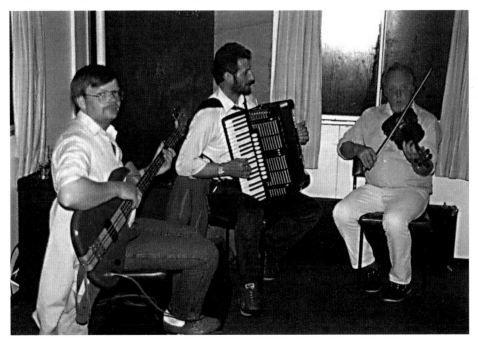

A session under way with Robert Goodlad (left), Johnny Clark and Bobby at the Sellafirth Motel, Yell, where Bobby and friends used to entertain the tourists. (Photo courtesy of Mary Ellen Odie.)

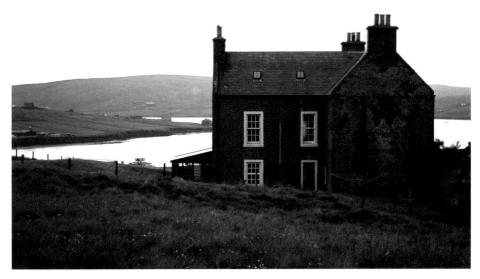

Lussetter House and the 'cra heids' where Bobby crawled through a skylight to rig up his CB aerial. (Jonathan Wills.)

him to come for to play the bass, and Bobby would tak the fiddle too, and we would end up hivin' a tune after he had done his talk.

And I ken another thing as far as I was concerned he inspired me to start photography for he was always takkin all those photos and showing me them. I used to go up many a time in the winter, say on a Saturday efternoon after it turned dark, and I would go up to him, for he wis always doing that many interesting things: he wis either working wi' photography or music or he wis writing in yon books. I wid go up and we would hae a peerie dram up there and I just enjoyed his company. And another thing, saying aboot good neighbours he had that big lenses at that time for his camera and he used to lend me them. I mind having one o' thon big yeens about this length just to try oot – telescopic lenses – to try and take photos, and it just inspired me to do photography for a bit . . . And he used to love that Robert Service poems, and then he used to hae a dram and he would recite those poems: Dan McGrew.

The other impression o' him – he wis a very clever man. He could speak aboot onything . . . I mind him on aboot butterflies at one point, and Shetland floo'ers or whatever and he kent the English names, and the Shetland names and the Latin names fir dem. I always mind him wance coming in to wis and *Mastermind* wis on

wi' Magnus Magnusson, and we wir fir pittin the TV aff but he said 'No, keep it on.' So we kept it on and it wis the general knowledge questions that was on and he nearly knew every question. He even answered the Greek mythology questions, and I just had in my mind if he'd have his special subject like Britain's birds or Shetland or whatever, he would have done as well if not better as the contestants that were on. He was a very talented man, and he could turn his hand to onything.

I mind another time he asked me to come up and he wis goin' to pit an aerial on his craw heid [chimneys]. At that time CBs [Citizens' Band radio] were on the go and you needed an aerial. And I gaed wi' him and, my goodness, he gaed oot the skylight on the roof and just climbed up o'er the slates to the ridge wi' no ladder and got me to fling him up rope and stuff and I wis to pass up the aerial and he took it up on a rope. Yon craw heids is a great big size on the manse, and he had to get a bracket right aroon the craw heid. He just fastened a rope aroond his middle and around the craw heid and he gaed oot like this [leans out] wi' his feet up like this, to get this bracket aroon and I thought, my goodness if he faa's, but he got it on and came back in the skylight. He didna seem to worry aboot the heights.[25]

He wis always tae'n up wi' going away up to the north o' Norway . . . He seemed to love this really oot o' the way places, and especially he seemed to have a soft spot for islands. He loved islands and just getting away fae it all. He even took trips doon to the Falklands . . . And he was involved wi' the Forty Fiddlers[26] . . . for a while. He learned the fiddle awful fast. It wis just no time from he couldna play til he could play. He wid a been middle-aged when he took it up, I couldna say exactly when, but it just seemed all of a sudden he wis playing the fiddle . . . He wis interested to go wi' the Forty Fiddlers and he wis also interested for he wis showing that many tourists around, and they seemed to be interested more in the fiddle, because it wis more traditional Shetland as, say, the accordion.

Charlie Inkster: I mind goin alang him wan day and he was sitting on the cooch and I

25. The only exception was an occasion when Bobby suffered from labyrinthitis, an infection of the eustachian tubes in the middle ear. This distressing affliction causes complete loss of balance and a whirling sensation which can result in nausea. Bobby told me his first attack of labyrynthitis struck him when he was replacing a ridge slate on Lussetter House. According to him, he lay spread-eagled on the roof, with an arm and a leg on either side of the ridge, until a neighbour heard his cries for help and organised a rescue party. JW.

26. The Forty Fiddlers was the name given by the late Magnus Magnusson to a group of Shetland fiddlers who first assembled for the Queen's visit to Shetland in 1960. JW

can best describe it as scraping oot a tune on the fiddle. And I mean to my untrained ear it wis really pretty poor and I said 'What's going on here?' and he says 'I'm having to learn the fiddle to play to this [tourists].' I think he had actually started goin' on these cruises. And they were always wantin, since he came from Shetland, to hear fiddle tunes, so he said I'm learning the fiddle. And it wis no lang efter that I was been somewhere, maybe at a party or something, and Bobby was playing the fiddle and he was playing it brilliantly. Just a matter of months efterwards. That wis his great talent, and tae my mind there were a lot o' folk said aboot Bobby, he was expert at photography and writing and songs and all the rest o' it. Bobby to me had one absolutely brilliant talent – he could learn anything he was interested in it. If he had interest in anything he could learn it, and not only learning things, he had the practical skills to go wi' it. I mean like widwark and things like that, you maybe didn't associate with Bobby.

Johnny Clark: Like yon boat, the *Consort*, he made all the upper decks.

Charlie Inkster: And Dr Brooker's boat, and the boat he had before the *Consort*. When the bakery was still going. I mind me gaen him a hand wi' that. That wis just an open boat then, and he heightened her, and put decks in and a wheelhoose and all the rest – a brilliant job he made o' it. I cannae mind the name o' that boat – it wis the wan he had before the *Consort* [the *Roselyn*, Eds]. It wis an open boat when he got it, and he put a wheelhoose in the front o' her. He was a remarkable man, truly.

Johnny Clark: I mind asking him wance how he could he remember those Latin names and he said: 'I can just see them,' he says. 'Just as if they are written.' Just like a photographic memory, and he said: 'I can just think about the alphabet and say it backwards, no bother.' He reckoned he could just see it.

Charlie Inkster: Amazing. As long as he had an interest. That's maybe sometimes when he failed a bit – if he lost interest. He would just forget about it. My first memories o' him was when he wis working at the pier. At the Mid Yell pier when it was first built [in 1952–54, Eds] . . . And the first time I mind him playing on the stage, playing the accordion, and playing the guitar, and singing, and as you say yondru, songs like 'China Doll' and that sort. And the first wan I heard him doing that wan he wis penned, well I think it was him and Arthur Nicholson that made it up between the two o' them when they were working at the pier. And him and Arthur sang it at a concert. I canna mind any o' the words o' it at all, except wan

Bobby Tulloch (top, left) with colleagues building the new Linkshouse Pier at Mid Yell in 1952. Back row: Bobby; Laurence Robertson; Arthur Nicholson; Jamie Robertson; [?] Haldane. Front row: Ronnie [?]; Jeannie Inkster; Willie Hannah; Belle Smith; Andy Mann; Jimmy Brown.
(Photo courtesy of Charlie Inkster.)

was working against the other: one would sing a line and the other one would reply and the only line I can mind aboot it was: 'I'm become the Earl and come in to the pier,' and Bobby retorted: 'I'm become a big spoot ebb[27] and end thy career.'

The thing wis, there was a lot o' controversy aboot the pier being built where he is built wi' the lack o' watter there. That's the only part o' that song that I can mind. I think that would be among the first ones that he ever wrote, but I imagine it was him and Arthur between dem. And that would have been some time about '53 when they were still working at the pier at that time.

And then of course him and Charlie William Smith, his brother-in-law, took o'er the bakery. And I started working in the bakery in October 1956, and I wis in it for six and a half years. And, I mean, I wis kent Bobby afore I gaed there to work, but I got to know him very weel in there. They were good to work for, both him and Charlie. I am no sure what year they took it o'er (the bakery). It had belonged to Charlie Guthrie, and Charlie Willie and Bobby worked in it . . . And Bobby wis the same wi' songs that he wid write, for he drove the van and I think that, sitting driving for a while, it was a good place to get the imagination on to new songs . . .

And I've seen him come in to the bakery sometimes and say to us come and listen to this and see what you thinks o' this song. And maybe sing a part o' it. And wan I definitely mind him singing to me wis wan o' my favourites was 'The Shetland Crofter's Garden'. I thought that was a brilliant wan that. And I mind him comin' in and saying he'd gotten an idea for a song and he sang me bits o' it and I thought it wis brilliant.

27. i.e. such a low tide that you can harvest razor clams (spoots) by hand.

And the thing is, you ken aboot [the] main things he did but there was all these peerie things he would do. Like the time everybody was buying transistor radios. That wasnae good enough for Bobby. He bought a kit and built wan, just like that. And the same wi' the fishing rods. He was a great wan for goin' fishing troots and he wis wantin' a split-cane rod. What did he do? He bought all the kit and built up a split-cane rod – I mean it all – all the bits of split cane that have to be whippit together. And that was the kind o' things he did.

There again, you were saying aboot him, if he wis interested it was no problem. Mind ye, he had a Vincent motorbike. It was a beautiful bike, a lovely bike. Noo Bobby for whit ever reason, I don't know, but maybe he decided something gaed wrong with it, he strippit doon the bike, just doon to the last nuts and bolts, and it was laid into the bakery garage in fish boxes and cardboard boxes and buckets, just standing at the side o' the garage. It lay there for months and Bobby never got it pitten back together again. For some reason he had lost interest in him. Eventually he selled it in the boxes to the Broons' Garage.[28] And they built it up and selled it on to somebody. Noo Bobby could have pitten that together and done up that bike, and it wid have been like a factory reconditioned wan. He could have done it perfectly, but the interest gaed and that was it. If there was flaw in his make-up it wis maybe that, but I dare say everybody is slightly like that – if they are interested in something they can learn it a lot better, but in Bobby's case it was more so. But he wis just such an amazing character.

The bakery van went roon like a travelling shop and Bobby drove the van but he'd work four hours in the bakery. Two o' us started at six o'clock in the morning and the other two came in at eight, me and Charlie Willie was always together, Bobby and Willie Nisbet was the ither two. Bobby would work up til the time the fresh bread was being loaded in the van, then he wid go around the island wi' the van. He

28. The Broon Boys' garage was a renowned local institution, and was run by three eccentric brothers, the late Davy Brown and Andrew, and a third brother, Willie. Davy concentrated on petrol engines and Andrew dealt with diesel vehicles and generators. When the Hydro (mains electricity) came to Yell in 1968 the 'boys' refused to have the garage connected and continued to use their own generator until the garage eventually closed in the 1980s when they retired. Willie operated a bookings only taxi service: he ran his regular customers to collect their pensions at the Post Offices, or to attend church, etc., but was not available to respond to phoned requests at short notice in the normal way. All four brothers – Jimmy was a jobbing joiner and had no interest in the garage – were unmarried. They all shared a house but prepared their own individual meals, and each did his own shopping. It was an amicable arrangement, which helped ensure domestic harmony. M.McD.

did the baking, then deliveries, so he was away most of the day. And he would do the bookwork on Friday afternoon . . . But then of course comin' up for Christmas time and such like, there was always overtime to be worked, and we would just work until the work was done. Bobby would go all aroon Yell every day, Saturday half day as well, he wid go oot, so it was fairly busy for a while, but the machinery in [the bakery] wis just antiquated. Not like the electric stuff they have nooadays.

It wis all driven by an old engine in the shed – the lean-to at the back of the bakery – and there were a belt up to a shaft that ran right through the roof (before the Hydro came), and then belts ran doon to each machine. It was all belt-driven, pretty primitive, but then you knew nothing else so it was all right. You just got on wi' it. It was just an engine driving a belt to start wi' – I started there wi' Tilley lamps in it for lighting, then we got gas lights. So it was quite a place.

I was interested in wildlife as well as Bobby . . . My grandfather [also Charlie Inkster, Eds] was a warden for the RSPB. I dinna ken for how many years, but he had a medal wi' them for thirty years, he must have been longer than that. I don't know when he actually retired. I think that he possibly got George Waterston in Bobby's direction, because he thought that Bobby would be very suitable. But the job that my grandfather had was very much low profile to what Bobby's wis, for he was no time in the job before the snowy owl showed up in Fetlar and everything took off. I mind being wi' Bobby in the boat in Fetlar a couple times, seeing the snowy owls and like Johnny says, being aff at the fishing . . .

He was such good company, in any company. And the strange thing wi' him wis . . . at a concert you would get the bairns – du kens the way o'dem – they would be getting restless and runnin aroon and makkin a noise, then Bobby would come on the stage carryin a guitar and then there would be a cheer and the place just gaed silent tae listen tae him, and the bairns just sat there like mice, all to listen to him.

And he could entertain them and he could go and pit on a slide show for the WRI and they were the same, fair made up wi' it, and then he could stand up in some huge venue doon in Glasgow or London or wherever and hold an audience there as well wi' all the eminent ornithologists fae around the world. It would make no difference to him where he was; he just could adapt and entertain. He was an absolute wizard at that.

Johnny Clark: And his comical songs were so appropriate too. One o' the great ones was 'Gifford's Old Iron Horse' – Gifford [Gray] was a bit of a traffic problem on the single-track road.

Charlie Inkster: I actually have a photo o' him on his Iron Horse . . .

Johnny Clark: I mind him coming in to us and reciting to me 'Tammie Troot-ie', a poem that he had made up. It was based on a local guy who exaggerated so much about the size of the fish he caught.

Charlie Inkster: The bakery closed in 1963 in June. The machinery and all in it was becoming done and it couldn't keep going and that wis it. The shop was closed before the bakery. I mind there a bit of a joke we played on Bobby. We got the scales – there was a plat-

Gifford Gray and his 'iron horse' at Hillend, Mid Yell. This unconventional vehicle was very slow and hard to steer. It caused frequent tailbacks as well as its spark plug interfering with black and white TV reception in nearby houses.
(Charlie Inkster collection.)

form on it for weighing sacks o' flour and stuff like that, and we got that from the shop doon to the bakery. At that time everybody was tryin' to lose weight – it was a bid o' a fad around the place – and Bobby and Charlie Willie at that time could both do wi' lossin' a bit o' weight. So there were a bit o' a competition between them, trying to lose weight.

Me and Charlie Willie found a place at the back o' that scales where you put on just a small bit o' biscuit dough on one of the levers in at the back to change the weight somewhat. Bobby would come in before he would go in the van in the morning and used to come bounding in up on the scales: 'Oh, yeah, I've lost a couple of pounds,' and the next day would be the same. So we would add this bit o' weight then Bobby would jump up on the scales and say nothing. And straight out again. Then we add a little bit more the next day, and the same thing and then we would takk a piece aff the following day and Bobby would jump on the scales: 'Oh, yippee, I've lost three pounds.' So he would loss a few pounds every day for a while then we add more weight again. Bloody shame, then he would lose interest in the diet altogether. There wis a lot o' pranks played then.

Bobby had so much going for him and it is a shame he didna live longer. When you consider that he was self taught in a way, because his education was in the East Yell School. I have no doubt that he had a good education there, a good basic education,

but the rest was all self-taught, and he could speak on any subject. Was it no' Renwick, the teacher that stayed here in the Old Manse, Frank Renwick, didn't he ask dy parents what university Bobby gaed to? He couldn't believe that he had been teached in a local peerie school.

Bobby wasn't very much for telling you about trips that he had made. He never bragged aboot it.

Johnny Clark: I mind him speaking Cantonese – he would speak a peerie bit o' it just for a fun.

Charlie Inkster: When the first Chinese restaurant opened in Lerwick Bobby just gaed in there and ordered whatever he wis wantin' in Cantonese, but that wouldnae be him boasting – that wis more as a joke. Bobby gave you the impression when you saw him walking aroond, he had that kinda flamboyant strut wi' him and you would have thought that he wis just a bit up stuck and that, but he wisna – he was a very humble person. It was just his demeanour. But tae speak tae him he was more interested in telling you something he wis seen affa the soond when he wis aff wi' the boat, than when he wis been aff tae Falklands or Spitsbergen or that.

Johnny Clark: I remember a fun aboot him wance. Renwick biggit aa yon bricks and dykes aroond the manse? It was kinda castle looking, and doon at the bottom of the dyke, the lower end, he biggit a big turret, like a big square, maybe five feet square right up. And he had a floor in it about half up. And then it was just bricks up aboon that, and I wis doon around there wan day – oor sheep was always around there and I heard all this cackle o' birds and there wis all this maalies [fulmars] gone in it. It wis just full o' maalies, and I climbed up on the dyke to see, and there wis maalies at all stages – there were eens dead and half dead, and eens full o'life, so I gaed for Bobby and he came and said: 'God sakes, tae think that I'm the RSPB representative!' And we had to get them all oot – they werna able to lift again. I think maybe wan had jumpit doon then another een, and they couldna get oot. They couldna get ta'en aff again. So he took the bottom oot of him eftir dat.

Charlie Inkster: . . . Aboot the names o'the floo'ers and that. I mind Mam saying that he gave a slide show to the WRI every year. And he wis gaein' a slide show this year, and there wis a lot o' birds and scenery, and all the rest o'it. And a lot o' floo'ers – he taen photos o' floo'ers and he said tae the women at the SWRI: 'I'll have to learn the names o' this floo'ers. It is something I'm no' very good at.' Then the following year

Bobby with the puffins on a cliff top in Fetlar. (Peter Guy.)

when he came back he was riming aff no' only the common names, but the Shetland name and the Latin name, just like that. And the same with mushrooms and toad-stools and all that – he did exactly the same. And it wisna good enough to learn wan name: same thing – Latin, the common name and Shetland name.

Johnny Clark: And at that time his photography was so good. He had some lovely slides. And a lot o' that wis done, no with the modern photography nooadays – it is so simple in a way compared to what it was then. That was before the digital camera came along.

Charlie Inkster: He had bits o' luck sometimes wi' that. I mind him telling me that when he wis aff in the boat and he wis left the camera on the tap o' the wheelhoose, and the boat hit a lump o'sea, keeled o'er, the camera shot aff o' the wheelhoose, but just wi' that the boat came up again and the camera fell on the side deck. A fraction o' timing difference and it wid hae gone clean o'er the side.

Johnny Clark: I mind goin' to the Clett Stack [in Fetlar] wi' him. He wis wantin' to go up on him and photograph the puffins but when we got there wis far too much swell and he couldna get landed wi' the dinghy. But I don't know how he would have climbed that, but to me it didna seem a very easy stack to climb . . .

He is certainly a miss, I feel. Even when you were aye seein' him comin' and goin' wi' the boat.

Charlie Inkster: I aye think if I see anything strange, like a bird in the garden, or something like that, it still goes through my mind I should phone Bobby to tell him.

Clett Stack, north Fetlar. (Jonathan Wills.)

The albino hedgehog of Mid Yell. (Bobby Tulloch.)

Johnny Clark: Folk wid go to him. I remember an albino hedgehog once. An' just different things. He had otters for a while.

Charlie Inkster: I mind him having a snowy owl in the shed when he stayed up at Reafirth. That wis the loveliest view you could have gotten there. He wis sittin' just inside the window wi' the snowy owl just that far away from you. It wis wan that wis come doon aboard a ship, I think. So they shippit up here to be pitten in tae Fetlar.

I mind him telling me about Capt Laurenson, that stayed in Sellafirth. He wis the teacher for a while in the Mid Yell School, and he asked Bobby if he could shoot him some scarfs [shags] – he liked some scarfs to eat. So Bobby got him some, and he left them hinging for about three weeks from the waa ootside. Then they disappeared for a while, and then he was there wan day, and he offered Bobby something to try to eat, and then at the same time they were just speaking and Bobby said: 'And how did you get on wi' your scarfs?'

And he said: 'How did you like what I gave you to eat?'

TUCKER IN HIS OWN WORDS

Mary Blance's interview with Bobby Tulloch, from BBC Radio Shetland's 'In Aboot Da Night' series, broadcast on 23 April 1986 and transcribed by Mike McDonnell.

MB: Weel, Bobby, welcome ta 'In Aboot da Night'. I suppose dat most folk will think o' dee as Da Birdman – dat is your CB handle.

BT: I suppose my work over da last 21 years justifies dat impression dat I am just a bird man. If I ever do think of definitions aboot my own work and so on, my inclination is much more of a general naturalist. Dat's an ootmoded term noo. It used ta be dat if you were interested in natural history you got into all sorts of branches o' it. Nooadays you have to specialise ta be really successful. You can specialise to reediculous extents. I never wis able to do dat. Dere wis always too many other branches, and dere wis an interlocking and an interweaving o' everything dat grows or lives or swims, and it becam so fascinating dat wan wid lead me to da next. Oh, sometimes it leads you to do nothing properly, but being a jack-of-all-trades is a very satisfying way to live.

MB: I suppose a lok of folk will associate dee with otters, and especially dat big study on Yell twatree years ago with Hugh Miles.

BT: Dat really cam aboot just because I happened to mak a careless remark wan [day] at a 'do' in [the BBC Natural History Unit at] Bristol. It wis at a time when either *Tarka*, or *Ring o' Bright Watter*, had been remade, and somebody wis going on aboot whit a lovely film dis wis and I passed a careless remark dat any competent so-and-so could mak a film using tame animals, an' of course an argument developed as to da ethics of whether, if an animal wis 'impossible' [to film in the wild], you were justified in using tame animals. And I said, weel, you have to first make sure it's impossible. Who says otters are impossible? Oh, everbody knows dey are nocturnal, and only come oot at night. And I said dat's because you don't know.

It wis all a bit light-herted, but I got a phone call a couple of weeks later, offering to put dir money where my mooth wis. An' dat pit me on da spot, because I dan had ta mak sure I knew what wir local animals wis up tae. Dey said dey wid send

In the kitchen at Lussetter House, Betty Tulloch blow-dries the fur of a young otter that had been oiled. (Bobby Tulloch.)

a cameraman up fir ten days, and if in dat time he'd got nothin' dan I wid have to admit it wisnae on, even costwise. Well, for da first ten days dat Hugh Miles wis up here lookin' fir otters [there was only] wan day we did not get some film of otters, and dat set da whole thing goin', and o'er da course of da next two seasons he made dat very successful film.

MB: I wis goin' tae say it wis probably da most popular thing you have ever been involved in, and it made dy name sorta known throughoot da British Isles, because yon film wis repeated again and again . . .

BT: Yes, dat's right, although at da time I suppose dat da snowy owl episode . . . it wis just because it so happened. So much o' whit you do in life is because of fortuitous things dat can happen to you withoot you plannin' it.

MB: Well, how did you get involved with da mushrooms?

BT: I suppose it wis because of a vague irritation to me dat here wis something dat I enjoyed, even tae eat, I enjoyed photographing dem, fir dey are bonny subjects, and

One of the fungi Bobby recorded during his mycological phase: Lactarius rufus. *He was fascinated to discover that this is a very common mushroom in pine and birch forests – and may therefore be a relic of the prehistoric woodland that once covered most of Shetland but was cleared by 3,000 years ago.* (Bobby Tulloch.)

I didn't ken enough aboot it: I wis seeing things dat I couldnae pit a name til. So I started looking a bit more closely. I discovered dat dere were only 56 species recorded tae Shetland, and da more I looked at it, da more I realised dat dis wis only . . . very, very superficial, wi' da result dat today da list stands at o'er 700 species.

Noo, I cannot tak da credit fir dat, for da subject is a very deep wan, and I had to call in help . . . We in Shetland have a lok o' species dat are unknown in Britain, only known fae places like Faeroes and Scandinavia. Dat, mind you, includes things like rusts and smuts and fungi dat only grows on ither fungi, very peerie things. Dere is quite a lok o' dat, but dere is several hundred things dat are big enough to be called either mushrooms or toadstool, whatever you feel like caa'in' dem. An interesting thing, though, is dat a lot o' mushroom types are sort of hooked on trees – dey can only grow in association wi' certain trees. Weel, everybody knows dat we have no forests in Shetland, but da mushrooms dinnae ken dat, because tae dem da willow –

da peerie mootie willow dat only grows an inch high up in da taps o' da hills – as far as da mushrooms are sayin', dat's a forest! And here is a forest o' willows inch high, an' mushrooms two inches high, towerin' above da forest.

An' dere are several species dat are completely and only known to grow in association wi' willows, which is why last summer Dr Watling and me wis divin' fae da top o' wan hill tae da tap o' da next. We were on da tap o' da Ward, Fair Isle, da Hill o' Sandness, Ronas Hill. I climbed more hills in a fortnight than I've done in da rest o' my life, but we added two new species to da British Isles.

MB: We'd better no' forget dat dere is music in dis programme as weel: what's dy first choice o' music?

BT: Weel, my choice o' music on da whole is things dat remind me o' certain time o' my life, and my first – weel, not really my first – knowledge o' music wi' my grandmother singin'. She wis a very good singer, and da first things I learned wis songs like 'The Bay of Biscay' and things dat my grandmother used tae sing. But da first instrumental music dat I wis conscious o' I think it wis fiddle music. But da first I got interested in, in a personal way wis accordion music.

During da war as a peerie boy in Aywick we were beginning to see unkan men comin' in – dis wis . . . refugees fae Norway, and we began to hear dis strange music and dis new instrument, da piano accordion, and dere wis no peace or rest in da hoose until I got a piano accordion, so my faither bought me a peerie twelve bass Hohner and I started to play. I mind sitting ben in da dark fir practically a whole winter learning to play 'Da Auld Hoose'. It must have been absolutely excruciating to da rest o' da hoosehold. Even da dug didna lik it. No. No, da dug wid sit and howl his heid aff. But I used tae argue though dat it wisna proved, because if you pit da dug forth he widna go away. He wid stay within earshot and sit an' howl. I think he wis just wantin tae join in, but anyway Norwegian music wis at dat time very exciting tae me, and I've chosen as a first piece Carl Jularbo playing 'Life in da Finnish Woods'.

. . .

MB: You were mentioning growing up in Aywick. Where did da Tullochs come fae? Whit wis dir roots?

BT: Oh, da Tullochs apparently originally cam in fae Speyside to Da Skea in Northmavine, so I believe. Da first wan tae come in wis a man o' da cloth, so we're lead tae believe. We're just da sam mixed up a lot as a' Shetlanders are. A' dis thing aboot

being true Shetlanders is a lot o' rubbish: we're all pairts o' every nationality. I have roots dat go back tae Denmark, Estonia, Lowland Scotland somewhere, Speyside – all o'er da place – an' Norway.

MB: What is da earliest wan oot o' dat lot?

BT: Well, da earliest wan dat we ken aboot wis a man dat wis wrecked in Fetlar on his way tae tak up a job . . . in sooth Yell, and he wis a Dane, and dis wis before da Scots took ower Shetland. And dis is goin' back awa' tae da 1420s, or something like dat.

MB: And to what extent have you traced your family tree?

BT: Dat wan goes back to Shovald, he wis caa'ed. He cam in and dat wis wan side o' da family. And dat side o' da family tree is traceable withoot any real break or guesswork right back. And dan an interestin' wan is another side dat goes back tae da Battle of Bothwell Bridge when da Covenanters were defeated in da early 1600s, 1630-something I think. Of course dey were defeated dere, and 250 of dem were chuckit in jail in Leith, an dey were sentenced tae be deported, and a ship wis procured from London and cam and loaded dem all aboard and set oot for da West Indies. On da way round da north o' Scotland to go dere, dey sheltered in Orkney and dere cam a big storm. Noo, it wis said da ship dragged her anchors and wis in danger o' founderin' and da captain ordered da fugitives tae be battened doon below: dere were nobody goin' to be allowed to escape although dey were in danger of losing dir lives. Da whole ship wis lost, but two o' da prisoners escaped apparently, an wi' da help o' an Orkneyman caa'ed Smith dey cam tae Shetland. Wan wis caa'ed Gardner, and he settled in Fetlar. And da other wis caa'ed Muir and he wis wir own, God knows how many times, wir great grandparent.

MB: I suppose in da search fir roots by folk nooadays . . . da problem o' kennin stories aboot dir own ancestors. Are dir any ither wans lik dat in your ain family?

BT: Well, most o' wir folk were actually Yell – lived on Yell a' dir lives and in many cases . . . my ain great great grandmother had seven relatives lost in da 1832 fishing disaster. Dat wis da wan dat happened tae da east o' Shetland. And dere wis other relatives dat wis lost at da Arctic whaling . . .

MB: Wan o' dy songs, 'Da Pressgang Song', dat's a very powerful song, obviously strong feelings dere.

BT: Yes, somebody wance accused me it wis nothing more or less than a protest song.

I didna see it dat way at da time. I wis tryin' tae imagine whit da scene wid be like at dat time. It is very difficult nooadays, da wye dat we live, tae try and imagine what it wid be lik if a ship cam intae da voe and your son or your relatives are dragged off. And possibly disappear forever. And it wis just an attempt tae try and imagine myself back in dat period.

MB: We've not really spoken very much aboot dee bein' a peerie boy.

BT: No, dat's true. I wis a peerie boy wan time. It wis a long while ago noo . . . I wis born on da fourth o' January 1929. Happy days, I suppose. I wis a healthy peerie boy, although dere wis a whole year I couldna walk . . .

MB: Ye ken what's comin' next: why could ye no' walk – you walkit when you wis a year old! Bobby, we'll have to go on and have another tune.

BT: My faither played da fiddle, and dat's wan o' my earliest memories, o' Daddy playin' da fiddle. He had a number o' favourite players, and favourite things, and wan dat he wis very fond o' wis Stephane Grappelli. And it's amazin' tae think dat my faither has been dead now in over 30 years, and Stephane Grappelli is still playing da fiddle – he is an amazin' man. So I think dat an appropriate record wid be Stephane Grappelli and Django Reinhardt and let dem play 'Sweet Georgia Brown'.

. . .

MB: 'Sweet Georgia Brown' dere, and it's bein' played as it wis played never again. You gaed tae da school in Yell . . .

BT: East Yell Public School. I wis teached by da same teacher as my faither wis teached, Jessie Mouat, a local wife.

MB: And wis du a good boy at da school?

BT: I think I must have been . . . no' a major irritation, but a frustration til a teacher. Not only wis I a bit precocious aboot some things, even at dat age I had developed an interest in natural history, and although I wis in some disciplines very backward in my learnin', like mathematics – I hated dem! – I saw no'reason for it, I wis an avid reader and loved readin' and doin' essays and anything to do wi' writin', even poetry. So I wis to read up aboot my favourite subjects, which wis birds and animals and like dat, and I used to argue wi' da teacher, and dat disnae go'doon weel when some peerie eight-year-old stands up and denounces what she's tellin' da class as bein'

rubbish, and dat indeed did happen, and lookin' back on it it must have been pretty nerve-wrackin' fir her. And I must say she took it in pretty good spirit.

There wis wan occasion in fact when I persuaded da class – because we had to say – we had da standard English poetry books and so on – and wan o' da poems we had to learn and recite wis da wan aboot da swallow: 'Swallows have come back again, blue is in da sky . . .' du kens da wan? Weel, I had persuaded da class dat dis wisnae really relevant tae Shetland – it should be tirricks. And next time we got to say dat poem in da school we would say: 'Tirricks [terns] have come back again, blue is in da sky', and of course dey did dis, and da teacher heard dis, and stoppit and said 'Who said that? Who told you to say that?' Of course six or eight fingers pointed at me and I had to stand up and justify it, which I tried to do. Dat wis dat forever more, while I wis at da school, it wis recited as 'tirricks have come back again', not da swallows. So, yeh, my schooldays . . . I think dey wir happy days. Fortunately da school wis situated more or less in da middle o' da hills and we had to walk aboot a mile and a half to da school every day, and I very seldom gaed da road wye: it wis either doon da burn and I could fish da burn fir troots all da way home, or you could go by da shore and find all sorts o' interesting things. Goin' to and fae da school wis far mair interestin' than school itsel'.

MB: When it cam tae leavin' da school what kinda wark did you look for? What wis dere at dat time?

BT: Very little. Dis wis of course just nearing da end o' da war. My first job when I left school wis cairtin' peats – da auld mare and da cairt. In fact I gaed oot day's warks plooin' wi' da twa mares and dat wis da kind o' croftin' life you lived at dat time. Dere were no tractors on da island.

MB: So, you were jist hirin' yoursel oot?

BT: Oh, yes. Dat wis da days' warks. I think we got aboot a pound a day fir me and da horses and da ploo'. It wis a' right. After dat I wis actually asked to go in, just afore Christmas, and tak da place o' an apprentice baker who had broken his collar-bone, just in da middle o' da Christmas rush. And I gaed intae dis, although I never had any real love fir baking. It wis a job, and home circumstances meant dat my inclinations to rush away tae sea, or do exciting things like dat, in practice it wasn't just awful good idea, and I just stuck it oot at da bakery and, although I changed til a different bakery, I served my time as a baker. When I wis finished wi' dat, dan I wis called up

to do my National Service. Dat wis quite an exciting time. I didnae really resent it at all. I looked on it as a chance to see something else o' da world, and I immediately put in for an overseas posting, and here wis my name on tae be postit tae da Number One bakery at Hong Kong.

I loved Hong Kong. I set oot tae try and get to ken da folk, and as I wis a baker afore I went intae da army and dey chucked me, in spite o' my pleas – wantin' tae go intae more exciting things, be a dispatch rider and all sorts of things – dey said: 'Oh, you are a baker, are you? We need bakers.' So I got a bit of promotion and I got a job of sort of walkin' foreman, and dis meant dat I had to learn a bit o' da language, and I got fascinated by dis, and took night classes for aboot six months tae learn Cantonese. So, da only other language, apart from a smatterin' o' Norwegian, da only other language dat I am reasonably conversant wi', or wis, is Cantonese.

MB: And du still speaks it?

BT: Well, wi' a peerie bit o' practice I wid be able tae bruck thru da basics. I still coont and do things lik dat.

MB: When du wis workin' wi' it every day, workin alangside, did du make ony freens?

BT: I made some lovely freens. In fact we had visits fae Chinese in Aywick, da very first Chinese dat had ever been in Aywick came up to see me a couple of year eftir I came back. So, da twa year I spent in da army, lookin' back, did me an awful lot o' good. It let me see how ither folk lived; it let me see dat I could in some ways hold my heid up among my contemporaries fae any pairt o' Britain in certain aspects. Dere were things dat I wis better at than most o' da boys dat I wis wi' – da practical things dat we wir learned to do, dat some o' da more academic o' me fellow squaddies just [didna] have a clue aboot. And of course you do whit you ken best, and you see dat you're superior and you make da most o' it. I think dat probably da best pairt o' it wis da six weeks trevellin' on a troop ship tae Hong Kong and da six weeks back. Three month oot o' your twa year, and it wis a lovely trip. Watchin' sea snakes in da Red Sea, and of course a new wildlife setup.

MB: Wherever du's been du must hiv been always lookin' oot fir da wildlife?

BT: Yes, any spare moments were spent, especially in Hong Kong, climbing da moontains and da hills and goin' fishing wi' da Chinese and goin aff tae, it wisna

da ollicks, it wis similar things dat you used to catch. Yes, dat side o' life wis always fascinatin' tae me and even oot dere it wis a great pleasure.

MB: But dan du came back tae Shetland eftir dat twa years? You didna bide?

BT: Yes, I did. At wan point dey wanted me to stay on, and I wis offered promotion. I wis actually a staff sergeant when I came oot, and dey wanted me to stay on and become a Warrant Officer, in spite o' havin' no really proper education certificates. But, no, da lure o' home and da islands wis too strong and I just couldnae sign on fir ony length o' time. So I cam back home . . . to find, of course I knew, dat da job dat I had been in wis no longer available. Anyway, I wasnae really fussy. I wanted something different, and I wrocht in Lerwick for a year. I worked tae da likes o' Georgeson da bakers up in Hillhead, but in dis case not in da bakin' side, but on da selling side, doin' da country van and dis I enjoyed since it meant meetin' da folk.

And although I can enjoy my own company and da company o' wild things, I lik meetin' folk. I particularly enjoy things like language and dialect and da wye folk speak, and I'm always listenin' tae dis. It wis interestin' tae, coming fae Yell, just tae find oot how insular we wir, and how much we had oor own dialect. Lerwick is different, though. Lerwick is a bit of a mix o' everything . . .

For da whole of da time I wis in Lerwick I played wi' da old Islesburgh Band. Tammy Anderson wis da leader. Violet Tulloch noo (Scott at dat time), Alex Sutherland – dey were accordion players along wi' me, and Peerie Wullie and Drew Robertson. Dat wis da standard set-up, and dis is a record dey made, just aboot da same time, although I wisna actually pairt o' da band at dis particular time, dis wis a record dat dey made, da Islesburgh Band:

. . .

MB: Da Islesburgh Band. Dat's a brawly scratched record, Bobby.

BT: Yes, yon has been well played. I didna work very long in Lerwick, just aboot a year, for an opportunity came up, and it seemed a good idea, to go back to Yell, and my brother-in-law and I took over da bakery dat I had served my time in. We did dat for six years, but it didna work oot fir various reasons. I think partly da fact dat we didna have much business sense between us tae run da place, and I think it wis at a bad time too, for Yell – well, da whole of Shetland – wis in a depressed economic state following da war. And folk were havin' to watch dir pennies, and we were trying to run a bakery withoot mains power, withoot running water. We were carryin' water fae a well, and

we were having to do everything by hand, and employing people, and paying union wages, and import coke fae Aberdeen at vast cost tae run da ovens. An dan we were having tae compete with folk like Bilslands and da Co-op, which were sending in bread made by modern machine methods and we thought we wid make money, and we couldna. So after six year we saw dat it wis just hopeless and we gave dat up.

MB: And dat wis really when you became da birdman?

BT: Well, dat wis really when I started livin . . .

MB: Weel, dat's wan wey o' puttin' it.

BT: What happened wis I still had kept up my interest in birds and all things to do wi' nature, just as a hobby. I had got to know George Waterston who wis dan boss o' da RSPB in Scotland, and he used ta come up to Shetland to see my predecessor who wis Charlie Inkster, Mid Yell, who wis still da part-time rep fir da RSPB when he gave up. I wis doin' very little dat summer: I wis between jobs, and I had married in da meantime, and my wife wis workin' and I wis potterin' aboot lobsterin' for da summer, and decided no' tae tak onything on fir a month or two anyway. And George Waterston came up on a visit and I wis tellin' him dat I might no' be able tae report local [ornithological] happenings fir long. I might have tae go somewhere else tae work. Dere wis nothin' in Yell really.

Now, he obviously thought about dis and realised – and it coincided with several cases o' egg-collecting and nobody in Shetland tae keep an eye on things – and he said when he gaed away: 'Don't do anything too hurriedly, I might have something to offer you.' Now dis wis something dat had been a dream, but I nivver thought tae pit intae reality: da possibility o' makin' my hobby become my work, in fact. And dat Christmas, da best Christmas present I ever had, I think, wis when da letter cam, sayin' wid I tak on da job, part-time job, as representative in Shetland fir da RSPB.

The first thing I realised wis how little I kent aboot da rest o' Shetland. How insular we had been, how much I had lived in Yell, and I didna even ken who wis interested in birds on da Mainland and on Whalsay and a' da different islands. It had been a very personal hobby.

MB: So dan you must have set aboot kennin' Shetland.

BT: Exactly, and I had ither things tae face too: da fact dat it wisna considered in Shetland tae be a very practical way o' earning your living. And I think it is fir dat reason

Although he'd lived in Shetland all his life, Bobby hadn't seen much of the islands beyond Yell, Unst and Fetlar until 1964, when his new job as Shetland Representative for the RSPB obliged him to escort visitors to all corners of the archipelago. Here one of his clients rests on the ruins of a Neolithic chambered cairn to enjoy the view over Yell Sound from the top of Ronas Hill, Shetland's highest summit (450m).
(Bobby Tulloch.)

dat I developed anither inclination o' mine, and dat wis tae write songs and do silly things on da platform. And I think dat wis a conscious, almost conscious thought, to show folk in Shetland dat I wis just an ordinary Shetlander and wisna really gone over tae join da birdwatchin' brigade, wha at dat time wis mainly elderly English women in tweed skirts wearin' binoculars. An image, I may say, is totally changed today.

I felt I had tae let folk see dat an ordinary Shetland guy could get enjoyment oot o' doin' dat sort of jobs. For da first few years, I saw dat my main job wis tae find oot what happened in da rest o' Shetland. Well, livin' in Yell at dat time, wi' no car ferries, it wis no' dat easy, fir I had no transport and, apart from depending an awful lot on my freens, I must mention Dennis Coutts in particular, because we did many journeys at his expense and in his vehicle, because I couldna get a car off da island. I

didna have a car in fact, but I had a motorbike and I used to take it on da ferry boats and on to Fetlar and all o'er da place, and got tae ken da islands and of course I had my own peerie boat at dat time. I used to go oot tae Skerries and aroond Unst in what wis literally just a fourareen wi' a peerie engine in it.

MB: And it wisna just Shetland dat you got tae ken in dat years you spent fir da RSPB?

BT: No, dis opened up ither things, because Shetland at dat time wis becomin' popular wi' both visitin' cruise boats and of course wi' visitors. Da National Trust organised a cruise every year on da old liner, da *Uganda*, and I wis asked wan year tae join her, just for da few days she wis in Shetland. Well, I thoroughly enjoyed it, and dey obviously thought dat I did a reasonable job fir dem because for da next twenty years I wis back every year on da whole cruise. Dis meant I had da opportunity to visit places which I could relate tae my work in Shetland by seein' what da situation wis like in like da Faroes, St Kilda, Iceland, Norway and all o'er da place. So da twenty years wis when I really began tae live, tae see what wis goin' on in other pairts o' da north.

Fair Isle yoals in their noosts at South Harbour, Fair Isle, in the late 1960s.
(Bobby Tulloch.)

Exploring further afield, as a guide aboard cruise ships, Bobby discovered St Kilda and later worked there for a spell as a volunteer. Here some daring visitors seek thrills on a rock outcrop a couple of hundred feet above the Atlantic. (Bobby Tulloch.)

A Soay ram on St Kilda, an animal with clear affinities to the native Shetland sheep. (Bobby Tulloch.)

In fact I'm going off again in a few days to go on da National Trust cruise. We're goin' up tae Lofoten. Dat's one of da few islands and places in da west o' Norway I havna yet visited, so I'm lookin' forward to dat and lookin' forward to havin' a captive audience to which I show slides and talk and mak a fool o' myself at ceilidhs and join up wi' friends like Freeland Barbour and Mary Sandeman.

MB: What is dy next bit o'music?

BT: My next bit o' music is to remind me o' pleasant experiences, and wan dat I really enjoyed wis goin' up tae da Faeroes. I got tae ken Spaelimenninir, da fiddlin' gang dat comes doon [to the Shetland Folk Festival] from da Faroes, and I up and visited dem. I spent da whole week and took da fiddle wi' me – a fine way o' gettin' aroon Faroe wis tae travel aroon wi' dem. Noo, travellin' aroon wi' dem is an experience in itself. Imagine nine folk in a VW minibus wi' da instruments, and dat instruments include a piano and a double bass, and dere wis always someone who had to be jammed in atween da roof an' da top of da piano, and lie full

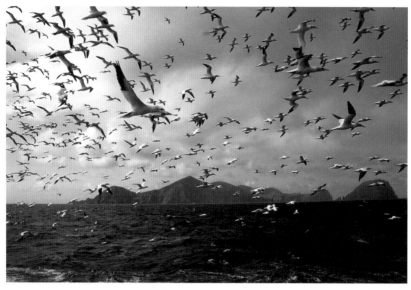

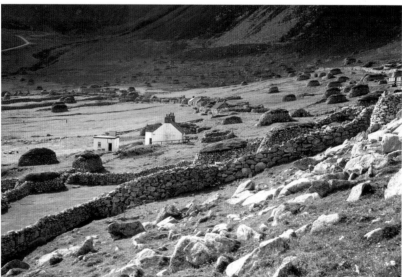

Top: *A flock of gannets following the cruise ship as St Kilda slips astern.*

Bottom: *Some of the houses in Village Bay, St Kilda, where Bobby worked as volunteer lifting heavy stones during reconstruction work. This was not long after he had suffered a heart attack, about which he kept characteristically quiet.* (Bobby Tulloch.)

Bobby and fellow volunteers on a wet day in St Kilda. (Photographer unknown.)

length across da wye, but it wis great fun, so here is Spaelimenninir, playing some Shetland reels.

. . .

MB: Lookin' back o'er dy life, you've obviously enjoyed da 20 years you've spent as Shetland's birdman, and natural history man. What's your plans for da future noo?

BT: My plans fir da future are tae tick o'er fir a while as best I can and enjoy, and try tae dae da things I've been tryin' tae dae all my life, but never got aroon tae. Wan o' my main interests a' da time along has been photography, and I get asked quite a lot to do, well its caa'ed lectures but I look on it as slide shows. It's an enjoyment rather dan a chore, and I get ta do dis quite a lot and always need fresh material and dere are some of Shetland's birds I've never even pointed a camera at yet. And it's high time I did. I dinna hae a decent picture o' a tystie [black guillemot], and things dat, in actual fact, da people come up fae sooth to do specially – da Shetland specialities – da wans dat I've never bothered wi' fir some reason And dis says something aboot my own character; I tend to go and look at things dat ither folk is no' doin', or no' lookin' at. So, dere is so much to be done, and time gets shorter.

MB: What aboot trevellin' – wid du like tae see more o' da world?

BT: Yes! Though my own inclinations disna lead me to be envious o' folk dat go and do safaris across da Sahara desert, or to see da steppes o' Russia or da pampas o' Sooth America. I kinda tend tae cut my cloth accordin' tae what I need my sails tae be, and my inclination is to go to peerie islands I like and I suppose it's because I live on wan. You either like where you live or you hate it, and I happen to like it. And dan an island has an awful lot goin' for it. If you're goin' to do a study – da study could be on da botany, da fungi, da birds or anything other on an island – you're no goin' to be worried aboot da next election. Dat is a very satisfying, complete, world-of-its-own sort of place to study.

MB: Dis is an unfair question: does du hae a favourite island?

BT: No. I have had favourite islands at wan time. Apart from our own islands, I loved St Kilda and I still do. I think dat's a super island. I love Mykines in Faroes, da most remote and westerly o' da Faroe Islands. I have islands I like and prospect and might no' get tae, but I would love tae, such as da Falkland Islands. I would love tae see some completely different set o' flora and fauna.

If dir wan thing I've learned, travellin' tae different pairts o' da world an' different parts of da north certainly, dat is: learn to appreciate what we have in Shetland, because I can say in all honesty dere is nowhere I've visited – and I've been tae most o' da supposedly good natural history places up in around da north – dere's nowhere better dan Shetland for showing a variety, for showing a collection of birds and animals you can see so easily. Dere is nowhere else dat can compare.

MB: Bobby, we must choose dy last bit o' music, and we can just say cheerio.

BT: Well, my last bit o' music I feel must come up tae da present time and no' be nostalgic aboot livin' in da past, because music is a very important thing. It has to be a livin' and an ongoin' thing. So, it's very heartenin' to see so many young folk are takkin o'er da musical tradition, and not only in playing – composin' and so on – so my own favourite at da moment is Debbie. Let's have Debbie Scott playing her own composition to finish up wi' . . .

Guarding Owls and Wrestling Gannets

Roy Dennis

I think it was the spring of 1964 when I first met Bobby Tulloch. At that time I was warden of the Fair Isle Bird Observatory and we both had this wonderful man called George Waterston[29] come into our lives. George was one of the key mentors in my life and he got in touch and said, 'Look, we're going to get a new RSPB man in Shetland. His name is Bobby Tulloch. He lives in Mid Yell and I want him to come to the bird observatory for you to train him, particularly in bird-ringing, because you can't be an ornithologist without ringing birds.'

So Bobby came to Fair Isle and that started the most marvellous friendship for the rest of our lives. I just found him a brilliant person. I taught him how to ring birds and I have a photograph of him with a young merlin, a migrant from Shetland or maybe from Iceland. It could have been that first autumn. I'm not sure. It then developed into a pretty regular relationship, on the telephone mainly, about things he'd seen, and soon involved me going out from Fair Isle to ring birds with him in other parts of Shetland.

One of my old notebooks records the 22nd June 1965. After the spring migration and the counts of the seabirds on Fair Isle there was a bit of time to spare, so I went off that day to stay with him and Betty in Mid Yell. I see that I met Bobby and Dennis Coutts in Lerwick and they quickly took me off to Seafield Lodge to look for a firecrest, which we managed to see. It was the first firecrest either of them had seen and we located it in that garden which was really nice. It would have been my first Shetland firecrest.

The notebook records that in Lerwick I bought an anorak and met Tom Henderson[30] at the museum and then got on the back of Bobby's motorbike. Lerwick was

29. George Waterston was the founder of the Fair Isle Bird Observatory in 1948 and owned the island until he gifted it to the National Trust. His connection with the observatory continued until his death and the museum on Fair Isle is dedicated to his memory. He was also at this time Scottish Director of the RSPB.

30. Tom Henderson, the noted Shetland antiquarian and storyteller, was at that time curator of the Shetland Museum, then housed in a former wartime hut in St Olaf Street, where the King Eirik Centre now stands.

Roy Dennis at home in Moray with one of his field notebooks from the 1960s.
(Jonathan Wills.)

absolutely full of herring boats. Our first stop was Kergord, where we ringed three oystercatcher chicks, had a look round the plantation, saw that the tree sparrows were nesting and ringed three hooded crows. Then we set off for the Yell ferry, and saw the Ramna Stacks in the distance as we crossed to Ulsta. On the way to Mid Yell we stopped at a merlin's nest which had three eggs in it. And then I had a fantastic week of bird-ringing and visits with him. Here's the entry for Wednesday the 23rd: 'No use for Fetlar – south east gale force eight so there's no chance at all.' We were talking about the sea eagles and Bobby said, 'Well, we can go and see where the last sea eagle nested.' We drove a wee bit north and then walked over the hills. I nearly trod on a male red-necked phalarope incubating four eggs in the grass. That was the first record on Yell for nearly 30 years. We came to the Lochs of Lumbister and Bobby said, 'Oh, we'll do a bit of fishing here first.' And I thought, 'He doesn't have a rod,' but he got his rucksack out and there was this piece of wood which he flipped into the water. It was an otter board.[31] I'd never seen one in my life. He sailed it out into the loch and we pulled it along the shore of the loch and kept catching really super fish. In the end, on the way out and on the way back, we got 'twelve nice trout', as it says in the notebook.

Anyway, we saw moss campion and then we looked out over Whalfirth to the eagles' last nesting area at the Neaps of Graveland. Much later I would see a photograph of the last one, a very pale sea eagle, taken by the pioneer bird photographer

31. An otter board is an illegal (and extremely effective) device for catching trout: a wooden board, from which hooks are suspended, is towed from the shore with a line.

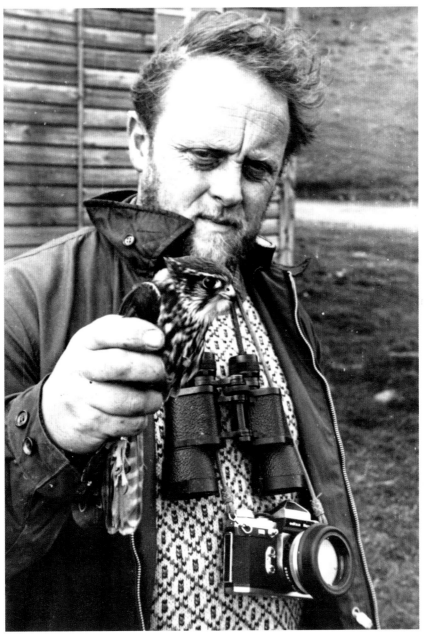

Bobby with the young merlin in Fair Isle, 1964. (Roy Dennis.)

Harry MacPherson of Balavil between 1912 and 1918. We then headed back home with our catch and I remember Bobby was cutting up the trout when an enthusiastic young Department of Agriculture guy, whom Bobby knew, walked into the house. He looked at the fish. 'Where did you get those?' he said. Bobby said, 'Oh, they're just rising to the fly like mad today at Lumbister.' 'Well, I'm not stopping,' said the guy and he roared off to get his rod and go there. Later we heard he caught nothing. Bobby never mentioned any otter board.

We still couldn't get to Fetlar next day so we went to Gloup Voe and climbed down and ringed a couple of rock dove chicks. On 25 June there was a collared dove outside Bobby's cottage, which was pretty rare in those days. We went up to Unst, saw several red-necked phalarope sites and walked out to Hermaness. The cliffs were very rocky but I found a place where we could climb down. We got very close to a lot of gannets down there. Eighty per cent of them had young. There were five to six thousand guillemots.

We ringed some bonxies on the way back and tried to catch some red-throated diver chicks but that wasn't any good. Then we went to see Magnus Sinclair and his father, Old Magnie, who'd been the RSPB birdwatcher on Unst. It was a great thrill for me to meet them. Next we went to meet Steven Saxby. Bobby had warned me this could be a difficult visit and we had to be on our best behaviour so that we could wander round his garden and see what was there at Halligarth, the most northerly copse of trees in Britain. It was just fantastic being with Bobby. Everyone we met he knew and we'd have a craic. There was so much talk and we were ringing all over the place. I was in heaven.

Later we were at the plantation in Voxter, near Brae, and found an icterine warbler which was new for Bobby. And then on the 27th we did a big day on Fetlar. We went down into a big shag colony and ringed adults and a lot of chicks. And I wrote in my notebook that I'd given quite a few rings to Bobby so he could continue the work on his own. He was already getting a lot of experience at ringing. In those days it was much easier to become qualified. I could basically say, 'You're fit to be a ringer now', and that was it.

After finishing the shags we climbed to the cliff top, up a tremendous slope of rocks, very unstable. This was my first sighting of serpentine. We walked across to Vord Hill and out to the west side, where the snowy owl pellets were first found. The owl had obviously been using the piles of stone as perches. We found a few feathers and plenty of white droppings but didn't find the owl, which was not yet breeding

on Fetlar. But there were six pairs of whimbrel up there. Later in the day we found the snowy owl sitting in the middle of open ground by some rocks: a very white bird with some greyish marks on the wing; a rather small head for the size of the bird; it flapped off when we got to within 100 yards. And then the notebook says we 'went down the cliffs, dodging the rain, and so out to the boat'. We had a bit of a punch back across to the moorings at Mid Yell and got home at 11.30 pm.

I always felt very safe with Bobby in the boat. I remember once we went to Skerries on a not very nice day. God knows how we got there but we did. It's mainly quite rough trips to Fetlar that I remember.

The notebook tells me that on 28 June 1965 I went home. So that was my first visit. Brilliant. Bobby was way ahead of me in photography. In those days photography was so different. Every slide you took, if you were taking colour, cost you a shilling, which in those days was really a lot of money, so you eked out a roll of 36 exposures and made it last. Then Bobby said, 'Well, you should do more black and white,' but I'd never done developing. So when I was at Bobby's he taught me how to develop film and how to use a darkroom, because he'd kitted out a poky little darkroom in his cottage at Reafirth, where he and Betty then lived. He taught me how to make prints and how to move your fingers about so you exposed one bit more than the others and I just thought that was brilliant. So when I got back to Fair Isle I concocted a sort of darkroom. It wasn't very good but at least it got me started. Bobby was always very helpful about equipment, for example letting me know if a friend had a camera or a lens going cheap because they were buying a new one and didn't need it any more. I remember admiring his Exakta camera.

Bobby would have come down to Fair Isle that autumn of '65, and then I met Dennis Coutts again. Now, Dennis and I had met in 1959 when he came to Fair Isle to photograph Alex and Margaret Stout's wedding. I never really got to know him at that time but by now we had the Shetland group of bird recorders who visited the observatory. It was mainly Bobby and Dennis but also Robert Duthie in Scalloway, who was just great craic, and occasionally Johnnie Simpson from Whalsay.

There are many funny stories about Bobby, of course. Things didn't always go to plan. A lady on Yell phoned while I was staying with Bobby and said she had a 'Mother Carey's Chicken' she'd found at the door that morning; obviously a young storm petrel that had got attracted to the house lights after leaving its burrow in the banks. Bobby said he would collect it and let it go again out on the voe. He went there and she had it all beautifully done up in this cardboard box. So Bobby undid the box and

Roy Dennis' field notebook, 24th June 1967.

had a look inside to check if it was a Leach's petrel or a stormy and it was a storm petrel. And then the woman said, 'Let me tie it up again, Bobby, let me tie it up.' Bobby said, 'No, no, it'll be fine. I'll just hold on to it.' 'No, no, Bobby,' she said, 'Do let me tie it up,' and he said, 'No, I'll be OK. I'm holding the lid.' Well, we walked out to the car and there was a sudden gust of wind and the lid blew open, the stormy jumped out, Bobby went to catch it and his foot landed on it. He squashed it absolutely flat!

My notebook for 1967 records an important year from Bobby's point of view. He phoned me and told me about the excitement over finding the snowy owl's nest and then I got a phone call from George Waterston: 'Look, Bobby has got this owl and he needs help. And because you had four years of Operation Osprey[32] I think it would be a really good idea if you go out immediately and give Bobby a hand.'

32. The RSPB operation to protect the ospreys' nest at Loch Garten, the first in the UK for many years, became a major conservation success.

The Consort *(with her original wheelhouse) lands beds for the snowy owl guardians at Brough Lodge, Fetlar, 24 June 1967.* (Roy Dennis.)

So my notebook records: 'On June the 23rd 1967 I set off from Fair Isle at six o' clock. I got rather seasick. I got to Lerwick and I met Dennis Coutts and Norman Baker, later to Helendale and met Bill Porteous.' Then to lunch at the Queen's Hotel with George Waterston, Peter Alpress and Stanley Cramp, the great ornithologist who was the chairman of the RSPB and became a great friend thereafter. We also went to see Lance and Willow Tickell.[33] They ran me up to Toft's Voe. I caught the Yell ferry at 6.30 pm and Betty met me and took me to Mid Yell. Bobby came in later from Fetlar.

The next day we went to Fetlar with beds for Richmond Cottage, which had been hired to accommodate the owl protection squad. We carried the gear from North Dale to the cottage and met Lollie Brown. Then up over the hill to Stackaberg. And our main job was putting felt on the roof of the hut where the owl-watchers would work shifts to ensure 24-hour protection for the first snowy owls to nest in Britain.

We watched and the female went off in the end. She was quite a sitter. Bobby and I went across to the nest. There were seven eggs. The male came flying in from further over and was squeaking and barking at us like a dog when we were close

33. Lance Tickell was Shetland's first Nature Conservancy Council officer. JW.

Bobby gives directions as the volunteers move the snowy owl watchers' hut into position, Stackaberg, Fetlar, June 1967.
(Photographer unknown. Bobby Tulloch Collection.)

to the nest. We walked back over the hill past lots of whimbrel and curlew. That evening we went down to Burravoe to meet Bobby's sister and then to the loch where there were two pairs of scoter and a long-tailed duck.

In the evening we had a meeting with the men from the *Daily Express*. We had a drink with them at the hotel. This was when the press interest started and George Waterston thought I could help Bobby with dealing with them but Bobby was perfectly OK on his own. George had been worried about how Bobby would deal with them, whether they might push him too much and try to get too close to the birds. I could have given him a few tips but he was just a natural at dealing with people so he had no trouble with them.

Next day, the 25th, was a miserable day. There was no clearance in the fog and rain. So by noon we just set off for Fetlar. The conditions were deplorable. But we saw the male owl well, the female at times through the mist. In the evening we went

to Ulsta with Dennis. The 26th was a much better day. We sailed over to Fetlar in the morning with the *Daily Express* men and some girls from Edinburgh. Charlie Thomason collected us at Brough Lodge and we walked up to the hide. The situation was similar. The male was on the ridge and he spent 25 minutes trying to eject a pellet. He brought a rabbit to the female at 8 am. We left early and had tea with Lollie Brown. Later we went out to the north east side of Fetlar and saw phalaropes on the loch, with broods on the fresh water.

Then back on the boat, after visiting the Fetlar manse garden. Super place for birds, but only starlings and sparrows that day. In the evening we took my mist nets out and went to Fetlar again. Saw 20 Manx shearwaters flying about and then we landed at the south-east end of the Red Banks and climbed the cliffs and put up the mist net. The stormies came in at 22.45 GMT and we had some in the net very quickly. That was the first time that Bobby was ringing storm petrels. We caught 22

Bobby on the snowy owl grounds, Stackaberg, Fetlar, June 1967. (Roy Dennis.)

stormies that night. They 'coughed up a great deal of oil, in some cases a pink fluid of shrimps'. By 1 am GMT it was quite light and the birds stopped coming in to the cliff so we set off for home and got back to Mid Yell at 2.30 am, seeing an otter and two young on the way back. What a day! That was just brilliant. Bobby and I had also walked to the East Neap, where we ringed 71 shags and got one wee trout!

Another night, Bobby and I set off at 10.30 pm and anchored near a Bergen trawler at Urie, below where the owls were nesting. We went on watch at 23.10. And then my notebook records, right through the night, what the owls were doing: for example, at 23.41, the female returns to the nest and turns the eggs; at 00.27 the male flies off to the south; 00.47 the male flies across to where the female ate prey; walks across the ground and flies off and lands on outcrop 'C'; at 05.30 the male is preening in front of a perch called 'B'; and Miles Clough took over from me and Bobby so we were off duty. So that was just absolute joy that Bobby should take me there and we should do the night duty together watching the snowy owls. Such an exciting time, it was.

One of the visitors to help guard the owls was Colonel Stanford, who was a real old character who wrote about birds and was very much involved with the RSPB. He was often a voluntary warden at Loch Garten so I knew him well. The weather was so bad that we couldn't land at Urie the next day but on 30 June we landed him at Brough Lodge. We carried on north past Sound Gruney to Uyeasound. Magnie Sinclair picked us up and ran us to a new red-necked phalarope site with two chicks.

Bobby and I went on to Baltasound and Haroldswick, had tea, and then to Hermaness. We went down the cliff and ringed 106 gannets, 20 shags, one razorbill and 11 guillemots, and came away from the cliffs at 7.30 in the evening. That was the first time he'd ever been ringing in a gannetry and I've got a photograph that looks as if he's strangling the gannet. These were also my first gannets because at that time there were no breeding gannets on Fair Isle. In the notebook it says: 'A really brilliant bird cliff'.

We scaled back up the cliffs and walked back over the hills among breeding dunlin and, as we walked down to the car at the lighthouse shore station, we rested behind the lightkeepers' houses. I was scanning the water at 8 pm when I saw a white-winged black tern flying in from the sea. It dipped around over the water near the Burrafirth beach. I think that might have been the first record for Shetland. Then we put the car back to the Springfield Hotel, had a drink and a sandwich, hitched a lift to Uyeasound to collect the boat, sailed back to Mid Yell and finally got to bed at two o' clock in the morning. What a superb day that was!

Bobby wrestling with a gannet on the Hermaness stacks, Unst, 30th June 1967.
(Roy Dennis.)

Other things I remember: Bobby regularly came to Fair Isle so I think he was there when we released the four young sea eagles from Norway in 1968. That was a typical George Waterston operation. He just said, 'I'm going to bring the eagles. You talk to the islanders and build the cages.' When we released them, one of them went off Fair Isle quite early. It disappeared in the autumn. The others stayed and Tony Mainwood, my assistant warden, looked after them through the winter. They were still with us in the spring and then on beautiful days in April and May the two females disappeared. Whether they went to Norway or what we don't know. The last one stayed on the island and finally got covered in fulmar oil and died in the sea. Of course, when sea eagles had become extinct in Shetland in the early twentieth century the fulmar was a rare bird.

In 1969 we built the new bird observatory and Bobby was at the opening ceremony and party that autumn. George always used to push him to play music: 'Oh, Bobby, bring your squeeze box,' he would say. Bobby would kind of groan because he didn't like taking the limelight like that. He needed a bit of time but the great thing about Fair Isle was that he met so many islanders who were great musicians and he could join in with them. I remember he also wrote a very funny song to a popular tune and the islanders loved that. So Fair Isle became a second home for him.

A young sea eagle arrives by Loganair on Fair Isle in 1968, to be met by a youthful Roy Dennis (left) with the Norwegian sea eagle expert John Wildgohs and RSPB Scottish Director George Waterston (right). (Dennis Coutts.)

In 1970 I left Fair Isle and joined the RSPB as their Highlands Officer, which was in some ways equivalent to what Bobby was, and later I had all of the north of Scotland to look after. He was then a work colleague and we met each other, particularly in the autumns, when we always had a get-together at The Lodge in Sandy, Bedfordshire, the RSPB headquarters. There'd be him, Eddie Balfour from Orkney and me and I sometimes drove them down to The Lodge so we'd have great craic on the way. There'd be two or three days of a wardens' workshop, organised by John Crudass, the reserves manager who knew Bobby from his visits to the Shetland reserves. The people at The Lodge thought a lot of Bobby because he became a tremendous ambassador for the RSPB as a popular lecturer. Trevor Gunton, head of RSPB Members department, organised lectures for him all over the country to members' groups, it was reckoned that Bobby earned his own salary in lecture tickets sales and membership subscriptions because he was giving talks with maybe four or five hundred people at a meeting as well as filling the Royal Festival Hall, so he was undoubtedly the absolute star lecturer for the RSPB. I loved being at conferences and listening to him.

I tended to lose touch with him a bit when he left the RSPB. I was always sad that he left as I wished the Society had kept him on part-time as a lecturer and ambassador and his photography and writing was really good. He was a real loss to the RSPB.

Some of the last things I did with him were when he started Island Holidays with Libby Weir-Breen. He'd make me envious with tales of the places and wildlife he'd seen, so I was thrilled when they asked me to be one of their lecturer/guides and I made trips for them to the Falkland Islands and the Seychelles. They were great fun and I really enjoyed doing that for Bobby.

So when Bobby died in May 1996 I was really sad to lose a great friend. He was so special to so many of us and Shetland was never the same. Sometime later I was in Shetland with Dennis and said I would have loved to have seen a memorial to Bobby, something unobtrusive, bolted onto the rock next to where the owl nested, just saying '*Nyctea scandiaca c.3.*[34] *Bobby Tulloch. Birdwatcher and friend.'*

34. The telegram Bobby sent to the RSPB to announce that a snowy owl had laid three eggs on Fetlar.

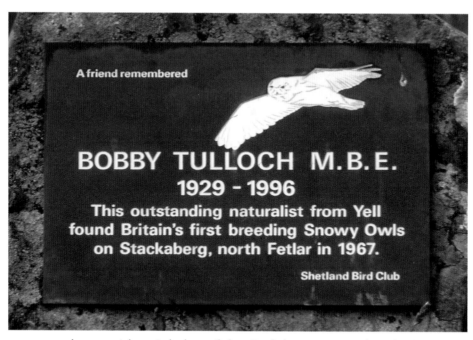

. . . and a memorial was indeed unveiled on Stackaberg, some years later, by Dennis Coutts and Bobby's sister Laureen. (Photo courtesy of Mary Ellen Odie.)

THE MOST NATURAL OF NATURALISTS
Liz Bomford

I didn't know it at the time – it was bucketing down rain with gusts of hail on the first occasion when I disembarked from the ferry – but I saw Shetland at its best. Pristine is the wrong word; people had been occupying the islands for five thousand years or more, but I was surprised to find how much of it was truly wild, scraped clean by Atlantic wind and eroding waves. Looking back I recall how rich it was, how extraordinarily generous the sea.

In 1970 our job was to make a wildlife film: an RSPB/BBC co-production called 'Isles of the Simmer Dim'. Bobby's job, as RSPB representative, was to guide

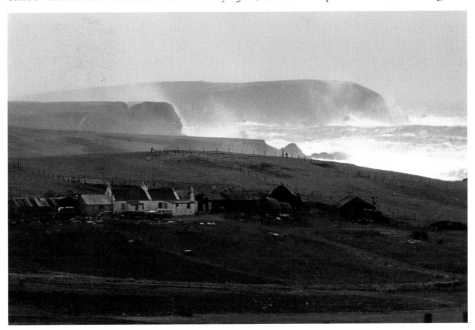

Not much of a day for filming: a gale sweeps over Gloup, North Yell.
(Bobby Tulloch.)

The cover of the RSPB's brochure for Bobby's film debut.

us; to help shape the film and its content, and to get us to the right places at the right time. In film jargon, he was the 'fixer' but of course, he was so much more than that.

Bobby wasn't what you'd call an organisation man. He was a Shetlander born and bred and he wore his love for the islands and their wildlife on his knitted sleeve. In no time at all we were introduced to his family and the community of Yell, with whom we were to live as neighbours, on and off, for three years between 1969 and 1972.

We used 16 mm film in those days; slow stock that required sunshine, or at least fairly bright cloud, to get acceptable images. On dull days, out-of-focus birds flapped across a murky seascape. We couldn't view the footage, it had to be sent off first for processing. Even then we didn't get to see the images ourselves, instead we received curt, dispiriting notes from 'doon sooth'. In my diary for June 1970 I noted 'It stopped raining for twenty minutes today.' More often than not, rolling the camera was an expensive waste of time.

Bobby's unfailing cheerfulness kept us going. We went out with him in his boat most days, on the off-chance the rain would clear or the fog would lift. We filmed little, but we learned so much that it soon became clear one film wouldn't be enough. We ended up making three.

Bobby had a compass, but I seldom saw him use it. Or if he did, it was out of the corner of his eye. Whatever the weather, he always knew just where he was, on land or sea. He taught us how to use the meids: lining up two points on the shore to fix your position, and taking a cross-bearing on two other points, so you could always

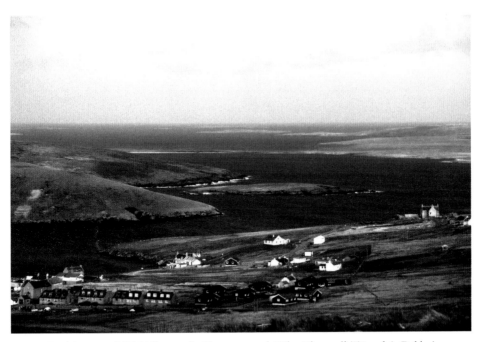

Looking over Mid Yell towards Hascosay and 'The Bluemull Triangle', Bobby's cruising grounds. (Bobby Tulloch.)

return to, or navigate from that position.[35] Bobby's landscape was criss-crossed by meids: long-standing points of departure and return.

Some of these meids were personal, others were well known to other Shetlanders. Peaks on the horizon, dark voes seen in distant cliffs, strangely shaped rocks: almost every feature had a local name and had been used as a navigational aid for generations. The old names were explicitly sexual – once heard, never forgotten. Memory experts confirm that this is a well-known technique for remembering and teaching, but it's probably one of the reasons women were unwelcome on fishing boats. Paps were everywhere, as well as references to dark clefts, erect rocks and useful holes. The land, looked at from the point of view of a traditional mariner, was lewd.

The perfect gentleman, Bobby alluded to these things, without breaking any local taboos. So we came to understand how he always dropped anchor in exactly

35. This system is still extensively used by sea-anglers and commercial fishermen around Shetland and can be more accurate than GPS.

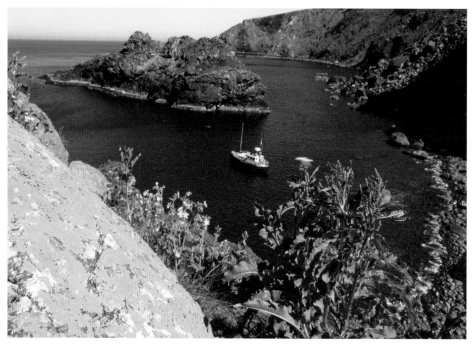

Consort anchored at a favourite dive site on the north coast of Fetlar.
(Bobby Tulloch.)

the right place, how he never damaged the boat or scraped the hull, no matter how difficult the approach. We sailed through the darkest nights and the thickest fogs, and always got safely home to Mid Yell. Bobby always knew exactly where he was.

The northern Shetland isles don't really lend themselves to roads. The best places are off the beaten track and can often only be approached by sea. The cliffs can only be seen from a boat, and the activities of the seabirds understood from the water. We could not have seen so much wildlife, we could never have understood the importance of the islands, without Bobby and his boat.

Bobby hit the headlines in 1967 when he discovered a pair of snowy owls on Fetlar. We wanted to film them, but he had to devise a strategy that would enable us to get close without disturbing either the owls, or the prey on which the precious clutch depended. It took two years. During the intervening winter, Bobby went to check on 'his' snowy owl – he identified with the resident male – only to find the bird poorly and unable to fly.

'What did you do?' I asked.

He confessed he'd taken the owl home to Mid Yell, perched it on top of the wardrobe, and fed it gobbets of rabbit. It perked up under Bobby's care, and a few days later, he took it back to Fetlar and released it back into the wild. Thanks to Bobby, we filmed the old male the following year, and he had another six seasons of breeding success. Although snowy owls are often seen on Shetland in winter, we are still waiting for snowy owls to return to Fetlar to breed.

Seals were being hunted in 1970. Horrid little knick-knacks made of sealskin were offered for sale in Lerwick's tourist shops and sealskin boots were all the rage. People loved seals for all the wrong reasons. At that time Shetlanders were cash poor – the oil had yet to make a difference – and seal-hunting offered crofters and fishermen the opportunity to buy a fridge, or some other luxury that people down south took for granted.

The seals were rightly nervous. The only way of getting close to them was to visit the remote colonies, and even there the seals disappeared into the sea before Bobby's boat got anywhere near the rocks. We tried and failed a dozen times. Bobby took

Bobby's best-known shot of a common seal. (Bobby Tulloch.)

Top: *Young grey seals in the kelp forest*. (Richard Shucksmith.)
Bottom: *A common guillemot 'silvered' with air bubbles as it dives*. (Richard Shucksmith.)

some remarkable still photographs, but movie footage was hard to get. Ideally we needed to follow the seals into the water, to see their underwater world.

A scuba-diving course gave us confidence, and we spent the winter nights stitching handmade wet suits. When spring came, Bobby took us out again. 'How long can you stay underwater with a full tank of air?' he enquired. The answer was quite a long time, up to an hour, if we didn't dive deep. So it was possible for Bobby to drop us in the water on one side of an island and for us to swim round to the seal haulout on the other side, without surfacing.

With Bobby watching over us, we swam off on a compass bearing. The adult common seals kept their distance, but the yearlings zoomed around us at high speed, hugely entertained by the strange creatures that had invaded their ocean space. On one of these trips we encountered a seal sleeping on the seabed, automatically rising and falling every few minutes, without waking, to take a breath of air at the surface.

Although puffins had been filmed at the nest many times, nobody had ever filmed them close-up on the surface of the water, and nobody had gone underwater with them. Bobby suggested using decoys to make the camera less frightening and helped us to make model puffins to attach to a polystyrene raft. Swimming slowly across the surface, we got a lot closer to the puffins, who sometimes rafted alongside us in a friendly manner. The waters off the Blue Banks of Fetlar were the best place, but close under the cliffs the sea was deep, and even on calm days, big swells broke on the vertical cliffs. I recall that I often felt cold, but I never felt afraid because I left fear behind on the boat with Bobby. I trusted him completely to get us out of trouble, and he always did!

Underwater, we discovered how elegant puffins and guillemots could be, like silver torpedoes covered in air bubbles, leisurely flying through their real element, the sea. Bobby was as excited as we were by this new world, now opened up to millions of television viewers.

At the time, we thought that making films about Shetland's amazing wildlife would in some way protect it. Did that happen? In many ways wildlife films have became victims of their own success. Today viewers see wildlife on television and – despite warnings – believe that the environment is 'OK, really', that there is nothing to worry about, that the doomsters are scaremongering, because (after all) some photographer has filmed it.

Much has changed in Shetland since 1970. The snowy owl has gone, and the kittiwakes (Bobby's favourite bird) have disappeared from almost all their old sites. The

great balls of sandeels that congregated in Colgrave Sound in August are no longer seen. The food fish that the seabirds depend on to breed are disappearing. The locals say they've been fished out to make salmon food, although the official line is 'reduced in number because of changes to ocean currents'. Without a bountiful ocean, seabirds can't breed. That's why there are far fewer puffins and guillemots.

Shetland is now cash-wealthy, but there is a worrying carelessness about the environment. Oil ushered in a new standard of living in the 1980s. Today wages are high, and so are expectations. The voes are filled (some would say overfilled and contaminated) with fish farms. Shetland is still an extraordinary place, but if the seabird colonies are a barometer of the health of the Shetland environment, then trouble is in store. These seabirds live more than 30 years. Missing the odd breeding season isn't a catastrophe, but failing to replace the breeding population will lead to extinction in Shetland.

Wildlife film-makers have entertained millions, but unless Shetlanders themselves are persuaded to lead the fight for the health of their environment, then our work is no better than TV wallpaper; films suitable for a Sunday's night's viewing, or a dentist's waiting room.

Someone else will write about Bobby the musician, Bobby the artist, the photographer, the traveller. He was the most natural of naturalists. The most friendly of friends. He had the rare knack of being able to share his knowledge and love of the natural world effortlessly with others.

If we'd known, we'd have cloned him.

AN ISLANDER WISE AND OF GOODWILL
Mike McDonnell

After spending five years in the Solomon Islands, I returned to Clydeside in 1970 and soon began to feel like a medical misfit. I learned that urban GPs are expected to provide medical care for their patients – and then take special care to keep them at a professional distance: at a social level any contact with patients was to be avoided. Any attempt by the GP to bridge the gap could lead to conflict with colleagues, or create suspicion within the practice population. Since the polarised nature of town life was at odds with my views on family medicine, I wanted to look elsewhere. The prospect of living and working within a finite practice strongly appealed to me, and an advertised post in Shetland seemed like an attractive option. Albert Einstein thought he was expressing a forlorn hope when he said, 'How I wish that somewhere there existed an island for those who are wise and of goodwill', but I did not share his pessimism. I applied for the forthcoming vacancy in Shetland, and soon formed the impression that the portents were good.

The interview for the single-handed Yell and Fetlar practice was arranged by the NHS Executive Council for Shetland at their cramped headquarters above Solotti's Cafe in Lerwick (how things have changed!). While I waited in his office, drinking coffee as we watched cargo being swung onto the pier from the *St Clair*, John Johnson persuaded me to buy a recording of 'Eftir da Humin' from the pile of LPs stacked alongside his desk; an interest in the work of the Shetland Folk Society would apparently provide any new GP with an additional therapeutic tool.

A selection of local movers and shakers had assembled to conduct the proceedings, each asking a question in turn. The inquisitors formed a jovial gathering, apart from Mr Nemesis (not his real name) who sat, arms folded and unsmiling, at the end of the row. When his turn came he asked: 'If you were to take up the post of GP to Yell and Fetlar, and you were confronted with a sebaceous cyst, would you send the patient all the way to the Gilbert Bain Hospital in Lerwick, or would you tackle it yourself?' Before I could waffle my way through an answer, the late John Graham came to my rescue: 'Geordie, you ask that same damned question at every interview. Now, are

The council's roll-on, roll-off ferries revolutionised transport in Shetland's North Isles during the 1970s. (Bobby Tulloch.)

you going to tak doon your breeks and show us yon cyst, or withdraw the question?' There were no further questions, and I was offered the opportunity to take over from Dr Dawson Clubb, who was moving to a practice in his native Aberdeenshire.

The following day John Shearer drove me north to see the practice for the first time. The new Yell Sound vehicle ferry operated an hourly service, and we waited at Toft for the ferry to cross from Ulsta. A burly, bearded figure emerged from the Volkswagen caravanette in front of us and approached the car: 'Fancy a coffee? I've just brewed up.' We clambered on board the caravanette and John introduced me to the stranger, who looked like a cross between a Viking and a benign pirate: 'Meet Bobby Tulloch, the man who will take you into Fetlar on your visits.'

Later, as Dawson tried to familiarise me with the practice, I mentioned that I'd already met the Fetlar boatman. No doubt with his tongue well in cheek, Dawson informed me: 'Oh, Bobby's more than just the boatman. He's also the local barber.' So, my first impression was of Bobby Tulloch, the boatman barber. But it wasn't long before the full range of his talents began to unfold.

On an early trip to Fetlar Bobby related how he had taken to cutting hair. He had served his time as a baker and, when called up for his National Service, was put in charge of a bakery in Hong Kong, where he picked up a working knowledge of Cantonese ('mainly swear-words'). As the troops lined up to board the ship taking them back to the UK, they were asked to state their occupations, before being allocated their tasks for the return journey. Bobby realised that, if he revealed his trade, he would be condemned to work through the night in the bowels of the ship. 'So I claimed to be a barber. Spent most of the time on deck, and was a bit of a Sweeney Todd for the first few dozen haircuts, but eventually became quite good at it.'

The trips to Fetlar with Bobby were always entertaining and informative, and provided valued moments of *diastole* – a brief break from the constant on-call demands of the practice. November was probably not the best time of year to be introduced to the Fetlar service, but Bobby was always remarkably sanguine in the worst of the weather. Like his fellow Mid Yell boatman, the late Douglas Brown, he maintained that, since their boats were the main lifelines to Fetlar, the crossing should always be attempted, and he made no distinction between routine visits and

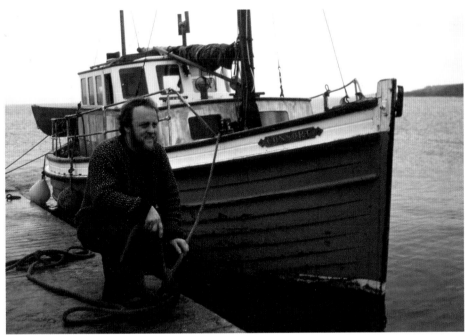

Bobby and the Consort *at Houbie Pier in Fetlar.* (Photographer unknown.)

emergency calls. Besides, he reasoned, the worst of the weather was usually from the south-east, which meant that the Fetlar landing places should be in the lee; some theory, but, if the Brough landing slip was too exposed, he would leave me to scramble up the rocks from Waar Geo with my wee black bag.

In the early seventies the Cod War was being waged and, until an armistice was declared, the Icelandic cod fishery was to have significant impact on the practice workload. The fishing fleet was based in Grimsby, and recruitment of crew members had much in common with the strategies adopted by the press-gangs. It was becoming increasingly difficult for owners of the rusty old trawlers to find suitable crews, and agents scoured the pubs in an attempt to persuade retired or unsuccessful fishermen to make one last trip.

By the time the trawlers were off Shetland, all sorts of medical problems emerged: infected untreated lacerations sustained during a weekend spree; incipient DTs; alcohol induced dyspepsia; and, since regular medication had been left at home, angina, high blood pressure, diabetes. The chronically healthy were often tempted to feign symptoms in the hope that they could be sent back south once they were issued with a medical certificate.

Knowing that half the crew would jump ship at the first available opportunity, the skippers would make sure they did not tie up at the pier. Instead, they would anchor in the middle of Mid Yell Voe and send for a doctor. Either Bobby or Douglas would then ferry me off to the trawlers to deal with the afflicted. Conditions on board were squalid, but in marked contrast there were always a few crew members still attired in their Saturday evening suits; morbidity was higher among the better dressed. The skippers would lead me to the patient, and caution me not to ask, 'Who wanted to see the doctor?' Too many hands would go up, and I wouldn't be able to cope with the rush.

After many consultations afloat Bobby eventually gave me an invoice for these charters. He very reasonably pointed out that the short boat journeys from the pier were not the problem – it was the prolonged standby time alongside the trawlers waiting to take me back ashore that was most time-consuming. The NHS regulations on this were complicated, and I phoned John Johnson for advice. I reckoned he had a penchant for cutting through red tape.

'What is the situation regarding the treatment of visiting fishermen?' I asked, 'Can I put in a claim for reimbursement?'

He wanted to know the exact circumstances.

'I reckon I've been on board half of the Grimsby fleet to treat casualties.'

'Did the patients come ashore? If not, you can't claim under the Temporary Resident provisions. And if their conditions were not actually life-threatening, you can't submit claims for Emergency Treatments,' he informed me. It looked like my efforts on behalf of distressed fishermen were going to cost me dearly.

'So, is that it?' I asked.

John sounded more upbeat: 'There is an easy solution – next time, ask for a box of fish.'

Contrasting priorities prevailed aboard Bobby's *Consort* and Douglas Brown's charge, the *Rose*. As befitted an engineer mechanic, Douglas believed in routine maintenance. He made sure that the engine started at the first attempt, but was not too concerned about the boat's overall appearance. Bobby, on the other hand, liked the *Consort* to look her photogenic best, but was a bit cavalier about keeping the engine in good order. Occasional breakdowns probably appealed to his sense of adventure, and could be added to his repertoire of boatman's tales, although his more sensitive passengers would be protected from any hair-raising stories, of which he had a few.

Before the plans for the Sullom Voe Oil Terminal were implemented the need for base line environmental surveys was acknowledged. As Jonathan Wills notes in his introduction to this volume, Bobby played a key role in monitoring the impact of oil-related development in Shetland, and he conducted routine counts of wintering birds in Yell Sound. In the middle of an early survey the *Consort* lost power, and started to drift alarmingly close to the Ramna Stacks. No other vessel was in sight and he'd not got around to repairing his radio. According to Bobby's own account, he rummaged around for two emergency flares, which were marginally out-of-date. As he inspected the first it suddenly went off, and almost set fire to the wheelhouse. Fortunately the second flare was released successfully, and was spotted by the late Johnny Leask, who was in the process of pumping out the *Osprey* at her moorings in Leady Voe, West Yell, and he went to the rescue.

When news reached Yell that a small boat flotilla from Norway had mustered at Baltasound, there was a lively debate in the pub. The fleet had set off to commemorate the Shetland Bus operations during World War II, and was due to sail for Lerwick the following day. Bobby was keen to photograph the convoy, but the likely route was uncertain. He reckoned that the visitors might sail through Colgrave Sound, and planned to rendezvous with them there.

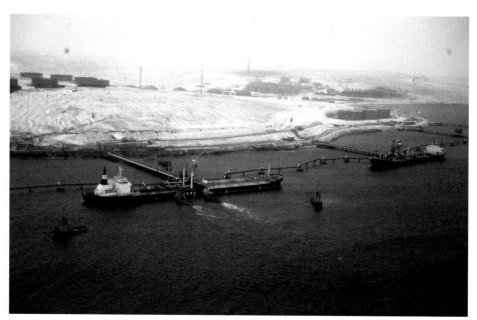

Tankers loading at Sullom Voe in the early 1980s.
(Bobby Tulloch.)

The next morning I set off in my kayak to meet up with Bobby, and spotted the *Consort*, just north of Oddsta. There was no sign of the Norwegian vessels, but the distant throb of engines indicated that that a course to the east of Fetlar had been chosen, rather than through Colgrave Sound on the west coast of the island.

The photo-opportunity appeared to have been missed, but a lively swell prevented me from boarding Bobby's boat. There was no response when I tried to hail him, and I retreated to spend the day in Hascosay. Meantime the *Consort* headed south towards Aywick, but later in the day she reappeared off Brough. I assumed that Bobby was taking time out to spend the day fishing. In the evening I caught up with him in the pub and explained that I'd failed to attract his attention earlier in the day, and asked if he'd spent the day fishing. 'Fishing, be damned,' he laughed, 'I had engine trouble. If I'd known you were there you could have gone and raised the alarm.' The *Consort* had drifted with the tide for six hours, the length of Colgrave Sound and back again without coming to grief.

Bobby didn't always take the time to be fully prepared, but was invariably resourceful. The small fibreglass dinghy from the *Consort* was in permanent need of

repair, and had a persistent puncture just below the waterline. Bobby's casual solution was to place the sole of his rubber boot over the offending leak as he ferried his charges ashore. His passengers never remarked on his unusual rowing posture; they maybe thought that the elevated left leg was the result of a hip problem which they were too polite to mention.

When the snowy owl, *Nyctea scandiaca,* decided to take up residence on Fetlar in 1967, the island became a compulsory pit stop for twitchers throughout the land, and Bobby and Douglas had to operate an all-day service during the breeding season. On arrival at Brough the ornithological enthusiasts had to tackle a challenging trek to the bird hide at Stakkaberg. Not everyone was fit enough to reach the hide, and the return trips could include a detour to the north of Fetlar, so that the less able passengers could spot the snowy owl from the boat. During one such detour, as the visitors clustered on deck, binoculars at the ready, Bobby chatted to me in the wheelhouse. He was explaining what a treacherous stretch of water we were negotiating, and how he had once to run the *Consort* ashore when she was badly holed on a nearby skerry. Just

Consort *at the ruined Dock of Urie, after negotiating the off-lying reefs (successfully, on this occasion).* (Bobby Tulloch.)

then there was a faint but perceptible crunch: we were aground. The boat remained level, the passengers oblivious, and Bobby quite unperturbed.

He launched the dinghy, placed his boot strategically over the leak, and invited the passengers ashore, two at a time, to have a closer look at *Nyctea scandiaca*. Once the requisite number had been taken ashore the *Consort* gained buoyancy and floated gently free. The passengers were then ferried back on board, quite unaware of their wee adventure.

To attract the visitors' attention and interest as they set off for Fetlar, Bobby would sometimes adopt the telescopic vision ploy. Throughout the breeding season a steady stream of puffins would commute through Colgrave Sound, between their fishing grounds and Hermaness, to feed their young; their behaviour was predictable and regular. As the *Consort* would draw away from Mid Yell pier, Bobby would gaze towards Fetlar, and announce that the *Tammie nories* (puffins) were having a busy day. All the binoculars on board would then focus on Colgrave Sound in a vain attempt to detect the puffins. Then, sure enough, two or three miles further on the puffins would come in to view as we rounded Hascosay, and the passengers would remark on Bobby's amazing vision.

Even the most inventive of guides tends to adopt a set routine after escorting hundreds of visitors who all ask the same questions, and so it was with Bobby. Although I never tired of his running commentary during my frequent visits to Fetlar, he suggested that, since I had heard it all before, I should take the wheel and point the boat in the general direction of Brough while he went on deck to entertain his passengers.

Flattered to find myself in a promoted post, I was just settling in to one of my first stints at the controls when there was a commotion on deck. A dozen excitable French tourists were gesticulating frantically, and proving themselves to be unusually fluent in English obscenities. I thought the boat was about to hit the rocks, but before I could slam the engine into reverse, Bobby reappeared in the wheelhouse, highly amused. He seemed to have no intention of taking the wheel, and I wondered how he could maintain his usual *sang-froid*. 'What's happening? What's upset the French folk?' I wanted to know. He reassured me: 'Relax – they're not panicking, just excited. They've never seen so many seals before.' I remained confused: 'But what about the bad language?' Bobby could hardly contain his mirth: 'Bet you didn't know that "phoque" is the French word for seal?' He could not resist a bit of playful mischief-making, even when it was reciprocated, and later highlighted my limited French vocabulary.

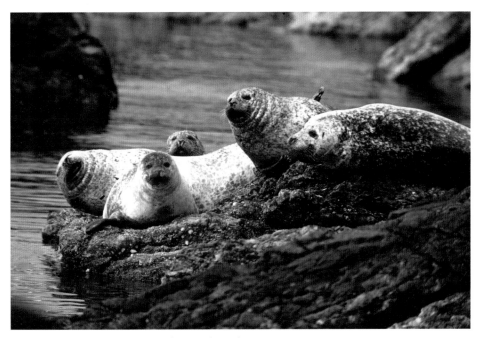

'Les phoques de Fetlar'. (Bobby Tulloch.)

By 1975, the patriarch among his snowy owl harem was beginning to falter. Behind the scenes, within the RSPB there was serious concern. The old male had been repelling his bachelor offspring, but could not fulfil his obligations: breeding females sat on two separate clutches, and he was finding it difficult to keep them both supplied with rabbits, their staple diet. He eventually collapsed and was taken to the warden's house. Bobby asked me to make a domiciliary visit. The diagnosis was exhaustion, compounded with purulent conjunctivitis, and after a few days' rest and a course of antibiotic eye drops, the old male was released but his condition continued to cause concern. Jo Grimond, the local MP, assured the House of Commons that the snowy owl was being treated under the provisions of the NHS, and every effort was being made to ensure his recovery.

The summer traffic to Fetlar increased: many twitchers hoped to see the breeding birds while there was still time, and others were making a return visit to pay their respects to the ailing patient. I had an encounter with one of the latter.

Bobby was on deck with a large group of birdwatchers and left me as his understudy to steer the boat. A fierce lady swept into the wheelhouse, well-armed with

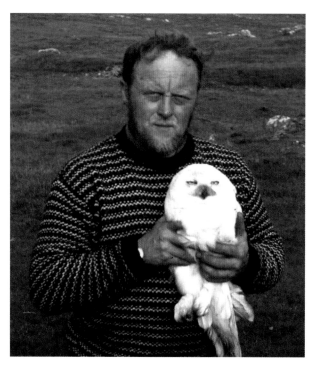

Bobby with the ailing owl, which was revived with eye drops.
(Photographer unknown.)

field glasses, camera, notebook at the ready and more than a dash of indignation, as she launched her ornithological interrogation: 'Mr Tulloch is obviously too busy – not like my last visit – so I suppose I will have to make do with you. Is this going to be a successful breeding season for the snowy owls?' An informed reply confirmed her impression that I was Bobby's assistant: 'Well, the old male is getting on a bit and is attempting to look after two females on two separate clutches of eggs, and rabbits seem to be in short supply,' I informed her.

'What exactly do you all intend to do about that?' she demanded. I decided to take a lead from my mischievous mentor: 'The breeding male was already past his best when he arrived in Fetlar eight years ago. On arrival he had marked arthritis of the right wing and he flew left wing dominant: since he could only fly in a circle, he was unable to leave the island, so he has been here ever since.' The notebook snapped shut and, just as I braced myself for the onslaught, Bobby joined us in the wheel-house to take the boat alongside the Brough slip. 'Not often there are two doctors on

board,' he remarked to our mutual consternation, 'You have introduced each other? I take the GP to Fetlar every two weeks,' he added, 'and Dr Ponsonby-Smythe visits every summer without fail. You'll know that she's a psychiatrist from London?'

We disembarked in silence, and went our separate ways. Afterwards I let Bobby know that I'd made a complete *eejit* of myself, and wondered if he had set us up. 'Now, would I ever do a thing like yon?' was his enigmatic reply. Although he was very loyal towards his summer visitors, he never objected when I claimed that the most fanatical twitchers were suffering from 'anoraksia nervosa', and I suspected that he would add the tale of doctors afloat to his fund of stories to be repeated at convivial winter gatherings.

Yell was not connected to the 'Hydro' until 1968, so in the early seventies mains electricity was still something of a novelty. Although television was beginning to have some little impact, reception was poor and limited to fuzzy black and white images, on two channels, which would disappear from the screen with the interference from every passing vehicle – a phenomenon immortalised in Bobby's comic song, *Gifford's Old Iron Horse*. Since the new car ferries stopped operating by early evening, access to any attractions on the mainland was denied, so most entertainment was home-grown. The only pub closed relatively early at that time, and the revellers would leave in search of a nightcap; any house light left on after closing time would be seen as an invitation. Rural GPs on constant call tend to keep the same hours as burglars, so our house was often the late-night venue for impromptu gatherings. Bobby relished such spontaneous occasions, which would provide him with the opportunity to try out work in progress. He would happily swap from guitar to mandolin or fiddle, until he was inevitably persuaded to explore songs of his own composition. He loved to exchange new songs or anecdotes, and had the happy knack of taking a new story away to be honed and polished, and, long after he had forgotten its source, he would gift it back to the grateful original donor at a later gathering.

He could be notoriously absent-minded and, despite the best efforts of his wife Betty, would forget that he had invited visitors to stay, or he would find himself double-booked, having arranged to give a slide show and perform at a concert at two different venues on the same evening. He would be readily forgiven as he gave of his time freely, and expected no reward for all of his fundraising efforts. When an emergency call came in from Fetlar once he put me across in the *Consort*, and forgot to collect me for the return journey. By way of apology he decided to offer me a bargain: 'Can I make you first offer on a binocular microscope?' he asked. 'It has great

magnification; a set of lenses including an oil immersion lens; any amount of slides; balsam. All in a nice wooden carrying case. Yours for £50: interested?' I wanted more information from him.

'What make is it?' I asked.

'It's a Russian make, but their optical equipment is very good quality,' he assured me.

'Very interesting, Bobby – I think you've just described the microscope I lent you four years ago!'

He was quite unabashed: 'I wondered where it came from. Thank God I offered it to you first!'

I remember well Bobby's ambivalence about his celebrity status. He liked to tell the story of his trip back home on the *St Clair* after yet another successful lecture tour promoting the RSPB.

As he sat alone having his evening meal in the Viking restaurant, an inquisitive tourist approached him. Bobby became decidedly uneasy when, in the middle of the

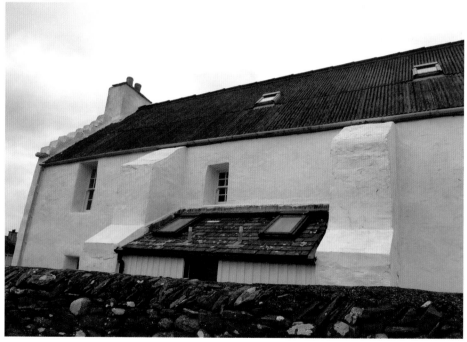

The Old Haa, Burravoe (before it was re-roofed). (Jonathan Wills.)

restaurant, the visitor boomed: 'I reckon I know who you are,' and as Bobby was about to crawl under the table, he continued: 'You're Captain Birdseye, aren't you?' And Tucker's embarrassment turned to delight.

In 1984 the Old Haa in Burravoe was restored, to be run as a museum by volunteers. The enterprise still survives but the finances have always been precarious, and when Bobby lent his support its fortunes improved. When he became a wildlife tour guide he used the building as a wet weather resource, bringing groups in for tea and sustenance. He provided sets of slides featuring local flora and fauna, and was largely responsible for the displays in the Natural History Room. When the museum set up a sound archives and recording studio he readily agreed to have two sets of commercial recordings produced by the Old Haa Trust of his songs. Many years after his passing, CDs of Bobby's recordings continue to bring in much needed revenue, and the museum has benefited even more from over 14,000 images in Bobby's photographic archive, housed in the Old Haa, some of which are printed in this volume.

There were many occasions when I had to call at Bobby and Betty Tulloch's house to arrange, or rearrange, another trip to Fetlar. At other times I would be seeking Betty's assistance. For more than ten years I worked closely with Betty, who had spent most of her career as the Yell District Nurse. She had an encyclopaedic knowledge of local families, and would readily recall family histories and illnesses, birth dates, and the occupants of every house on the island, and her freely given advice was invaluable.

At home Bobby was usually to be found in his darkroom, or in his office answering correspondence from potential visitors or academics, drafting reports or preparing another article or book for publication – although he would always claim to be more of a birdwatcher than a 'word botcher'. He also illustrated one of his first publications, a small book on the breeding birds of Shetland, and started a trend of writer/illustrators which has been continued in the impressive annual reports of the Shetland Bird Club. He would always find time to assist postgraduate students, such as Annie Say, who sought his expertise, and more than one PhD thesis depended on his unselfish support.

Bobby Tulloch made a lasting contribution to Shetland. Through his broadly based approach, including his work as a tour guide, his numerous media appearances and winter lecture tours on the UK mainland, he evangelised thousands in the cause of Shetland's natural history. Now, as the momentum grows within the Shetland tourism industry, there is more formal provision for visitors with an interest in wild-

Bobby's sister, Mary Ellen Odie, with Mike McDonnell and the kittiwake memorial to Bobby at the Old Haa, Burravoe, Yell. (Jonathan Wills.)

life, traditional music, writing, storytelling, and fishing: many now work in those specialist areas. Bobby was self-taught, but managed to embrace all of these topics and more, with unflagging enthusiasm and expertise, and, more often than not, he passed on his gifts and interests without reward. He never accumulated wealth but as he reached the end of his life he continued to organise his curiosity, and died fulfilled. Until the end this remarkable islander remained 'wise and of goodwill'. Einstein would have approved.

Field Notes on Bobby Tulloch

Annie Say

Reflecting on a Special Friend

At Durham University, studying botany, my friend Meg Philips (now Denning) and I planned our first summer expedition. Not to those far-flung places that are so attractive today but to Shetland, which seemed magical and remote and a world away, which it really was, with the *St Clair* the only option (sleeping on the floor!) for us to get there. Meg had first met Bobby on Foula with the British Girls Exploring Society. She wrote to him when we decided to go to Shetland and Bobby, being Bobby, arranged our accommodation at Basta and then took us in hand! We were greeted

Annie Say with Bobby, 1971. (Photo courtesy of Annie Say.)

with twinkling eyes and smiles as Bobby met us off the *Earl of Zetland* from Lerwick at Mid Yell pier, the beginning of a lifelong friendship. My Shetland adventure too began.

What made Bobby 'Bobby' and that dear friend? Mary Ellen, his beloved sister, and I sat and yarned quite recently about this over a cuppa in her kitchen and both ended up laughing and crying and reminiscing with love and fondness. Bobby had a strong love and affection for his family – his maamie and his sisters and their men-folk and bairns – he loved them all and was interested in them all. His relationship with Betty was more special than many people appreciated. They were not blessed with children but both shared in the wider family with absolute commitment. Betty adored Bobby too and was so proud of him, although he followed interests so different from her own. Reading an old letter from Bobby just now was full of what he was doing with his family (with a dram or two to help!) and that was how it always was: his family; his first love.

My holidays over those two first years in the early seventies were full of explorations and adventures on Bobby's boat, often with a group of happy tourists too, watching seals and birds and the magic of the islands and the sea. We were always introduced as his 'twa lasses' and proud to be; but less so, perhaps, when we saw photos of ourselves on full screen at an RSPB film show in York!

Times shared had so many magic moments – trips on the boat to the wee islands – Haaf Gruney covered in thrift and scurvy grass; coming back from a dance in Unst, watching the sea alight with 'sparks' of mareel (phosphorescence); being stranded on Hascosay when Bobby's boat hit the rocks, and sharing his pain and agony after we were 'rescued' by a rib, and involved in the trauma the next day – one of his very unhappy moments; arriving in Skerries and catching up with all his pals whom he valued so much, and collecting field mushrooms the size of dinner plates for supper; catching fish with a line on many trips and frying up on the boat – so good; Bobby cracking eggs into the pan with one hand (a trick learnt from his time as a baker); watching Manx shearwaters one night from the boat and falling in, with Bobby and Meg laughing so much as my wellies filled up; trips to Fetlar and Skerries and everywhere we found so many people he loved and who cared for him; baby grey seals on beaches – each trip a learning experience about nature, explained in the most engaging way by someone who loved and respected and valued it all.

Perhaps our biggest adventure was our trip to Foula. Bobby had always wanted to go in his boat and Meg was keen to go back. I think it was the summer of 1971.

Top: *Bobby reeling in piltocks off Fetlar, 1974.*
Bottom: *. . . and showing the students how to use a gutting knife.*
(Photographs courtesy of Annie Say.)

The west coast of Foula, 1971. (Bobby Tulloch.)

The forecast was good (well, calm at least) and Betty helped pack our provisions – I can remember an egg and bacon pie she had made for us! We set off quite late in the afternoon and as the light began to fade the sea stayed dead calm but the rain was lashing down, the fog came in and the lightning flashed. Bobby stayed pinned to the wheel, peering out and grabbing a half bottle at each flash with a cry of 'Jesuuus!' In those days he had no radar, he wasn't sure where we were and he had a big fear of the Ramna Stacks. It was deadly quiet outside; he suddenly heard an eerie cry in the fog and told us that it was a rorqual whale!

Bobby then decided we needed to head into the shore . . . we edged in and he heard the water lapping on rocks through the fog; cautiously we edged in a little further and the mist cleared to show a voe and, on the bank, a telephone box! Meg and I rowed ashore to see where we were . . . Lera Voe [in Walls on the West Mainland of Shetland. Eds] . . . the ditches were full of grass of Parnassus – unforgettable!

We moored for the night and later the next day set off for Foula. It must have been uneventful as I don't remember that journey till we got to Foula and the excitement of the arrival and everyone so pleased to see him and making us so welcome.

Chatting in Foula more recently with Jim Gear and others, we reminisced about what was then a very big trip.

We stayed a couple of days or so with a cruise in the boat right round the island and walks through the hill to the magnificent cliffs of the Sneug, watching birds. We ate lobster, given as a present, cooked on the boat and eaten out of newspaper, and had some fun parties with his old pals.

We left early in the morning. Meg and I were asleep on the floor in our sleeping bags below. We woke to a huge sea and some heave around the Ramna Stacks, and I remember being roped to go to the loo! Bobby couldn't believe it. Meg and I had actually slept through the worst of the storm – he said it was the worst sea he had been in when in the boat– Force Eight and above, I guess. Betty and all the family were relieved when we got back and we spent the evening going round to see his family with all the stories.

When we first met Bobby birds were his passion and he shared his knowledge with never-ending patience and humour, mimicking his favourites and with names

Oysterplant on a Shetland beach. (Bobby Tulloch.)

Wild irises by a Shetland burn. (Bobby Tulloch.)

for them all. He had many friendships through a shared love of birds, including Dennis Coutts. As time went by his love of flowers and other wildlife grew too.

Bobby became a true naturalist, learning and enjoying every day. He always said he had got more interested in botany in part by coming to places and sharing ideas and identifications with us, when Judith Roper-Lindsay (then Hilliam) and I were doing our PhD studies, but he also had great respect for Walter Scott[36] and Laughton Johnston and others (as well as all the birders from south – including Roy Dennis).

He loved the sea, being at one with the boat and with the seals and birds. The local seals knew his boat so well. An understanding of otters I think came later but how he loved them! I once asked Bobby why we hadn't watched otters on our early trips and he said he really didn't know whether he had got his eye in or there were more now or what. He couldn't think why he hadn't seen their signs on his boat in those early days.

36. Shetland's premier botanist, co-author of Scott, W. and Palmer, R., *The Flowering Plants and Ferns of the Shetland Islands,* Lerwick, The Shetland Times Ltd, 1987.

His trips with the National Trust and to Norway he loved. His photographs were always superb. I remember some lovely pictures of alpine plants and the VW camper van midge-covered beyond the Arctic Circle! He always said how much he loved the Falklands and told me that was the place nearest to Shetland he could imagine living in.

To us as young students Bobby was an inspiration, making exploration of wildlife what it should be – an adventure, always changing, always something new and always something to learn about how ecology works. He had the highest respect for all he saw and even after travelling the world never lost the wonder of his native Shetland. Bobby was always interested, but we always teased him that he didn't ask us questions! 'Go on, ask us something!' He rarely did, but our conversations were always real and worthwhile.

Family, friends, Shetland, wildlife, travel but also the love of music is how I think of Bobby – playing the accordion, the fiddle or whatever and a song and a tune with Mary Ellen. He was a very good MC and a great raconteur at dances and shows, and a great dancer too. He helped a lot of people have a lot of fun.

Bog cotton on a Shetland hillside. (Bobby Tulloch.)

Judith Hilliam (left) and Annie Say with a grey seal pup in Fetlar, October 1972.
(Bobby Tulloch.)

So why was Bobby so special? He was warm and engaging, funny and kind, interested and interesting. He had a unique quality of treating everyone as though they were special and gave the same attention and interest to everyone, whatever their background or interests. All ages loved him and he loved them. There are not so many people you can say so many lovely things about. He was always there for you.

The end wasn't so good. I always wished he had passed away walking in one of the places he loved so much. His spirit lives on in all those places which meant so much to him. We were friends to the end. My last phone call with him was heartbreaking, but special, as he always was.

He is missed but his catch-phrase lives on in our home: 'Weel, weel, I hear dee bairns . . .'

A Starling in the Custard

Wendy Dickson

I first met Bobby way back in 1965 on Fair Isle. I had unexpectedly got the job of cook at the Observatory, when I'd actually planned to emigrate to Canada instead – something I did the following year. However, with Shetland firmly in my system by then, I returned from across the pond after just over a year, and hastily made plans to visit Fair Isle again, making, en route, the customary visit to Dennis Coutts' shop in Lerwick. Who should come in but Bobby, and so grew the seeds of a friendship which lasted for over thirty years. From that time there are many lively memories, of which there is only room to mention but a few.

A year or two after that meeting, Bobby and I were both delegates at a Scottish Ornithologists' Club Conference along with his friends, Pam and Tony Collett. Over a few drams, plans were hatched for a camping trip to Lapland. Bobby had the transport in the form of a VW Campervan, and a contact (of course!) who would take him to Bergen on a boat. Pam and Tony were going independently and I was making my way from Bristol, armed with enough food for us for about ten days, courtesy of a cash-and-carry card I had somehow managed to procure. The other three came to meet me in the customs shed in Bergen, but were not allowed through to relieve me of my burden – bacon, ten pounds of cheese, pots and pans and much more, all much to the amusement of the Norwegian officials – I suspect they kept me waiting on purpose!

Eventually relief was at hand, and so started a splendid trip to north Norway, only blighted by the fact that I was recovering from glandular fever so had to be prodded from my slumbers periodically to make sure I didn't miss anything. That included the 'interesting' lunch spot that Bobby chose beside a Lapp tented summer settlement. It soon emerged that the bridge we were parked by doubled up as the local public loos! So, lunch put on hold, we moved on . . . But, despite the distances we had to drive and the mozzies taking a heavy toll on both Bobby and Pam, it was a splendid trip which Bobby enjoyed tremendously, affording us all plenty of new birds and for him in particular, some good contacts. Coming face to face with a great grey owl in the

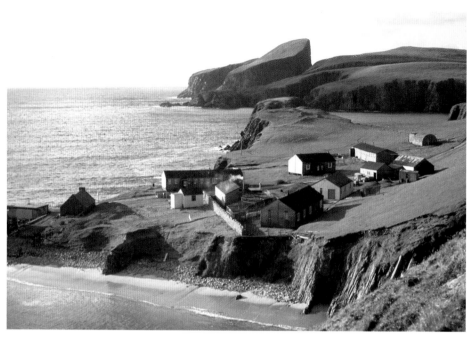

The old Fair Isle Bird Observatory buildings in the 1960s. (Bobby Tulloch.)

forest was certainly a memorable moment. But, needless to say, when we returned to Bergen, the boat promised to transport Bobby and his vehicle back to Shetland was nowhere to be seen!

Some time later, when I was working at the BBC Natural History Unit in Bristol, Bobby was down dubbing the commentary onto Hugh Miles' *Track of the Wild Otter* film for 'Wildlife on One', produced by the late Dilys Breese. Now, out in the field, when he could see, or was at least in the habitat of, his subject, Bobby was an excellent communicator. But it was an entirely different matter spending a whole day in a dark studio, having to fit his speech to the pictures – that was not his *forté*. As he was staying with me, it was arranged that someone would phone when he was ready to be collected. Well, the evening wore on and still no word . . . I could sense it wasn't all going very smoothly. Late into the evening the phone finally rang and I set off. He didn't look very happy when he got in the car and there were several mutterings on the way home.

Next day was Saturday so, by way of some light relief, we set off up the motorway for the Wildfowl Trust headquarters at Slimbridge in Gloucestershire, a place

Bobby had said he would like to visit while in the area. We paid our dues and for a while Bobby seemed enthralled at the variety of ducks, geese and swans from all over the world, in close proximity. But then disaster struck! We encountered a red-breasted merganser taking food from the hand of a visitor. To see one of his wild, free, rakish *herald deuks* indulging in such urban behaviour was too much by far for him; he completely lost interest and we had to leave without further ado.

We subsequently fared better at the Red Kite Viewpoint at Gigrin Farm at Tregaron in mid-Wales. Although the birds are fed here too, they all come in of their own volition, so it was a totally different scenario with the kites as well as common buzzards and ravens having to work hard for their rewards as they flew in, affording us some memorable views of spectacular manoeuvres and aerial skirmishes. So at least a few Brownie points scored there!

On another occasion, by which time I was living in Northumberland, Bobby stopped off as he passed through – a real treat for my mum, whose hero he definitely was. It was summertime and he wanted to visit the Farne Islands, about which he'd

Birding at Homningberg, north Norway, with Bobby's VW camper van and tent, 1973. (Wendy Dickson.)

The upland goose – a vegetarian on the menu. (Jonathan Wills.)

heard a lot. I was a bit nervous as to whether he would enjoy it, as it was a very different scenario to back home. We set off from Seahouses in one of the 'Glad Tidings' boats owned and, as it happened that day, skippered by another well-kent personality, Billy Shiel; each was delighted to make the other's acquaintance. Soon the birds started appearing all around as we made our way out to Inner Farne, the nearest of the group. Here there is a boardwalk going right through the nesting seabirds which are well programmed to visitors appearing for a few hours each day – incubating eiders just beside the path, terns of three species, and soon puffins.

But there is one word of advice to visitors to this island: it's a good idea to wear a hat as the Arctic and common terns, in particular, will notoriously land on your head in their efforts to defend their nests. I'd offered Bobby a light blue knitted bobble-type hat (fortunately without the bobble!) to put on, which at first had been refused, but was soon requested. Well, no-one would ever describe Bobby as 'big-headed', but for purposes of millinery, he did have quite a large circumference

round his head, and the hat gently slipped up so that it sat like a bit of a peak on top of it. Probably just as well mirrors are not a feature on the islands, but it did do the trick, to the slight amusement of a few visitors who may well have recognised him. But to one tern this was irresistible. It landed on the hat, but as it took off, its claws were still embedded in the knitwear, whereupon the hat began lifting off too! Fortunately it was soon dropped and retrieved. He got some nice photographs of kittiwakes and some of the other birds while on the Farnes, but I'm not sure he would have wanted a second visit.

Bobby was a fund of good stories, but it was also the way he told them, to extract maximum mirth from the punch-line, that meant it didn't matter how often you heard them. Stories about when he used to visit Lady Nicolson at Brough Lodge in Fetlar to play, I think it was draughts . . . using packets of smarties when they mislaid the pieces. About the rather timid gentleman on one of his trips to the Falklands who, upon learning that the farewell dinner would consist of Upland Goose, thought Bobby had forgotten that he was a vegetarian. Choosing a suitable moment, he reminded Bobby of this, whereupon, quick as a flash, Bobby said he could assure the client that this goose had been entirely vegetarian all its life! He was tickled pink when his old school in East Yell was turned into a pub. And who else but Bobby could have had one of the first starlings he ringed, drown in a discarded bowl of school custard?

No narrative about Bobby would be complete without mention of Betty – the anchor from whom he could stretch the chain to go off and pursue his many interests – photographing the local wildlife, trips to the Falklands and other far-flung places, always feeding him with stories to recount on his return. Their house at Reafirth, and subsequently at Lussetter, was an open door for the great, the good and the rest of us, but Betty, the district nurse, was always on hand to provide nurture for weary travellers, listen to their stories, act as purveyor of messages and even spot bearded seals on her rounds. One night when I was staying, Bobby was out at the pub with a friend while Betty and I had a good evening yarning and taking a dram. As I moved my foot under my chair during the evening there was a little squeak as I encountered something soft and moving. When I looked down, there was the cat having kittens under the table, and by the time Bobby returned, there were at least three more felines in the household. But I seem to remember that we tried to persuade him it had been rather too good a night down at the local and he was definitely seeing things!

I remember once attending a conference where Bobby was one of the speakers. Several earnest folk had given their presentations about the latest research they had done, liberally sprinkled with pictures of lists in very small print, pie-charts, graphs and so on – all very worthy stuff, but with barely a picture of a bird. When Bobby was introduced, he stood up and promptly announced: 'I wouldn't recognise a histogram if it bit me on the leg,' which lightened the atmosphere a lot. He had that unique ability to adapt to any situation. Whether as a conference speaker, holding an audience enthralled at the Royal Festival Hall, or taking folk across to Fetlar in his boat, Bobby was just Bobby. The outfit might change for the occasion but fortunately the character never did. Thank you, Bobby, for that.

The RSPB's Star Turn and the Leith Piano

Frank Hamilton

After the snowy owl had bred on Fetlar, the RSPB established a reserve over quite an area there and rented a house for the warden. After a couple of years one of the wardens contacted me and said the lintel over one of the front windows was splitting and needed replacing. I phoned Bobby and he said, fine, he'd see to it. Several weeks later the warden told me the lintel was getting worse and was now letting in rain. Again

The beach below the old house at Housa Wick, Hascosay, where Bobby did much of his beachcombing. (Jonathan Wills.)

Bobby said: 'OK, in hand.' Still later the warden phoned to say things were getting desperate. This time I was less gentle with Bobby and asked him what the problem was. Back came the answer: 'The wind's been wrong.' What the hell had the wind got to do with buying a decent piece of wood? 'Oh,' said Bobby, 'I'm waiting for a piece to be washed up, rather than go into Lerwick and buy the wood!' The timber was in place within a few days!

When staying with Bobby at Lussetter House, I went into his little room where he dealt with all his photographs. The floor was littered with slides, as Bobby was thinning them out. I asked him if I could take them. 'Sure!' was the answer. We used those 'reject' slides in the Edinburgh office for lecturing for years, as they were so good!

Bobby told me that for years he took hundreds of slides of twites perching on multiple telephone wires. The reason was to see if he could get one with the birds showing notes that were a chord or start of a tune he could use. He never achieved it as far as I know.

Bobby introduced the Shetland film *Isles of the Simmer Dim* to a packed Usher Hall in Edinburgh (*c.*2,000 people). I introduced Bobby, and he came on and stood for a few seconds in silence looking around. Then he said slowly: 'I think there are more people here than the whole of Shetland.' He brought the house down.

Bobby was staying with us and he suddenly announced that he'd seen an advert in the local paper for an upright piano and he thought he'd go and see it. He told me later that when he went to the tenement in Leith it was four floors up. He bought it.

I said: 'How are you going to get it down and up to Shetland?' – perfectly reasonable questions. 'Oh, I'll manage,' he said. He disappeared the next morning and in the evening returned to say everything was fixed up. How did he do it? He went into the nearest pub to the flat and got chatting to the blokes there, who offered to carry it down. Then someone said he had a van that could take it wherever Bobby wanted. It wasn't long before someone in the pub said he knew a friend that dealt with containers going to Orkney and Shetland and soon the piano was brought down from the flat, loaded into the van and taken to the docks and transported to Shetland. Only Bobby could have achieved that in one day!

A Knack of Befriending

Pete Kinnear (prompted by Martin Heubeck)

Any well-known naturalist, zoologist or botanist going to Shetland would seek Bobby out because of his wide knowledge and breadth of interests. He could not only hold his own with the experts but he also provided all the entertainment. His habit of sharing what he knew made any day in the field with him a treat and full of fun.

I first went to Shetland in 1968 just so I could see breeding snowy owls. Bobby took me to Fetlar in August that year and left me there to enjoy it. It must have been the end of the season because we took down the Stakkaberg hide.

I think Bobby had a knack of befriending everyone he met and if you were interested in what he was the quicker that friendship formed, better still if you were a naturalist. Probably even better still if you were female and attractive, but I have no personal experience of this!

He was incredibly generous with his time, given the demands on him, and rarely did what we did get in the way of what he was supposed to be doing, whatever that might have been. I never really knew what Bobby did to earn his RSPB money (he wasn't paid very much) but his public relations value to the RSPB was huge, although they didn't value him in any tangible way. Bobby hated confrontation so I don't think he could have been effective in any 'conservation battles', but if you wanted to raise public awareness by conversation, showing slides, telling anecdotes and generally charming people, then Bobby was 'The Man'.

He was exceptionally well-informed. Most of the experts who came to Shetland sent him stuff and copies of scientific papers. I have never seen his archive but if it contains even half the correspondence he received (not counting the fan mail), it would make a fascinating read.

Bobby was involved in the baseline studies for Sullom Voe but I found he was never very keen on monitoring work unless it involved messing around in boats. Bobby nearly always saw at least one otter when we were out boating. I invariably saw a splash, a tail or nothing at all. But then he always knew exactly where to look. He had a story of otters crossing the Mid Yell Pier when he went down to his boat.

In 2000 I was in the phone box at the pier and watched an otter amble across the pier in broad daylight, just as Bobby had described. The spirit of B.T.!

Bobby had a story of a tystie (black guillemot) nesting on a boat (was it his or someone else's?). The bird would slip off the eggs when the boat went out and resume incubating when it returned to the pier. On another occasion he spent ages moving a photographic hide to a tystie nesting site – only to find that in its final location the tystie had laid her eggs inside the hide, so he could neither move it nor photograph the bird!

One of his favourite places was the north coast of Fetlar, to sail around the Clett Stack for puffins or attempt a landing on a grey seal pupping site (where there was usually too much swell) – and always with a quick stop to catch pollack. He was forever deviating from the planned course to look at sandeels spawning in tight 'bait balls', or at minke whales or whatever.

Bobby's hide in Hascosay – occupied one day in 1979 by five-year-old Magnus Wills, with the Consort *at anchor off the beach.* (Jonathan Wills.)

To snap otters sprainting is a technical challenge, even with modern lenses and digital cameras on motor drive, but Bobby managed it with a manual SLR camera on 35mm film. (Bobby Tulloch.)

In the first year when I attempted to census dunters (eider duck) he was incredulous that I should want to count them accurately. At first I could not get him to take the boat up Bluemull Sound to Linga and had to guess that there were 'a lot' of eiders there. It turned out to be the main wintering site for eiders in the whole of Shetland at that time . . .

When Mike Richardson came on board, Bobby's skill at boat-handling came to the fore and we were able to count individual birds from both sides of the boat, Bobby steering with his feet, picking off any birds flying overhead or anything we had missed, usually while making welcome cups of tea to ward off mild hypothermia. And when proceeding up Yell Sound, you could guarantee Bobby would say, at some point, 'Bigga but not better!'[37]

37. Bigga is a now-uninhabited island in Yell Sound. The place-name means 'the island with a house on it'.

Salt piltocks and seaboot socks drying on the line at Lussetter.
(Bobby Tulloch.)

He was never happier than when jumping out on islands or putting someone ashore on an island, be it Fetlar, Hascosay, one of the Yell Sound islands or the Ramna Stacks – usually looking for birds, otters or seals. I don't think we ever went aground and I picked up a lot of small boat-handling skills from him.

Apart from stops to look at birds, plants, fungi, etc., almost every road trip I made with Bobby was at breakneck speed, usually to catch a boat! When meeting an oncoming car on a narrow road with no passing place nearby, he told me the secret was for both drivers to glance sideways to check for a drop or a ditch and, if you didn't see one, you could run your nearside wheels off the road and both cars could usually pass without injury – or slowing down. This seemed a bit hair-raising at the time, but it worked.

Bobby once had an old Volkswagen. I recall a rapid dash down to the Ulsta ferry terminal. He told me not to open the passenger door and the back door at the same time because the last time a passenger had tried this both doors fell off, as the hinges

Top: *Bobby with his Volkswagen camper and a rescued gyr falcon at Tingwall, Shetland, in March 1973. The exhausted bird had landed on a ship off Faroe and was sent to Edinburgh Zoo before the RSPB asked Bobby to release it in Shetland so it could resume its migration.* (Dennis Coutts.)

Bottom: *Eiders in Hascosay Sound – spot the king!* (Jonathan Wills.)

were completely rusted away. This was in the good old days before roll-on, roll-off ferries, when old cars that failed their MoT test were sent to end their days in Yell and Unst.

While he and Betty were still living in Rose Cottage he had some system rigged up so that he could tell the wind direction and wind strength without getting out of bed. I think it involved a wind vane, a flag, a hole bored in the roof and two mirrors!

Few people did more to encourage youngsters and give them opportunities. There are lots of RSPB wardens and professional nature conservation staff who owe Bobby for the start he gave them. I don't think he ever talked down to anyone. He was always everyone's best friend and he simply loved sharing his knowledge. If I had never met Bobby Tulloch I would probably never have had the confidence to work in nature conservation professionally. He was a great and enthusiastic teacher.

THE HON MAN AND THE SNOWY OWL

Laughton Johnston

When I became the Nature Conservancy's representative in 1969 I had been living in Shetland for only one year, although I had visited the islands since childhood. I had always been interested in natural history but my knowledge of Shetland's wildlife was somewhat patchy. I read the little literature there was and got out into the field at every opportunity, but I was conscious that I had a lot of ground to cover.

I did not know Bobby then but I knew he was the RSPB representative and so I tentatively approached him, in the expectation of a polite rebuff. I have to admit that having my, relatively fresh, degree in zoology and being a crisply new young Government Officer, somewhere in my head was an air of superiority. Bobby, if he saw that, chose to ignore it. His knowledge and interest in Shetland's wildlife was not, as I had imagined, confined to birds. He was fascinated and passionate about everything, from fungi to fritillaries, char to chaffinches and spiders to sparrowhawks, and he put me to shame.

It was not that he was overt in displaying his wide knowledge, it just permeated everything he said about it and everything he showed me; for he did show me. In his open and generous manner, from Sumburgh to Hermaness and from Ronas Hill to Fetlar, he led me by the hand and helm through Shetland's natural history. This was 'work' for both of us but it was also vastly entertaining, at least for me.

About that time he told me an anecdote that illustrates his openness. The *Sunday Post* had a column headed 'The Hon Man', whose weekly exploits were apparently daring and selfless. His epithet may have been short for honourable but proved not to be short for honest. Bobby had received a phone call from 'The Hon Man' who – no doubt sitting with his feet on his desk in Dundee – asked him for information on the snowy owl, then breeding on Fetlar. Bobby answered all his questions, even many about the geography of Fetlar, and the call went on for some time. When Bobby put the phone down he felt good that a journalist had shown such a genuine interest in the snowy owl and its haunts. However, in the paper the following Sunday, Bobby read 'The Hon Man's' opening lines: 'As I climbed the craggy cliffs of Fetlar . . .'

'As I climbed the craggy cliffs of Fetlar...' (Bobby Tulloch.)

Maybe Bobby was a little naïve on that occasion, but he had endless patience with the amateur ornithologist whom he believed had a genuine interest. As the RSPB man he was regularly obliged to take people out for the day. Another anecdote he told me was about such a visitor, apparently short-sighted, who desperately wanted to see a shag. They set off, with Bobby pointing out each Shetland bird as they came upon it. The visitor saw an oystercatcher: 'Is that a shag?'

'Ah, no, that's a *shalder.*'

A little later: 'Is that a shag?'

'Ah, no, that's a *tystie* [black guillemot].'

And so it went on through the day: 'Is that a shag?'

'No, that's a *maalie* [fulmar].'

Eventually, time was running out and Bobby had to deliver the visitor back to the ferry. They approached Ulsta and there, sticking its head out of the water was a *selkie* (common seal).

'Is that a shag?'

'Yes, *that's* a shag!' And the visitor went home happy.

Aithbank, Fetlar, in the 1960s: Bobby's friend, the great storyteller and folklorist Jamesie Laurenson, pauses for a yarn while cutting hay with a scythe.
(Bobby Tulloch.)

Cormorants (not to be confused with shags…) (Bobby Tulloch.)

Bobby had many talents, among them hat-making. He fashioned a peaked cap for himself, of the semi-nautical design favoured by many Shetlanders, but of corduroy, not the usual sombre and stiff black article. I coveted it and maybe unconsciously thought that with such a hat I might absorb just a little of his talents. Having a green corduroy jacket, not yet past its best but which I was willing to sacrifice for a hat, I asked him if he would make one for me. No problem. I handed over the jacket. I did not see him for several months that winter and waited patiently, but when we next met he was wearing my jacket! He'd obviously forgotten all about it. I didn't get my hat, didn't deserve it anyway.

Bobby opened my eyes to Shetland's wildlife, not just as a natural history phenomenon but as something I was part of, something to enjoy and to treasure.

Borrowing Bobby's Camera – for Six Weeks!

Charlie Hamilton-James

I first met Bobby back in the late eighties. I was 16 years old and I'd come to Shetland to look for otters. I'd read Hugh Miles' book, *The Track of the Wild Otter*, which had mentioned Bobby throughout, and I decided that speaking to him was the first thing I should do on arrival. Being only 16, my mother thought she'd best accompany me from Bristol to Shetland and stay with me for a couple of weeks, to make sure I was OK. She rented us a small cottage in Gutcher, as we'd decided Yell was the best place to start. Within a few minutes of arriving I went down to the phone box by the Post Office and called Bobby.

I'd never spoken to him before but explained what I was doing and asked if he could give me any advice. 'You'd better come over,' he said. 'When would be best?' I asked. 'Tonight at seven?' he replied. Of course to me Bobby was celebrity, so I immediately said yes. From the look of the map, Gutcher to Mid Yell didn't look far. That evening when I set out on my push bike in the dark, I discovered that actually it was quite far. It was very windy and dark and I didn't have any lights on my bike. By the time I reached the south side of Basta Voe I felt more isolated than I had ever felt before. I grew up in the middle of Bristol. It was also darker than I'd ever experienced before. By rights, it was extremely dangerous for me to be cycling on the roads at that time of night without any lights but, of course, it being Yell in the late eighties, I didn't have many cars to contend with.

I arrived at Bobby's slightly flustered and shocked by my first Shetland evening. He invited me in, made me coffee and talked to me with great enthusiasm and interest. He told me stories of otters and showed me amazing pictures he'd taken.

I remember one particular shot he had of a hooded crow, brilliantly framed, wings outstretched flying straight to camera. It was old and ragged and black and white, but a great shot and a real testament to his skill.

He showed me his cameras and his lenses and went through which he liked and which he didn't. He dragged old ones out of boxes to play with and we talked hides

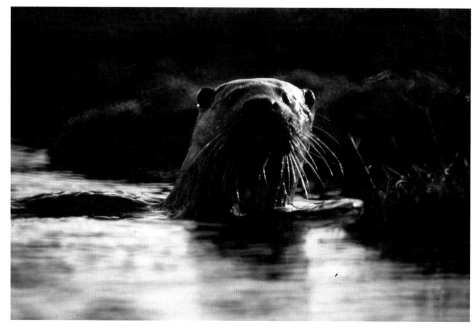

A wary otter scents an intruder. (Bobby Tulloch.)

and tripods. After a while he asked me what camera and lenses I had. I explained that I didn't have much, I was just a kid with a washing-up job back home and I'd saved all my money to pay for the trip to Shetland. I did have a camera but the lens wasn't great. Bobby told me I'd need a lens a lot more powerful than the one I had. 'You can borrow mine,' he said. I was amazed at the sudden generosity. 'I'd love to, Bobby, but it won't fit on my camera,' I explained. 'Well, then you can borrow my camera too.' I was gobsmacked.

I left Bobby's later on that evening with a bag full of cameras and lenses. He'd never met me before; he didn't really know me or have any idea whether I'd bring the stuff back. But his great generosity and trust meant that for the six weeks I was in Shetland I had his camera and his lenses. I went on to spend those weeks tracking the otters and taking some truly awful photographs of them. But thanks to Bobby's lens they were at least all very close-up!

I returned to Shetland every year after that and always stopped in to see Bobby or go out on his boat. He was always kind and generous to me and, like all the people of Yell, made me feel nothing but welcome.

The Royal Wedding Walrus

Mike Richardson

On 29 July, 1981, the rest of the world – or at least many hundreds of millions of them – were glued to their TV screens, enthralled at pageantry in St Paul's Cathedral. We (Martin Heubeck, Bobby Tulloch and myself), on the other hand, were perched high up in one of the garret bedrooms of Lussetter House, peering down upon the waters of Mid Yell Voe below.

'That's a far, far better sight than any royal wedding,' was Bobby's comment.

Slowly, and for all its chubbiness, gracefully, a young visitor from the high Arctic, with tusks barely longer than a thumb, was swimming just off the pier, twisting and rolling amongst the mooring buoys and ropes and diving around and under the M.V. *Consort* with an almost nonchalant abandon. Precisely why and how this immature walrus had strayed so far south, perhaps from the frigid waters of Svalbard or Jan Mayen, was anyone's guess. But Arctic seals, just like their feathered counterparts, can end up well away from where they should be.

Such vagrants from the high north are all part of Shetland's varied wildlife and Bobby, perhaps more than anyone else in Britain, had clocked up more than his fair share in sighting them. Mirroring the appearance of Ross's and ivory gulls, the *snaa-fools* (snow buntings) and harlequin duck, had been harp, ringed, hooded and bearded seals, along with, in this instance, walrus. Most frequent, though, were the bearded seals; instantly striking, even from a considerable distance across a voe. These chunky,

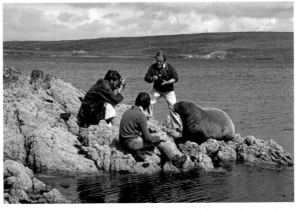

The walrus, when first sighted at Gutcher, Yell, in July 1981. (Chris Gomersall.)

angular animals with their pale uniform colour seemed in Shetland to have a curious, if perverse, attraction to small concrete slipways – curious because, I suspect, such slips are not exactly commonplace in the high Arctic. It was on one of these slips, at Cullivoe in north Yell, that Bobby had captured an evocative photographic portrait of a fully moustachioed male beardie. The individual whiskers of its beard had curled into tight spiralling coils, giving it the appearance of some benevolent, if corpulent, cavalier.

A pure white adult ivory gull on a killer whale provided another iconic photograph from Bobby's lens. The scavenging gull, again a visitor far from its Arctic home, was in its element. Here, aptly at the head of Whale Firth, was a whole 32 feet of dead, mildly decomposing bull killer whale, or orca, to feast on. But unusually, other than being in photographic mode, Bobby was that day acting as my less than enthusiastic dental assistant. I'd already broken the blades of two stout knives, trying to extract some teeth from this pretty awesome, if aromatic, corpse. Each tooth, solidly set 3-4 inches into the jawbone, was clearly not going to yield without a fight. A new, more brutal technique was clearly called for.

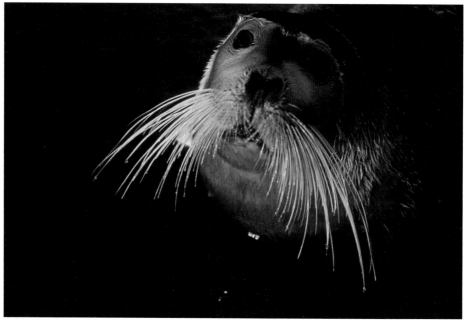

A bearded seal at Camb, Mid Yell. (Bobby Tulloch.)

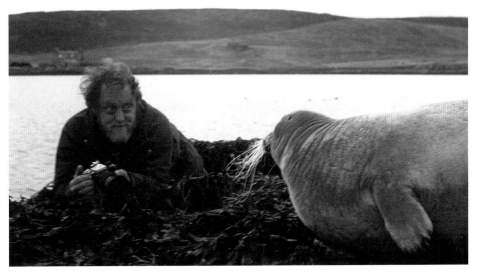

The original caption to this picture read: 'Bobby Tulloch (left) and the bearded seal . . .'
(Andy Gear.)

'Why not try a hammer and chisel?' Bobby suggested, as he also volunteered with alacrity to pop home for some suitable tools. I then understood why Bobby, on his return, judiciously stood well back as I took my first swing. For every hammer blow on the cold chisel or hatchet head sent a spray of fine, rotten killer whale mush everywhere. Peering out from well-splattered glasses, I judged that we would sadly have to fore-go that well earned pint in the Mid Yell pub. Even in the pitch dark of a power-cut our presence (well, at least mine) would have been detected well before we made it anywhere near to the bar. But, as reward, at least we had the teeth. One was duly despatched south to be sliced up into thin layers to determine the age of the animal from its dental rings – rather as one would do with a tree. Some of the other teeth from that Whale Firth orca are still with me today, joining the varied collection of zoological 'stuff', from Tasmanian wallaby skulls to South Georgia reindeer antlers, that adorns our house. I call them valuable and interesting artefacts; my wife Sandy uses less enthusiastic language.

Lussetter House, perched up there on the hill, was an odd architectural hybrid;

Top: Consort *in Basta Voe with a pod of pilot whales, Bobby with SLR camera at the stemhead and Christine Guy at the rail.* (Mike Richardson.)

Bottom: *That leaking dinghy again – among a pod of pilot whales off Unst.* (Bobby Tulloch.)

the well-proportioned, though rather bleakly grey, former manse, at contrast with the surrounding harled and crenellated concrete block walls. They were a sort of bygone Norman aspiration of a quirky previous resident [Frank Renwick, Baron Ravenstone, Eds]. It was here in Lussetter, in the much lived-in kitchen, with its Rayburn stove and faithful barograph, that each winter boat trip started. Over a coffee, rapidly conjured up by Betty, our discussions invariably centred on wildlife, or weather, or both. The state of the latter was crucial for counting sea duck and seabirds, when the foreshortened days of winter were compressed into those few hours that adequate light and calm seas allowed. Trying to find, never mind count accurately, *tysties* (black guillemots) or *calloos* (long-tailed duck) in any sort of grey chop was a non-starter.

Even then, trundling around the set course of Hascosay Sound, up to Belmont and Bluemull and then away south east towards Urie Lingey, off Fetlar, it was never warm even on the calmest and sunniest January days: a few hours standing on *Consort's* deck, Martin on one side of the wheelhouse, myself on the other, or sheltering on the minute poop deck if the weather kicked up, was a hypothermic experience; eyes watering-up behind the binoculars, feet stamping the deck. It was often a blessed relief to pass Da Rett on the south point of Hascosay, heading back into Mid Yell Voe and yet more coffee in the kitchen – this time well laced with something stronger. Regular boat counts through the winter months around the Yell, Unst and Fetlar 'Bluemull Triangle' were all part of the much wider monitoring programme for the Sullom Voe Terminal, and interspersed with similar monitoring counts in parts of Yell Sound and Sullom Voe itself.

Sometimes, arriving on the early morning ferry at Ulsta, *Consort* might already be moored, exhaust burbling, at the end of the jetty just opposite the Ulsta Stores. More coffee would be on the boat's stove. On other occasions, depending on what tide and wind conditions Bobby had had to contend with coming down the east side of Yell, he would be delayed. Well before the advent of mobile phones, we would just have to wait, probably unwisely devouring our intended lunch in the process. There would be the merest glimpse of a white speck, *Consort's* wheelhouse, as she turned the corner of the Holm of Copister, heading north up Yell Sound towards Ulsta. Then would follow another eye-watering, chilly day out on the water. The course would take us down to the rather stygian head of Sullom Voe, where birds of any description were few and far between, then up the west side of the voe to where, at least in the days before the catastrophic *Esso Bernicia* oil spill in 1978/79, it was always a delight to pick up, just off Sullom village, a sprinkling of velvet scoter and the more diminutive

Consort in a tight corner at the Horse of Burravoe, Yell. (Bobby Tulloch.)

Slavonian grebes – grey and drabber than in their summer finery. By early afternoon, with the wintry light already fading, we would be off Lunna, by way of Samphrey, Linga and Fish Holm to count the extensive wintering flocks of *calloos* feeding on the shallow *baa* between Lunna Ness and the Rumble. Difficult to see in the declining light and wintry sea and always flighty, long-tails would invariably take off, only to plonk down again with splashes a few hundred yards further on, an irritating behaviour that they could repeat time and again. Though never easy to count with any precision, all the time their evocative calls could be heard even above the noise of the diesel engine.

Bobby always appeared most in his element on *Consort*. He was totally at ease with the boat, and intimately knowledgeable of the local waters – their hidden rocks, shoals and tides designed, it seemed, to catch the unwary. Yet so often Bobby would brew up yet another pot of coffee or tea with an almost casual attitude towards the boat's handling. It was as if she was quite able to look after herself, for a few minutes at least.

Bobby did, though, have this maddening, if disarming habit, of suddenly popping up through the wheelhouse hatch, like some bearded submarine skipper, to casually

ask: 'Have you seen that great northern diver over there, close into the shore?' or 'That otter feeding up in the tang, there, just to the right of the waiting black-back'.

And, of course, so often we hadn't. Bobby's eyesight was absolutely pin-sharp, and even peering through the spray-splattered wheelhouse window he so often saw things well before us out on the deck, armed though we were with binoculars. *Consort* had, if I recall, this rather quaint retaining mechanism for the wheelhouse side windows – a hole-punched leather strap reminiscent of the sort used on the old steam railway carriage doors. But right in front of the wheel, in an open box, was always the pair of binoculars – just in case. There was never anything mischievous or smacking of oneupmanship in these casual observations from the wheelhouse. Bobby simply had an intimate grasp of the marine wildlife around him – where it should be at any stage of the season or tide. And he was invariably right.

There were other memorable trips on that little boat: up the west side of Yell, north of the Nev of Stuis (a very nasty piece of water closer inshore), even up to Muckle Flugga and its vicious tides, or out to Skerries, just for a run.

Sometimes he seemed to put *Consort* into what could only be described as 'interesting' places, cautiously venturing well into what seemed an impossibly narrow geo to count the *scarfs* (shags) and their nests almost alongside, or rolling alarmingly in a steep swell close inshore in the curious milky waters of the Blue Geo off Fetlar's north shore, to count the mewing grey seal pups ashore. And although Bobby could hardly be described as sylph-like, he soon demonstrated just how swiftly he could climb some of the Ramna Stacks, with *Consort* anchored precariously down below.

In all, so many days of my life were spent on *Consort* in Bobby's company. But despite his love and appreciation for his hardworking little 28ft Scaffie, there was a reality about keeping her fully operational, and cost-effective. There was the time, I recall, when a significant number of her planks, almost eaten through with shipworm, had to be replaced at some expense by Malakoff's yard in Lerwick. And there came the day when *Consort* rather sadly was no longer there, just 40 yards off the Mid Yell pier. Lying to what had been her buoy was instead a dark blue and white fibreglass launch, the *Starna*. Very functional, but not quite the same.

About that time I harboured totally impractical and somewhat romantic dreams of putting that boat of Bobby's back to sail, which she would originally have carried. I even recall going out to Hamar Voe near Hillswick to see if the wooden spars from Dr Dowle's Norwegian-built yacht, gale-driven ashore one winter, were still lying there on the tide-line, and serviceable.

Consort *laid up at Baltasound, Unst.* (Mike Richardson.)

Sadly, my last recollection of *Consort* was of her standing up on the Baltasound pier; paint blistering, bare wood exposed and with her boards starting to open from the blasting early summer sun and wind that in Shetland can prove so fatal to any wooden boat's planking.

Invariably, Bobby was totally at ease with his surroundings, as a superb naturalist in the field, behind the wheel of the boat, giving a lecture or playing the fiddle. And he was a born entertainer. His ease with such occasions, and with people, was always so evident. Where Bobby was less than content was stuck in a suit, or attending committee meetings. He didn't do committees, and struggled with their inevitable mountains of paperwork.

I have to confess that I've never much been given over to studying other men's eyes. But Bobby's were just a fascination. That bright, piercingly blue pupil with that tell-tale, paler circle which, I understand from the medics, may be a foreteller of problems to come. Bobby's razor-sharp, naturalist's eyes invariably twinkled; they were indeed mischievous. They were also remarkably expressive. Not being of a bureaucratic nature, Bobby rarely ventured into our former Nature Conservancy Council

office in Lerwick. The old, grey-painted, corrugated-iron-clad Albert Building, with its lurid orange window frames, had interesting features – the floors in the former coal store were so uneven that desks relied upon six-inch wads of old herring auction tickets propped under one end to provide anything like a horizontal surface. Heat conservation was so non-existent that it was like trying to warm the north Atlantic. Bobby was in one day, and we were talking. About what I now have absolutely no idea. I simply recall being drawn, fascinated to his eyes. The pupils had dilated hugely and instantly – a remarkable reaction which seemed to have no bearing at all on our conversation. Unbeknown to me, just at that very same moment, my Australian assistant Jenny had hove into view in the doorway behind my left shoulder. Now, more than 30 years later, Jenny's locks are steely grey, and she is an eminent specialist in sub-Antarctic botany. Back then, her looks, coupled with long, jet black hair, induced Bobby's wonderfully expressive bright blue eyes to almost pop out of his head. It was decidedly amusing to witness.

'An artist's eye for a picture . . .' The Noup of Noss, seen from Burravoe, Yell, through a telephoto lens. (Bobby Tulloch.)

Bobby excelled at so many things, and he had an uncanny ability to excel without it seeming any effort. Photography came easily. He had an artist's eye for a picture – its composition, colour balance or black and white contrast. And he was always experimenting. His study at Lussetter was crammed with all the paraphernalia of a naturalist's curiosity – a wealth of books that I would then have died for on the walls, bits of nature all around, be they bones or lichens on rocks. Suddenly, one day there was a salt-water aquarium with all the local rock-pool denizens – anemones, blennies, tiny little crabs, other crustaceans of every colour, size and shape, and eelpout – the inshore favourite of otters. Bobby had suddenly catapulted himself into the fascinating and, for him, exciting world of marine macro-photography.

Amongst all this nature stuff I made one day the most dreadful of faux pas. I incautiously delved into his slide collection. Well, in defence, I didn't exactly delve. There it was, the top drawer of the filing cabinet open and I was simply leaning against it. I had always envied Bobby's methodical way of filing his myriad slides in individual, transparent hangers. Mine in contrast were chaotically thrown together in boxes all over the place.

'It must be great, Bobby, to be able to just pull out these folders and look through, say, 20 or 50 slides at once on the light box. Fantastic for sorting out a slide show . . .' (for the local SWRI, I was thinking).

At that point my voice sort of stuttered, and my eyes must have glazed over, for what I was looking at were not birds, well, not in the RSPB sense, but ornithology of an entirely different nature; and most of the birds seemed to be clad in very few, if any, feathers.

I hastily, though with a remarkable degree of coolness, I thought, returned the folder to the depths of the drawer . . .

THE TEACHER AND COMMUNICATOR
Chris Gomersall

My first encounter with Bobby Tulloch was at Grimsby College of Technology in 1973. He never went to Grimsby, as far as I know, but this was where I saw the RSPB film *Shetland – Isles of the Simmer Dim* in which he featured. I expect there are thousands of people who saw that film and, like me, envied Bobby his island life-style and proximity to nature, no doubt naively, and were enchanted by his Shetland brogue.

A few years later I came to work for the RSPB and, in 1981, was despatched to Shetland to commence a three-year study on red-throated divers (or rain geese, as they are known in the local dialect). I was based on the isle of Yell, just across Mid Yell Voe from Bobby. As he was the society's regional officer at that time, he was my first point of contact and helped to get me started on my research project. He certainly seemed to know lots about the rain geese, and was quick to point me to a wooden photographic hide he had built overlooking a hill lochan some years previously. Mind you, he showed no inclination to join me in the steep climb uphill – he was always much happier travelling by boat wherever and whenever he could. The hide was still intact, and I was able to use it for my own photography a few times.

We shared an interest in wildlife photography, though I was still pretty young and inexperienced at this time. I knew something of Bobby's achievements as a photographer, among other things, and in particular his remarkable black and white shot of two otters on the seashore, each pointing in opposite directions.

The received wisdom at this time was that you couldn't possibly hope to photograph wild otters – they were still very rare further south. But I guess Bobby never knew that it was meant to be impossible and just got on with it, and the results certainly cemented his reputation as an outstanding fieldworker. He was always very disparaging of the run-of-the-mill otter shots you tended to see published in the magazines of the day, invariably captive specimens from the Otter Trust site at Bungay in Suffolk. His greatest venom was reserved for those photos of Asiatic short-clawed otters (not even our indigenous species) so often depicted 'begging' while

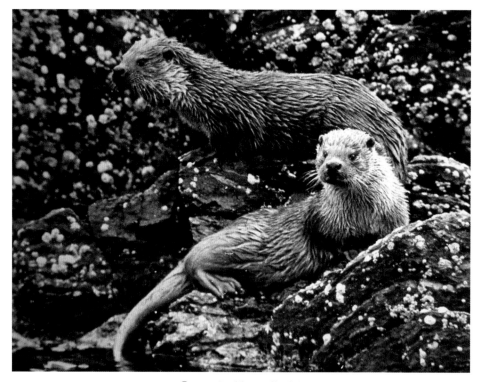

Otters. (Bobby Tulloch.)

stood on their hind legs. It's fair to say that a lot of that purist attitude rubbed off on me, and I see it as a beneficial influence in my own development as a photographer.

I had recently bought an Olympus OM2 camera before my arrival in Shetland, but hadn't yet had much chance to use it. That soon changed, when in my first week on Yell Bobby directed me to a bearded seal, a red-footed falcon, and a pod of pilot whales in Basta Voe which we were able to view from close range in his boat – all new to me, and presenting great photo opportunities. Not long afterwards, a young walrus turned up at Gutcher and once again we were able to get some fantastic close-up photos. Indeed, this made national news and I think represented my first ever published photograph, appearing in *BBC Wildlife* magazine.

Looking back, I'm all the more impressed by Bobby's generosity and openness. He might easily have viewed me as some young upstart and rival, who had no business usurping his patch, but instead his enthusiasm for the wildlife was always uppermost,

and I'm proud to say we became good friends. Boxes of processed Kodachrome slides were eagerly awaited in the post, and we enjoyed many evenings of projecting and comparing our results together with another RSPB friend. In spite of Bobby's help and encouragement, and many days exploring the coast with my camera, I never came close to emulating his success with the otters in those three years.

Towards the end of my spell in Shetland, Bobby's employment with the RSPB was also nearing an end – pretty much by mutual consent, I think. I know he felt quite remote from the affairs of the Edinburgh office and the Society's HQ in Bedfordshire, and was reluctant to attend meetings in the south, or engage in such activities as preparing dossiers for planning enquiries and all the new-fangled duties the increasingly sophisticated organisation demanded. Bobby was principally a communicator, and a damned good one – something I believe would be more valued nowadays – but then there seemed to be an institutional suspicion of employees who were seen as just too cosy with the media, for fear they detracted from the corporate message. I'm sure his commitment to conservation and the aims of the Society never wavered. It's just a shame they weren't better appreciated and an appropriate role found for his talents.

Talking of Bobby the communicator, one thing he never seemed to tire of was welcoming visitors to his beloved islands. During the summer months, there was an endless procession of pilgrims to Shetland, all seeking his advice on where to go for this and that. Every time I popped in to Lussetter, it seemed the kitchen was home to the next English family or camper van full of Germans, and he never tired of entertaining and enlightening them over a cup of tea and home bakes. The questions were always the same – 'Where can I find a puffin/otter/snowy owl?' – but Bobby never seemed to betray any irritation, just endless patience and goodwill.

THE ORIGINAL GREEN TOURISM MAN
Libby Weir-Breen

I first went to Shetland in 1980 to pitch for the post of public relations consultant to the Shetland Tourist Organisation. I was amazed that so little was made of the unique natural heritage of the islands and approached Bobby to ask him to come to talk to some travel writers about this aspect – my own knowledge was lamentable at that time. So began many years of collaboration which took us all over the world as well as the UK.

It didn't take long for the Shetland Tourist Organisation (as it was then known) to appreciate the benefit of using such a natural raconteur to charm his audience and put across the message that Shetland was indeed a good place to go. We went all over the

Bobby and Libby Weir-Breen. (Photo courtesy of Libby Weir-Breen.)

country, me driving (much safer – Bobby never stopped birding long enough to undertake that particular task on an English motorway!) and organising television and radio interviews and Bobby switching into 'in public' mode. I remember one particularly ignorant radio chap in Leicester saying that he'd heard it didn't get very dark in the Shetland summer and that you could sit outside at 4 o'clock in the morning and read a newspaper. 'No,' pointed out our ambassador: 'You can read a newspaper at midnight; you'll be getting a suntan at 4 o'clock!'

Bobby had an enquiring mind and endless curiosity. Of course his ancestors had gone south every winter to the whaling and the South Atlantic was an area he was keen to get to. He wanted to compare a remote group of islands in the North Atlantic with their southern equivalent – the Falkland Islands. The original expedition holiday, run by the

Bobby in Iceland on an Island Holidays expedition.
(Photo courtesy of Libby Weir-Breen.)

amazing Angus Erskine, had tried several times to sell a holiday to the Falkland Islands but without success. This was before the Falklands War (or Conflict, as the islanders prefer to call it).

To cut a long story short, I was invited to go to the Falklands as a travel writer in 1987. I was still working with the Shetland Tourist Organisation and with Bobby, who'd become a close friend. I felt a bit mean, getting to a place of which I knew hardly anything, but which Bobby so wanted to visit. So I suggested that we set up a little company, that he should go down in the November instead of me and that I'd go another time. 'Why should we succeed when everyone else has failed?' he asked. Of course the answer was Bobby himself – the best secret weapon a business could have!

And so Island Holidays was born – at an office in York (Falkland Islands Tourism). They very much liked the idea and, again, Bobby's charm was an important factor in getting the grant to produce a leaflet and run an advertisement. The company's name? Well, predictably, that was Bobby's idea: 'An island is an island and there's no argument. The boundaries can't be changed at the whim of a politician.' He took our first group down to the Falklands in January 1988 and the rest, as they say, is history.

'I'd like to go to the Seychelles,' he said one day. Fair enough. It just so happened that I was working on the Shetland stand at the World Travel Market, so I popped upstairs during a break and met the folk from Air Seychelles and a handling agent on the islands. Soon we were heading off to the Seychelles. The only time I saw Bobby getting really cross was when he fell off his bicycle three times on La Digue and all I did was laugh! I could sense him twinkling with mirth when I fell off mine 20 years later on Lord Howe Island and broke my foot.

'I really think we should go to the Pribilof Islands,' he said one day. The WHAT islands? Well, as most people knew, the kittiwake was Bobby's favourite bird and

Black-browed albatross, Falkland Islands. (Bobby Tulloch.)

Top: *Magellanic penguins and kelp geese on a Falklands beach.*
Bottom: *King penguins, Falkland Islands.* (Bobby Tulloch.)

Bobby had come across an article in a magazine about red-legged kittiwakes on the Pribilof Islands off the coast of Alaska, a bird found only there and along the Aleutian chain. Naturally, we went.

Our clients were usually RSPB member groups. After one evening in the pub a youngish man came up to Bobby and asked: 'Have you considered doing an island holiday to Cuba?' 'No,' said Bobby, 'Hot and sticky.' He never went to Cuba, a country I'm sure he would have loved in spite of the climate, and not only because of the birds – he was fond of a tot of rum and I reckon the dusky maidens there would have held some appeal as well.

Readers won't be surprised to know that Bobby was soon a folk hero in the Falkland Islands, as well known as he was in the UK. It was typical of the man that he made lasting friends wherever he went, enriching the lives he touched. He had a wonderful gift of sharing his knowledge rather than telling it, of making ordinary mortals feel that they mattered. Not that he was a saint: we had one particularly unpleasant client who wrote a not very nice letter when he got home. I asked Bobby how he'd put up with this character for 18 days, to which he replied: 'When I went

Horned puffins on the coast of Alaska. (Bobby Tulloch.)

Kelp gander and goose, Falkland Islands. (Bobby Tulloch.)

to bed at night I would imagine him pegged out in a field with the caracaras[38] and they were going for his tongue first.'

Stories run around of Bobby discovering fungi at Port Howard and drying them on radiators, much to the consternation of other guests. And he was always game to give a tune at the drop of a hat. Of course, in islands there are always instruments to hand; these hardy people have a history of making their own entertainment and doing it vibrantly. Bobby was a classic exponent of the art and the Falkland islanders loved him for it. Of course, so did the Island Holidays clients who benefited not only from his knowledge but also from his character and social talents. According to one islander, 'He made friends wherever he went and I cannot imagine anyone who ever met him not loving him at first sight, such a charismatic character, so very knowledgeable and wise.'

It didn't take Falkland Islands Tourism long to realise that in Bobby they had found a marketing gem. Soon we were setting off around the UK, this time with

38. A Falklands bird with the habits of a vulture.

Bobby showing his Falklands slides to enraptured audiences. It was in the days when tourism was only just beginning in the islands and unquestionably the growth in the number of people visiting had much to do with Bobby's high profile and massive enthusiasm.

The British Birdwatching Fair is now 27 years old and Island Holidays has been exhibiting there for most of that time. For the first few, Bobby came too and there were queues at the stand of people wanting to talk to him. He would sit there holding court – and occasionally referring someone to me if they showed interest in a particular holiday. But he wasn't a commercial animal and disliked that side of things. 'You'd better ask Libby,' was his common refrain and it was that expression that led to us setting up another small company with John and Chris Henshall in Crete.

Bobby was the original 'Green Tourism' man before any such concept had crept into the country's vocabulary, and this was recognised by John, a genius in every sense of the word. He had been in Shetland – I can't remember why – at the time when he had resigned his job in computer sciences in Edinburgh University and

Elephant seal bulls, Falkland Islands. (Bobby Tulloch.)

Bobby was prepared to defend the bloody slaughter of pilot whales in the Faroe Islands, on the grounds that it was a traditional subsistence practice and part of the local culture. If you killed something, you ought to be prepared to eat it, was his attitude.
(Bobby Tulloch.)

decided to move to Crete, lock, stock, barrel and cats! He was aware of Bobby's involvement in Island Holidays and had an idea of doing something similar in Crete, but didn't know how to start. He was a passionate conservationist, a brilliant naturalist and naturally he and Bobby had a lot in common. So he asked the question: 'How to we start?' to which came Bobby's inevitable reply: 'You'd better ask Libby'. So John and Chris came to Comrie and Wine Dark Sea was born, a business designed to show people 'The Real Crete'. Naturally Bobby was to be the bird man for the tours, which would offer a wide variety of options from birds and flowers to the Minoan civilisation and wind and water mills. Bobby loved Crete and he really enjoyed working with John and Chris. It was the destination he chose to introduce to one of his sisters and Mary Ellen just loved it.

Like all great naturalists, Bobby was quick to learn in a new environment. The only thing he really wasn't very keen on was woodland – 'too many trees getting in

the way'. After all, he was a Shetland man! Not only did all his travelling allow him to experience a host of different environments and species, but it also added hugely to his already bulging library of slides. I often wonder how he would have adapted to digital photography and rather suspect he would have enjoyed it – especially not having to pay for film, on which he must have spent an absolute fortune!

THE MUSIC MAKER

Lynda Anderson

Among his many talents, Bobby Tulloch was a musician, composer and song-writer. It was through his music that I first knew of him, in 1982, when he sparked my interest in the fiddle. I was six, and we'd just moved next door. Bobby had known my parents, Jean and 'Peerie' Carl, who ran the Linkshouse Shop at that time, for many years. During a visit to Lussetter House that Christmas, Bobby struck up the fiddle and played a few tunes. I was so taken with the music that I couldn't wait to get home to dig out the fiddle case at the back of the couch, and announce: 'I want to learn to play the fiddle!' A few months later, I started lessons with Trevor Hunter at the Mid Yell School, and have played ever since.

In the following years, I would trek 'doon ower da broo' with my fiddle, to play him the latest tune I'd learned. The house was an intriguing place to visit, with his many projects on the go, a perfect backdrop for music. He listened patiently, and when I learned to read music, would give me copies of tunes he'd written himself. I remember feeling a bit in awe – he was the first composer I'd met! I took a genuine liking to the tunes and their lilting rhythm, an added attraction being that many of them were named after people or places I knew in Yell.

The reels 'Colgrave Sound' and 'Arisdale Burn', were the tunes of his I first learned, both now well established in the Shetland fiddle repertoire. Distinctively Shetland in sound, they fit within a contemporary style established 30–40 years ago by the likes of Ronnie Cooper, Gideon Stove and Tom Anderson. Other favourites of mine include 'Bakka Tek' which has a distinctively Irish sound, maybe influenced by Bobby's listening to the Irish fiddler Sean McGuire; and 'Rae's Wedding Waltz', written for the marriage of Rae Anderson of Mid Yell to Peter Thompson of Aywick. Other tunes of his include 'The Draatsie', the Shetland name for the otter, which, highlighting his imagination, includes notes instructing that 'the tune is to be played in the style of an otter walking along a beach'. It's not clear over what timeframe he wrote them, but most likely around the years I first met him, by which time he was in his early 40s. The time and dedication he gave to these compositions is clear, with each having its own unique sound and rhythm. It was lovely to be reminded of that

lilting style in his own playing, listening to a tape my mother rediscovered recently of Bobby playing at our house in Linkshouse, close to 40 years ago.

As well as his ability to compose, it's impressive that he also taught himself to write music, a skill that many musicians never master. This enabled him to share the tunes he'd written, which he did generously. I remember him phoning to say he'd composed a jig and that if I came down to the house and could play it, he would let me name it. I set off down, made it through to the end and settled on the name 'Da Spoot Ebb', inspired by a recent trip to the head of the voe for spoots. A few years on, he presented me with a tune he'd written and called 'Lynda's Reel', which I was chuffed to bits with and still play often.

Bobby's Early Music Days

Thinking back through my memories of Bobby, I became intrigued to learn more of his musical heritage. Mary Ellen Odie, Bobby's sister, told me their father played

Douglas Brown, a former South Georgia whaler, working a 'spoot ebb' in Gloup Voe, Yell, one of the best places for gathering razor shells or spoots. (Bobby Tulloch.)

Bobby in the cast of one of Freddie Houston's pantomimes in Yell, about 1954.
Back, left to right: John William Smith; Wilma Smith; James Barclay; David Nisbet;
Campbell Gray; Vina Gray; Joe Smith. Middle, left to right: Mimie Jean Smith;
Mary Jamieson; Phyllis Clark; Jim Gray; Peggy Sandison; Mimie Thomason. Front,
left to right: Charlie Guthrie, Dan Spence; Bobby Tulloch.
(Photo courtesy of Mary Ellen Odie.)

the fiddle and was a great musical inspiration to Bobby to learn the instrument. She remembers him practising determinedly behind closed doors as a boy. His fiddle, though, appears to have been sidelined early on for the accordion, the instrument for which he is best remembered performing in public as a young adult. Many remember him playing at dances in Yell, which at that time were led by local musicians, whoever was in the hall that night and willing to turn a tune. Bobby's eagerness to play at a dance in the old East Yell Hall on a night he had no accordion was recalled by Maggie Ann Nicholson (*née* Scollay), a cousin of Bobby's. She mentioned that Lowrie, her brother, was away and his accordion was at their house. Wasting no time, Bobby fired up his motorbike (very few had cars at that time) and, with Maggie Ann on the pillion, headed for Gossabrough. Despite the lack of space, he was determined to get the accordion back to the hall so perched it on the tank in front of him, with Maggie

Ann on the back. They set off for the hall at breakneck speed, enough to terrify poor Maggie Ann, clinging on for dear life! Thankfully they made it back safe and sound, and Bobby wasted no time in getting straight to the stage with the accordion.

As well as performances in Yell, he played occasionally with the Islesburgh Dance Band, led by Tom Anderson. It may have been this connection with Tom, who worked tirelessly in his retirement to archive regional Shetland fiddle styles and tunes, that rekindled Bobby's interest and led him back to the fiddle during the 1970s. In his late 30s or early 40s by then, he was intrigued by the tradition and its preservation which was picking up interest in Shetland and beyond. He played briefly with the Shetland Fiddlers' Society, dropping in on practices between 1980 and 84, if he happened to be in Lerwick. He played some concerts with them too, including a tour throughout England in the early 80s, and to this day the Fiddlers' Society still plays a set of his tunes. That renewed interest in the fiddle was fortunate timing for me, as it was in the midst of those years when I heard him play that night in Lusetter.

The Songs

Bobby is probably best known musically for his songs, telling hilarious tales of local life. Andrina Tulloch first remembers him on stage at a Yell concert, singing 'The Wild Side of Life' with Arthur Nicholson of Burravoe. Renditions of American country hits were popular concert items at that time. As well as the singing, humour soon started to feature in his time on stage. Andrina remembered another night when he started singing in a key different to one he was playing on guitar. A shout came from the audience: 'It's D!' referring to the chord he *should* be playing, to which Bobby replied, 'Yes, it's me . . . is yun dee?'

The humour soon became the focus of his performances, and he started to write parodies of well-known songs, based on local life. The topics were wide and varied, from the worry of catching the latest flu:

> Each day we go aboot wir wark, we meet wir neebor folk,
> An aye we pass da time o day or stop an hae a smoke,
> But when dey hurry past you wi a hanky ower dir face,
> Dan weel you ken, hits come ageen to spread aboot da place.
> (Somethin' Goin' Aboot)

. . . to the plight of poor Jamie, a local crofter trying to find a wife:

> Jamie was a bachelor, he lived aa by himsel
> In a peerie bit of croft on da lee side o Yell,
> He had sheep by the hunder, an hens by da score,
> But never had a wife-body darkened his door.
> (Jamie Was a Bachelor)

Two annual concerts in Mid Yell became regular outings for his songs; the Regatta Concert in the summer and the New Year's Social in January. Both drew crowds from across Yell and were highlights on the social calendar until their demise through the early 80s. The concert line-up would comprise a mix of local acts, everything from David Nisbet's magic, to Campbell Gray's accordion, to local singing groups. Bobby became a much-anticipated item, bringing a new song each year, often based on an event of only days or weeks before, like his recollection of a fight that broke out at the Gossabrough Barbecue. Written specifically for the Regatta Concert that year, it was only ever performed on stage that night, and unearthed 15 years later while he was recording at the Old Haa.

For added comical effect, he would sprinkle in real, local characters. The story of Gifford Gray's Iron Horse, causing disruption to traffic and TV signals in Mid Yell, is a perfect example that brings a smirk to many a face who remember Gifford out on his tractor. He had a knack of painting a very visual picture that his audience could immediately recognise:

> He passed the manse at eighty-five
> and the minister offered a prayer,
> as da windows crack, and Mrs Slack
> dives in below the stair.
> But Gifford's cap is front to back,
> and his jaw is firmly set,
> If he doesn't stop he'll make the shop
> before it closes yet!

I spoke to Brian Nicholson, a musician, singer and songwriter himself who also performed in those concerts: 'When he was on stage, in front of an audience, he

Always a party animal, Bobby is seen here in a 1985 Cullivoe Up Helly Aa fire festival squad with (left to right): Trevor Hunter, Jennifer McCloud, Christine Guy and Peter Guy. (Photographer unknown.)

looked extremely at home. A really natural performer, and able to have the audience eating oot o' his hand. Very, very good. Getting an audience to laugh is one of the most difficult things to do an' he was extremely good at it, an' as good as anything you would have seen on TV at the time, or today.'

In recent years, Brian has performed Bobby's songs himself and in studying them has found a renewed respect for his songwriting talents, describing him as being 'every bit as good' as the great songwriters who 'create a whole film scene'. One source of inspiration for Bobby was the British-born, Canadian-based poet Robert Service, whose work was characterised by the use of humour in verse and included 'The Shooting of Dan McGrew'. Bobby's poem 'Trootie Tammie' displays that influence, which Brian Nicholson could tell me was based on two real events: the story of an old woman in Aywick who saw something drifting ashore which, although it was feared to be a mine, turned out to be a dead horse; and of an annual visitor who would exaggerate and claim to have caught huge fish. Bobby

combined the two, to tell the story of a man catching in the loch what turned out to be a dead horse!

Amongst the satire, he did pen some serious pieces, including 'Da Press Gang', a familiar tale of the impressment of local men into the Royal Navy, and 'One Hundred Shetland Islands', telling of the beauty and nature of Shetland. Local performances of these were rare, though, where hilarity was the call of the crowd.

The success of the local performances soon built a precedent of expectation for a new masterpiece each year – a recent local event, ideally paired with a song popular at the time. This would lead to great pressure when a deadline loomed if no new song was ready. Mary Ellen told me of him phoning in one such panic on New Year's morning, the Social just a few hours away. Although she helped pen some of his songs, she had no time that day. Trying her best to spark ideas, she asked of recent events in Mid Yell. With a heavy sigh, Bobby could think of nothing. The only happening he could recall was of sheep finding their way into the graveyard and eating roses laid by Mrs Brown. She made mention of 'Don't Fence Me In' as a possibility, and the conversation ended. Not more than half an hour later, the phone rang again and she lifted it to hear him say: 'I could showe [chew] on a knowe but I'm no dat kind of yowe' then sing to the end of his new masterpiece. As my mother recalled, he took to the stage that night with a toy sheep as a prop and the song went down a storm. I couldn't resist putting the original lyrics alongside Bobby's version and trying to picture him crafting his ewe's perspective in that half an hour.

Don't Fence Me In
Lyrics by Robert Fletcher and Cole Porter, 1934

Oh, give me land, lots of land under starry skies above,
 Don't fence me in,
Let me ride through the wide open country that I love,
 Don't fence me in.

Let me be by myself in the evenin' breeze
 And listen to the murmur of the cottonwood trees,
Send me off forever but I ask you please,
 Don't fence me in . . .

Don't Fence Me In
Lyrics by Bobby Tulloch, adapted from original by Robert Fletcher and Cole
Porter, early to mid-1980s
(Bobby's version is written from the perspective of a Mid Yell ewe!)

Give me land, lots of land and a quarry hol to bul [shelter] in,
 But don't fence me in.
I could showe on a knowe but I'm no dat kind of yowe,
 So please don't fence me in.

You can drive me wi dogs to where the banks commences,
 Run and shout and swear until you lose your senses,
But I'll be back again to jump your daeks and fences,
 For you can't fence me in.

I'll go on making ravages among your neeps and cabbages,
 If you don't fence me in.
I'll go for all your fuchsias and breathe on all your bushias,
 If you can't fence me in.

You can pit me in sticks if it keeps you happy,
 Cut me lugs in bits until dey all go flappy,
I'll even let you fit me wi a dungaree nappy,
 But please don't fence me in.

Oh I'll bul by da pul til da night begins ta faa
 If you don't fence me in.
In da munelight I'll sune fin dat hole ita da waa,
 If you don't fence me in.

Dan I'll graze all night on your gladioli,
 Munch up your marigolds as weel by golly,
An leave haaf my fleece on your prickly holly,
 If you don't fence me in.

In the park after dark, bairns I got an awful fright,
 Don't fence me in.
When a man wi a knife cam and chased me for me life,
 Don't fence me in.

He followed me ta Gairdie like an express train,
 My lugs bright red at the things he was sayin',
He even said me faider was a Wast banks quhain,
 Don't fence me in.

There's no thrill on da hill when da winter storms arrive,
 So please don't fence me in.
I can sook crabbie shalls just ta keep mysel alive,
 So don't fence me in.

A Skerries ewe keeping warm after losing her wool a little early in the season: one of Bobby's best-known pictures, predating those famous internet Shetland pony sweaters by 40 years. (Bobby Tulloch.)

For there's lots of lovely girse aroond aboot Isleshaven,
 Dey'll never hear me comin in or see me leavin',
An da new playin field is my idea of heaven,
 So please don't fence me in.

I can jump ower da mune, I can swim beneath the sea,
 An you can't fence me in.
I'll have roses for breakfast and cauliflower for tea,
 If you don't fence me in.

I'll be into some een's gairden every blessed night,
 Filling up wi greens just ta keep me boo'els right,
Dan I'll bul upon your doorstep, an leave a heap o – muck,
 If you don't fence me in.

Throughout his songs, he was keen to incorporate Shetland dialect, as in his song dedicated to Mary Blance's dialect weather forecasts on Radio Shetland:

Oh Mary dis Shetland's a wonderful spot,
Tho some tink da wadder is no just dat hot,
But in English it always soonds very much worse,
When a 'gooster o' wind' is described as storm force,
And 'drush' never weets you laek 'drizzle' ava,
And 'snow' is much colder than saft Shetland 'snaa',
And as for da 'troughs' and 'occlusions' dey fear,
Bairns, I've never ever seen wan o' dem here.

The Recordings

That his songs, of which he wrote at least 30, were recorded, released for sale and immortalised in the process is somewhat a stroke of luck. The Old Haa Trust was established in Burravoe, Yell, in 1986, with the aim to preserve and exhibit local history and culture. Amongst the gathering of information and artefacts, the Trust set out to capture a snapshot of musical talent in Yell at that time. Bobby was approached as part of this work, and was asked that some of his songs be recorded for the archives.

He agreed and was filmed singing a couple of them. A few years later, the Trust asked if he would consider recording a few more for release on tape, to help raise funds for the Old Haa. Happy to help, he agreed. As Brian Nicholson told me, this was likely also a welcome opportunity to quiet the frequent requests for home tape-recordings of his songs, some of which, I learned, still exist in houses across Shetland today.

So in 1989, Bobby headed from Mid Yell to Burravoe, to the studio by then established at the Old Haa, and Brian was called on to play guitar, leaving Bobby to concentrate on the lyrics. 'I mind it as being just wan night,' Brian told me. 'He came ower wi a big book of songs and his peerie half-rimmed glasses.' With no rehearsals, they got straight to working their way through the songs, one by one, with just time enough between for Bobby to flick through the book to find the next: 'Right, we'll do this one noo,' Brian recalls. 'We would just get a key and work away. The whole thing went past in a flash.' They were interrupted a few times by chuckles from Brian, hearing some of songs for the first time. 'I mind him looking disapprovingly ower

Something Goin' Aboot and Goin' Aboot the Banks.

his glasses and would say: "Is du alright noo, will we do it again?" They recorded 28 songs that night. Two or three he decided were not up to scratch and another two or three that 'Bobby didna want to use because when we listened back, he thought the lyric was a bit insensitive'. This included one with reference to 'Shetland Roses', red McEwan's Export cans discarded on roadsides, which Bobby thought might paint Shetland in a bad light.

Bobby's Musical Legacy

His musical legacy is, thankfully, committed to more than just memory. From those Old Haa recordings, the first cassette 'Somethin' Goin' Aboot!' was released for sale in 1990, and a year later, 'Goin Aboot the Banks' was released. Both sold well, with 'Goin Aboot the Banks' remastered and re-released on CD in December 2012, again to raise funds for the Old Haa. Thirty years on, they are historical gems, providing a nostalgic visit to places and characters of island life now passed. The tunes and songs are not only a treasure of his musical skill but a means to remember and still be entertained by the humble, talented and inspiring character who just happened to live next door. I feel very lucky.

Something Goin' Aboot!

Released: 1990
Label: Magnetic North Recording
Catalogue No.: MN2
Format: Cassette

Track List
1. Gifford's Iron Horse
2. The Road to the Altar
3. The Crown of Golden Hair
4. The End of the Pub
5. Somethin' Goin' Aboot
6. Don't Fence Me In
7. Jamie Was a Bachelor
8. The Broken-down TV Set
9. Where the Banks' Flooers Grow

10. Mindless Maunsie
11. Outside Toilet
12. The Shetland Cowboys

Goin' Aboot the Banks

Released: 1990
Label: Magnetic North Recording
Catalogue No.: MN5
Format: Cassette

Track List
1. The Tangle of the Isles
2. Mary's Weather Forecasts
3. Trootie Tammie
4. Du Picked a Fine Time to Faa By
5. The Press Gang
6. The Tourist's Lament
7. Peerie Ting-a-Ling
8. The Gossabrough Barbecue
9. The Un-Lagged Lamb
10. Goin' Aboot the Banks

The Seafaring Entertainer
Freeland Barbour

I first met Bobby in 1977 on a cruise run by the National Trust for Scotland on the schools ship *Uganda*. He and I were on the NTS staff (he as lecturer and I as musician) and we all had to take our turn as couriers, helping out in ceilidhs, and anything else that came to hand. Normally these were annual two-week cruises with over 50 NTS staff (including guest lecturers, musicians etc.) and about 1,100 passengers, about 800 of whom stayed in dormitories on the boat (as did the staff). However there was an extra trip put on in May '77 with far fewer passengers and staff, so we all had rather more to do. It didn't take long for Bobby and me to find we had much in common, and many friends too, and we quickly became firm friends. Bobby of course had that ability with everyone he met. I did 20 cruises over the years with the NTS and Bobby must have done a good few more, quite apart from all his other trips. I found the whole thing hugely inspiring, as the staff always contained a large number of talented and highly-respected people from different walks of life, and the same was true of the passengers. We all made many friends.

We did indeed play together at the on-board ceilidhs, and spent a good deal of time in the dormitories and cabins working up stuff to play. Bobby played the fiddle but I could tell from his box-playing just how good he had been (he played with Tom Anderson in the Islesburgh band in the '50s I think). We did one turn when he played the box and I played the fiddle but we concluded that he was bad and I was worse so we let it drop. We played a mixture of his tunes, old Scandinavian stuff (Carl Jularbo), older Shetland material, and music we'd both learned from our Faroese friends in Spaelimenninir (who I later played with for a number of years). He gave me quite a few of his own tunes but he had a terrible job remembering the titles, and I recorded a number of them and have a few more that I didn't get round to. He also played guitar a bit when he sang.

Bobby always did at least one of his dialect songs at these ceilidhs and they always went down a storm. 'Somethin' Goin' Aboot' was the big hit, I seem to remember. Everyone loved Bobby and he could have sung the *Shetland Telephone Directory* and

The cruise liner Uganda, *latterly a hospital ship in the Falklands/Malvinas War.*

still got an encore! He gave me quite a few of his poems and songs and I used to use his outside loo piece at Wallochmor Ceilidh Band concerts and since then.

I always had the bunk above Bobby on the *Uganda*. One night after a late session in the bar (playing music I think) Bobby and I came in to the dormitory and the noise of 20 snorers was epic and hilarious so I recorded it on a cassette recorder that I had (I still have the recording which opens with a huge crash as Bobby falls over some luggage in the dark, and is then followed by muffled Shetland swearing and the roaring snoring). The next day Bobby and I and John Wilkie (photographer and wonderful wit) found ourselves in an office after a meeting and John discovered a microphone which was connected to the PA system for the entire ship. So he opened up with 'Scotland the Brave' on the pencil (which he was very good at), then we followed with the playing of the snoring recording and as Bobby was just getting into his stride with his imitation of a hen laying an egg (I think) we heard running feet out in the corridor so we aborted the broadcast. The feet ran by and no one came near us, though later on I did hear one elderly lady complain to her friend that her hearing-aid

was malfunctioning because she was sure she'd heard pigs and hens earlier on. We had a lot of fun on these trips.

Bobby was the best ambassador that Shetland could have had. His illustrated talks were masterpieces of knowledge and love of life, and particularly Shetland life. He was interested and interesting and he gave great encouragement to all around him. I couldn't believe how lucky I was to be able to count him as a friend and I can't tell you how happy I was when my tune 'The Ornithologist' became so popular, as I had hardly dared have the effrontery to name a tune after him. He was so humble, as many really great people are, and he had a warmth and aura that was a magnet for all sorts of people. It's a real delight that his legacy is being preserved and his uniqueness acknowledged.

The A to Z of Bobby Tulloch

Dennis Coutts

Everybody in Shetland's heard about Bobby Tulloch. He's especially well known as the finder of Britain's first breeding snowy owls, back in 1967. I had the good fortune to know him longer than most. Bobby was typical of the many Shetlanders living on small islands who could turn their hand to anything.

He was the most resourceful guy I've met. I've done an alphabet of his talents, with a **V** for **versatility** especially coming to mind. But I'll start with **A**:

Angler: Bobby not only knew how and where to catch sea fish and trout; he knew how best to cook them as well. **Athlete**: in the sailing regattas of the 1950s there were also land sports. In his youth, Bobby's legs could move very fast. He was one of three

Bobby baiting his hooks on a sea angling trip with Sterna *in 1992.* (K. Jamieson.)

Consort *nosing in among the Ramna Stacks.* (Bobby Tulloch.)

Tullochs who dominated the sprints. **Artist**: first class pen-and-ink sketches by Bobby, mostly of seabirds, enlivened many publications. **Author**: *Bobby Tulloch's Shetland* sold 15,000 copies; it was reprinted and was easily the most widely-read book he had a hand in. Single-handedly. he wrote and published the first Shetland Bird Reports.

Baker: Bobby's first job on leaving school was to serve his time as a baker. He was later a partner in the bakery at Mid Yell. **Barber**: I had many a haircut from Bobby. He was rough, but did ladies' hair better, I'm told. **Boatman**: he just about lived in his boat, with Yell ideally placed just one isle away from so many others.

Carpenter: Bobby fitted out several boat interiors, where nothing is ever straight or square!

Driver: Bobby drove bread vans, both in Yell and for a time Mitchell Georgeson's van in Lerwick. **Dialect** was the Yell man's great love, but I'll give you some of his classic dialect at the end.

Eric (that's **Hosking**) Britain's most famous bird photographer: when the snowy owls nested on Fetlar, Eric took about 3,000 photos and I made a film for the RSPB. Bobby used to visit Eric in London. Once they drove in Eric's Rolls Royce to the back door of Buckingham Palace to collect a tripod Prince Philip had borrowed. The Prince and Eric used to go photographing birds.

Erne is the old name for the sea eagle. A baby girl was carried off by an erne to its nest in a cliff, but a young boy climbed to retrieve the baby unharmed. When they grew up they married. It's true; it's in *Bobby Tulloch's Shetland*, where he claims descent from 'the eagle bairn of Fetlar' – an event from around 1690.

Fungi expert: Bobby's knowledge extended to mushrooms and such. He added several species to the Shetland list.

Globetrotter: as a tour leader Bobby travelled from Spitsbergen to the Falklands, from the Mediterranean to the Seychelles. When he showed me slides of breakfast among the

The fairy tern that left its mark in a Seychelles sugar bowl. (Bobby Tulloch.)

palm trees at the beach, it seemed idyllic. I asked if there was anything about it he didn't like. He said: 'Yes da peerie birds cam on da table and shat i' da sugar!'

Historian and **Humorist**: he had a great interest in Shetland's history and genealogy. He claimed descent from a Bishop Tulloch, in Shetland in the 1300s. Bobby assured me an actress was probably involved!

Island Holidays co-founder, Bobby loved islands – 'Give me an island and I'm happy', he said.

Justice of Peace: for refusing to fight police. As a **JP** he could certify that any passport photo I'd taken was a true likeness, even if it made the person look like a criminal.

Kiosk: in 1965 Johnnie Simpson found a black-headed bunting on Whalsay. Bobby went in his boat to see it. From a telephone kiosk he phoned me as I was photographing a baby in my studio. 'Nae sign, boy. Hit's poured fir da twa hours since I got here. I've trudged round in the rain until my backside's ripen' wi' watter . . . ★★★★★!!! It's right here outside da kiosk!' The phone slammed down – only a hum in my ear. My enthusiasm for child photography took a rapid nose-dive.

Lobster fisherman was Bobby's main occupation before working for the RSPB. **Lecturer**: he was an entertaining and competent lecturer. A slide show he did for the RSPB attracted an audience of 1,200 in the Royal Festival Hall, London, and was a great boost for membership.

Milliner: he made caps from old corduroys and was a keen **Motor Cyclist**: before car ferries, at suitable tides Bobby would manhandle his motorbike on and off small boats between Unst, Yell and Fetlar. **Musician**: he was a singer, composer, accordionist, guitar picker and fiddler. When a friend of mine called on Bobby once, he found him lying on his back in that old restin' chair – playing the fiddle! The **MBE** was awarded to Bobby for services to ornithology.

Nyctea scandiaca: when Bobby found the snowy owl's nest he sent the cryptic telegram to his RSPB boss – *Nyctea scandiaca* c/3 – which meant snowy owl, clutch of three eggs.

Ornithologist: not many people have a dance tune in their honour but Bobby does – *The Ornithologist* – and no wonder, for he was Shetland's best-known ornithologist.

Ploughman: Bobby could plough. During a shower he leaned against his pony for shelter as he rolled a cigarette. Gradually he felt the weight of the animal leaning on him. When Bobby jumped away, the pony fell over. He had some unusual experiences! Bobby was the Shetland Bird Club's first **President**. Also a **Poet** and, as a **Photographer**, he illustrated many magazines and especially his books. **Pantomime Horse**: Bobby and I got into a pantomime horse outfit in an attempt to photograph a snowy owl. I had a camera up front. Bobby was in the rear. The owl flew away, but with ponies in the area, and a stallion among them, Bobby said he needed a syrup-tin lid in his trousers!

Bobby (left) and Dennis Coutts getting into the pantomime horse suit intended to serve as a mobile hide to photograph the Fetlar snowy owls. The owls were too wise, however, and fled from the apparition. (Photograph: the late Lance Tickell.)

Quartermaster Sergeant: during his National Service days, for a time Bobby was in charge of an army bakery near Hong Kong with the rank of Quartermaster Sergeant.

RSPB Shetland's representative: when Bobby became the RSPB's man in Shetland, he quoted *The Shetland News'* obituary of his predecessor. The weekly reported Charlie Inkster as being a great asset to the Royal Society for the *Prevention* of Birds.

Snowy owls: after finding the owls' nest on Fetlar, Bobby was never out of the spotlight. He led groups up Stakkaberg to see the birds – sometimes rather unfit people. Bobby told of an old doctor whose steps got shorter and shorter until only his knees were twitching!

Twitcher: many people think birdwatchers are twitchers. Only a few are. A twitcher is a birdwatcher who goes to great lengths to see any species he hasn't seen before, like Bobby going to great lengths to see the rare bunting on Whalsay. When he'd had a successful twitch, and I hadn't been with him, he'd phone, singing falsetto: 'Be kind to your web-footed friends' and then ask me to guess what he'd seen. We had tremendous friendly banter.

Unst was an isle Bobby loved, where he led so many groups. In the 1970s Bobby christened that great attraction, the black-browed albatross, Albert Ross. Sometimes we went to Muckle Flugga in Bobby's boat and saw Albert from the sea, but I preferred going on foot to Hermaness – Bobby's tea on the boat had a terrible effect on me!

Volunteer Coastguard: in pre-helicopter days Bobby was in team of volunteers taught to use a breeches buoy – a pulley system fired by rocket to a grounded ship, enabling its crew to be winched safely ashore.

Wedding cake icer: as a baker with artistic talent, Bobby baked and iced wedding cakes. He also became a **Wedding photographer** for me, often covering the North Isles while I was doing a wedding elsewhere. Talking of weddings, on the day Prince Charles and Diana Spencer married, we watched the ceremony on Bobby's TV at Lüssetter. At the same time, from his window we could see a **W** for **walrus** – in Mid Yell Voe.

Lost and far from its icy home, the young walrus was extremely tame. No telephoto lens was required. (Bobby Tulloch.)

Xian is a Chinese dialect. Bobby learnt Chinese of a kind in his army days. Whatever dialect it was, he ordered in Chinese whenever he had a meal at the Golden Coach in Lerwick, then ate using chopsticks with great ease.

Yodeller: Bobby had an excellent singing voice and was adept at yodelling in the style of Hank Snow and Jimmy Rodgers. Their records were almost as popular as Scottish dance music in Bobby's younger days. Yell Sheep Tief: Until a few years ago every district had its own breed: Whalsay pilticks, Lerwick whitings and many others. Born at Aywick, Bobby was 'a **Yell sheep tief**' [thief], although probably because he was a Justice of the Peace, I have found no record of Bobby purloining sheep. Yell was obviously his favourite isle. With a smile he would quote a writer who visited Yell in the 1700s: 'Lest he be born there, Yell is an island where no man can survive'.

Zoology is a science Bobby was well versed in, especially the behaviour of seals, cetaceans and otters. Seals knew his behaviour and during the shooting era seals

Shetland sheep in winter, Weisdale. (Bobby Tulloch.)

recognised his boat was no threat. He used to show a super slide of a seal high on a rock with the tide out. Someone in the audience asked how it got up there. He told them that's where it had been born! **Zetland** was one of the old names for Shetland. Place-names were of great interest to Bobby; he worked out their meanings in the old language. He loved old dialect with its humour. When asked to 'say something in Shetlandic' he would say:

> Ida mirknin a air da streen,
> He cam awa sicca steekit moori caavi…
> At lang afore da dimriv
> Wir peerie moorit gjimmer wis smöred itil a fan.
> Hed shö bön kringed wi' da catmuggit hug at da knowe
> Shö widda fön a böl, krugin ida lee a da krö.[39]

39. 'In the dusk last night such a blizzard came on that our little brown ewe was buried in a snow-drift. Had she been gathered with the piebald sheep at the hillock she would have found shelter in behind the sheepfold.'

That great achiever, the friendly Bobby Tulloch, was surely one of Shetland's greatest-ever ambassadors; it's a privilege to have known him.

The memorial to Bobby Tulloch, by Mike McDonnell, in the Shetland Amenity Trust's boardroom.